Historic

RICHMOND

CHURCHES & SYNAGOGUES

Historic

RICHMOND
CHURCHES & SYNAGOGUES

WALTER S. GRIGGS JR. | *Photography by Robert Diller*

THE
History
PRESS

Published by The History Press
Charleston, SC
www.historypress.net

Copyright © 2017 by Walter S. Griggs Jr.
All rights reserved

First published 2017

Manufactured in the United States

ISBN 9781467137416

Library of Congress Control Number: 2017940949

This book is dedicated to my wife, Frances Pitchford Griggs, and my daughter, Cara F. Griggs.

CONTENTS

CONTENTS

PREFACE

Richmond, Virginia, is a city of churches and synagogues with interesting histories that portray the search of people for a place to worship their God in accordance with their beliefs. In writing this book, I have provided a summary of how each religious group came to Richmond and the churches and synagogues they established. Following the summary, I have written histories of most of the churches and synagogues that were in existence prior to 1850. In some cases, I quote sermons, and in other cases, I recount significant events that occurred in that place of worship. I have tried to capture something of the history of these sacred buildings, many of which are still being used today.

Richmonders have made many sacrifices to build their houses of worship. These churches and synagogues have heard prayers from the settlers at Jamestown to the American Revolution and from the unspeakable tragedy of the Civil War to the present time. Their walls have heard the prayers of generations of worshippers, and if these walls could speak, they would tell of triumphs, tragedies, baptisms, weddings, funerals and many other events that people face on a daily basis. They are sacred spaces that can provide comfort for all people.

—Walter S. Griggs Jr.

ACKNOWLEDGEMENTS

For my entire life, I have lived in Richmond and attended or visited many of its churches and synagogues. It was suggested by my longtime friend Jerome Becker that I write about Richmond's sacred spaces. I am very grateful for his suggestion.

In writing about these churches and synagogues, I have depended on the help of a lot of people and organizations. The Library of Virginia archives staff provided valuable assistance as did Bonnie Eisenman, the administrator of the Beth Ahabah Museum and Archives, Richmond, Virginia.

The clergy and staff of the following churches and synagogues provided invaluable assistance: St. John's United Church of Christ, Grace and Holy Trinity Episcopal Church, St. Patrick's Catholic Church, Grace Covenant Presbyterian Church, St. Peter Catholic Church, Leigh Street Baptist Church, Second Presbyterian Church, St. Philip's Episcopal Church and Trinity Methodist Church. I am also grateful to the Historic Richmond Foundation for access to Monumental Church.

In various ways, the following people contributed to this book: Drs. Richard and Patricia Harwood; Susan Guckenberg; Jerome Becker, PhD; Martha Jane Biglow; Eileen Foster Beane, Holly Clary, the Reverend Dr. and Mrs. Robert W. Griggs; Carolyn W. Brittain; Jennifer Spann; Burrell Stultz, Ann Williams; the Reverend Dr. William Blake; the Reverend Dr. and Mrs. David Jarvis; Joan Newell; Melanie Becker; the Reverend Dr. Alexander Evans; the Very Reverend Phoebe A. Roaf; the Reverend Tyrone

Nelson; and Pegram Johnson, PhD. I would also like to acknowledge the inspiration of the late Monsignor Charles Kelly and the late Fred Neurohr.

Robert Diller is responsible for the photographs in this book. I appreciate the time and effort he gave to enhance this book. I will always be grateful to him.

Lisa Ermbridge was most helpful on photograph selection and editing.

I want to thank my daughter Cara Griggs, whose skills as an archivist were extremely helpful in finding obscure material. But I am most grateful to my wife, Frances Pitchford Griggs, a retired English teacher and librarian, who edited and proofed the book. Her patience, expertise and suggestions were most helpful. Thank you, Frances!

Banks Smither of The History Press has also been a tremendous help. His kindness, understanding and patience will always be appreciated. Other people at The History Press who helped in this endeavor, including Abigail Fleming and Katie Parry.

CHRISTIANITY COMES TO JAMESTOWN

Go therefore, and teach all nations,
baptizing them in the Name of the Father, and the Son, and the holy Ghost.
—Matthew 28:19 (Geneva Bible)

Galilee is a long way from Richmond, Virginia; it is very different from the eastern coast of North America. But it was in Galilee that Jesus said to his disciples, "Go ye therefore, and teach all nations, baptizing them in the name of the Father, and of the Son, and of the Holy Ghost" (Matthew 28:19, King James Version). This is the Great Commission that led Christians to challenge the fearsome Atlantic in small boats to carry the mandate of the gospel to Virginia, the New World and beyond.

With the discovery of the New World by the Viking adventurers and Christopher Columbus, European nations sent out ships to explore and settle this new land. These nations were also committed to bringing Christianity to the Native Americans. But the Christians frequently sacrificed their lives to fulfill the Great Commission. This is the story of their work in Richmond and the legacy they left behind.

By some accounts, the first Christian worship service in Virginia was held in the summer of 1526 by Spanish explorers led by Lucas Vázquez de Ayllón, who was accompanied by Dominican friars. The service took place in the area where the English would eventually establish their colony at Jamestown. Mass was said at the new colony, but the efforts were soon abandoned, as was a subsequent effort in 1570 led by Father Juan Segura

and seven other Jesuits who sought to convert the Native Americans. The Jesuits planned to carry out the Great Commission, but the Native Americans attacked and killed them in 1571. These Jesuits died for their faith and became the first martyrs in Virginia. Following the massacre, the Spanish gave up their efforts to establish a colony in Virginia, leaving the area open for English colonization. The Spanish called the area Aljacán. The English, who would arrive decades later, would call it Virginia in honor of their virgin Queen Elizabeth I.

Following the failure of the Spanish, the English sought to establish colonies in the New World. Three English ships—the *Susan Constant*, the *Godspeed* and the *Discovery*—set sail from England on December 19, 1606, with 145 men on board. The plan was for about 105 men to be left as settlers. On board the *Susan Constant*, the largest of the ships, was Reverend Robert Hunt, a parish priest of the Church of England. The trip was difficult, but the three ships finally reached the shores of the land they called Virginia on April 26, 1607. The four-month voyage was at an end, but many challenges were ahead of them.

George Percy, one of the colonists, described Virginia as "having fair meadows and goodly tall trees, with such fresh waters running through the wood, I was almost ravished at the first sight thereof." Captain Christopher Newport wrote, "On the nine and twentieth day, we set up a Cross at Chesupic [Chesapeake] Bay and named the place Cape Henry" in honor of Henry, the Prince of Wales, the oldest son of the king. Following prayers for their safe arrival by Reverend Hunt, they raised a seven-foot cross, signifying that Virginia was an English colony.

This was the first formal prayer service held in Virginia by the English. Before leaving, Robert Hunt claimed the land for God and country and consecrated the continent to the glory of God. He then declared, "From these very shores the Gospel shall go forth to not only the New World, but the entire world."

Following the ceremony, the English continued to explore the Virginia coastline and countryside looking for a place to settle. They finally decided on a marshy, swampy peninsula that they called Jamestown. They did not know it at the time, but the first permanent English colony in North America had been established. The newcomers then moved on to explore what the Native Americans called the Powhatan River, but they changed the name to the James River in honor of their English king.

About a week later, some of the English settlers decided to continue to explore the James River. Using a small boat, Captain Christopher Newport

and twenty-three men left Jamestown, sailed up the James River and started to look for the head of the river. Captain John Smith described this voyage as follows: "The people in all places along the way kindly entreating us, dancing and feasting us with Strawberries, Mulberries, Bread, Food, and other provisions whereof we had plenty." The voyage continued until the river became too shallow to navigate. Smith explained, "We were intercepted with great, craggy stones in the midst of the river, where the water falleth so rudely, and with such a violence, as not any boat can possibly passe [*sic*]." The explorers had reached the fall line of the James River, and their boat could go no farther.

Leaving their boat, the Englishmen stepped onto ground that would eventually become the site of the city of Richmond. It was May 24, 1607, when the men gathered around a cross that they had made. Captain Gabriel Archer noted, "Captain Christopher Newport set up a cross with this inscription, 'Jacobus Rex, 1607'." To reassure the natives that the cross was not a threat to them, they told the natives that one piece of the cross represented Captain Newport and that one piece acknowledged Chief Powhatan. In fact, however, the cross represented the Church of England and the British Crown and served notice to all that the English had just claimed the land for God and country. After the cross was raised and prayers for King James were offered, the settlers returned to Jamestown. It would be many years before Richmond was settled. Today, a metal cross located at Twelfth and Byrd Streets marks the area where the first cross was erected.

Reverend Hunt conducted the first religious service at Jamestown under a canopy made of an old sail suspended from several trees. Captain John Smith wrote, "I well remember, we did hang an awning (which is an old sail) to three or four trees to shadow us from the sun, the walls were of wood nailed to two neighboring trees. In foul weather we shifted to an old rotten tent." The tent was said to have twofold significance. It would not only shield the settlers from the sun, but it also marked a holy place. Reverend Hunt stood behind a rough table and repeated these words from the Book of Common Prayer: "Lord, we beseech thee mercifully to hear us, and unto whom thou hast given a hearty desire to pray; grant that by Thy mighty aid we may be defended through Jesus Christ our Lord." The Christian Church had been planted in Jamestown. To worship God was one of the first priorities of the Jamestown settlers, and eventually, a church of wattle and daub was constructed.

The first Anglican Eucharist in the colony was probably celebrated on June 21, 1607. After the service, two of the ships that brought the

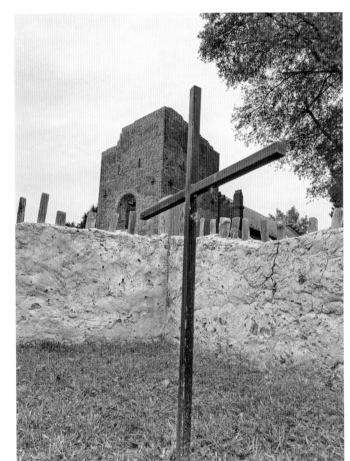

Right: Grave site of Reverend Robert Hunt at Historic Jamestowne. Remnant of original church tower in background.

Below: Bronze bas-relief representing the June 21, 1607 celebration of Holy Communion by Reverend Robert Hunt.

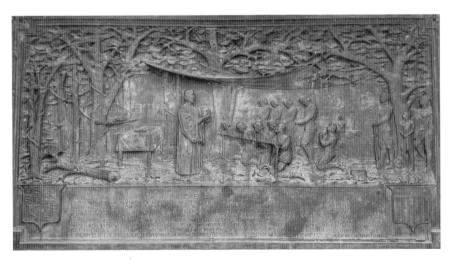

colonists to the New World returned to England. The colonists were now on their own. Help from England was over three thousand miles away. Through many hardships, the colony at Jamestown survived, and the colonists began to move to other parts of Virginia to promote the gospel and raise products to send back to England.

Today, Jamestown is a sacred site where visitors can walk where the colonists walked, see where Reverend Hunt prayed and reflect on the challenges endured to build the United States of America with the help of Almighty God.

When I was in the fifth grade at Ginter Park School in Richmond, my class went to Jamestown on a class trip. Carolyn and I can still recall seeing the old church tower. However, we could not appreciate at the time that we were walking on soil where people suffered and died to establish a new nation.

2

HENRICOPOLIS AND THE EPISCOPALIANS

Let the beauty of the Lord our God be upon us:
and direct thou the works of our hands upon us, even direct thou our handy works.
Sent from Henrico in Virginia, the 28th of July, 1612.
—Alexander Whitaker

The settlers did not stay long in the area of Jamestown; it was not a healthy environment. In 1611, the "Citie of Henricus," also known as Henricopolis, Henrico Town, Henricus or Henrico, was founded by Sir Thomas Dale and named for King James's eldest son, Henry. To encourage settlers, Dale wrote to Robert Johnson, a London promoter, as follows: "I have surveyed a convenient strong, healthie and sweete seate to plant a new Towne in." The promoter wrote in a 1612 pamphlet,

> *The Colony is removed up the river fourscore miles further beyond James towne to a place of higher ground, strong and defensible by nature, a good aire, wholesome and cleere (unlike the marish seate at James towne) with fresh and plenty of water springs, much faire and open grounds freed from woods, and wood enough at hand.*

The new area was viewed as an alternative to the poor climate and hostile natives at Jamestown. Indeed, it was expected to replace Jamestown as the principal seat of the colony. The Church of England's spiritual leader was the Reverend Alexander Whitaker, known as a gentleman of God.

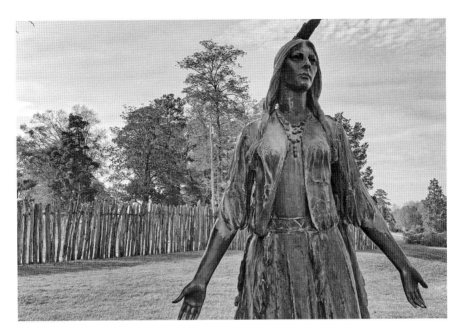

Statue of Pocahontas located at Historic Jamestowne, originally the most well-known Christian convert in the New World.

Both Dale and Whitaker were deeply religious men who gave a decided religious tone to the new city. Accordingly, the first building constructed was a church. It was Thomas Dale who taught Christianity to Pocahontas, who is best known for saving Captain John Smith. Sir Thomas Dale commented, "Were it but for the gaining of this one soul, I will think my time, toil and present state well spent." Reverend Whittaker is remembered for baptizing Pocahontas and giving her the Christian name Rebecca. He also performed the marriage ceremony that united Rebecca (Pocahontas) in marriage to John Rolfe in 1613 or 1614. Rebecca would have one child and die a young woman in England, far from the forests of her native Virginia with its deer and turkeys. Tragically, Reverend Whitaker drowned in the James River in 1617.

In 1622, a Native American massacre destroyed the settlement, and it was not rebuilt. Many of the settlers returned to Jamestown, and Henricopolis was abandoned for a time, resettled and abandoned again. But its name, Henricus, lives on in the name of the County of Henrico, and Pocahontas is on the county seal. (Today the area is known as Henricus Historical Park and is in Chesterfield County.)

Another settlement was at a place called Varina. John Rolfe, who owned the plantation, provided land for both a home and for a church known as the Varina Parish Church. It was built in 1629 and was still in existence in 1720.

Moving ever closer to Richmond, a third Episcopal church was built at Curle's (now Curles Neck). It was in this church that a meeting was held to plan for a church to be built in Richmond on Indian Hill or, as it is now known, Church Hill. No one knew it at the time, but Richmond was about to get its first and most famous church.

St. John's Episcopal Church

I know not what course others may take, but as for me,
give me liberty or give me death.
—Patrick Henry

In 1732, Colonel William Byrd laid the foundations of two large cities: one at Shockoe to be called Richmond, the other at the point of the Appomattox River to be named Petersburgh.

Richmond was laid out in a series of streets and lots by Major William Mayo. The city began developing rapidly, with much of the development in the area called Indian Town, which eventually became known as Church Hill. Lots 97 and 98 were donated by William Byrd to be set aside for a church.

Meanwhile, the vestry of Curle's Church in Henrico County, after some debate, accepted the lots. Colonel Richard Randolph, the great-uncle of Thomas Jefferson, built the church, which was completed in 1741, making it the oldest church in Richmond and, also, providing the name Church Hill to replace Indian Town. Originally a small frame structure, it was twenty-five feet wide and sixty feet in length and left unpainted. The first rector was William Stith, who left the parish in 1752 to become president of the College of William and Mary.

The new church had several names, including the following: the Church, the Upper Church, the Richmond Hill Church, the New Church, the Town Church, the Old Church and, finally, St. John's Church. There is no known

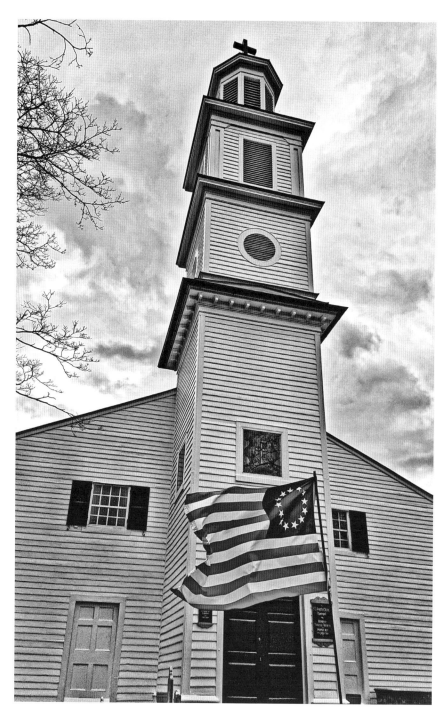

St. John's Episcopal Church.

official act for naming the church, it was just written by the Reverend W.F. Lee in the vestry book. The original building was very different from the church that exists today. Beginning as early as 1772, the church was enlarged and altered in appearance to meet the needs of the growing congregation.

In 1775, the Virginia Convention met in the church, as it was the largest public space in the city. The convention had planned to meet in Williamsburg, but interference by the colonial governor forced the move to Richmond. It was at this convention that a young Patrick Henry ignited a revolution when he stood in pew forty-seven on March 23, 1775, and asked, "Is life so dear, or peace so sweet, as to be purchased at the price of chains and slavery? Forbid it, Almighty God! I know not what course others may take, but as for me, give me liberty or give me death!" This was not a sermon preached in a church; this was a call for a revolution.

It is unusual for a revolution to be sparked in a church, but that is what happened. Samuel Mordecai wrote, "The use of the old church by the apostles of liberty was not considered a desecration except by those who advocated a union of Church and State, and those who adored monarchy in the infallible person of King George III." The American Revolution

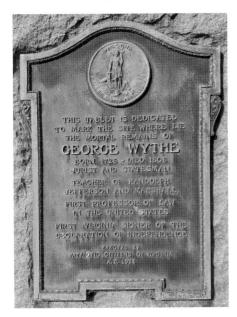 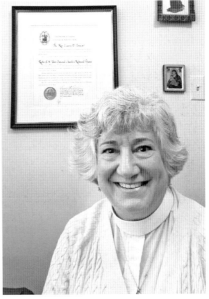

Left: George Wythe, Virginia's first signer of the Declaration of Independence, is "one of the good men devoted to country" buried in St. John's Churchyard.

Right: The Reverend Laura Inscore was the first female rector of this historic congregation.

Statue featuring Patrick Henry on the grounds of the Virginia State Capitol.

did not leave St. John's untouched. Benedict Arnold, the American traitor who attacked Richmond, used it as a place for his soldiers to bivouac. The war continued until the Continental soldiers finally won independence at Yorktown, Virginia, in 1781.

Following the war, the church was having difficulty in getting members to attend. In fact, the church was practically abandoned. There were even plans in 1807 to build a new church to replace St. John's, but fortunately, those plans were not fulfilled and St. John's was saved for posterity.

In 1891, William Wirt Henry, the grandson of Patrick Henry, spoke at the church. He observed, "We would fain believe that a special providence has watched over and preserved this frail wooden structure since 1741."

St. John's survived through much difficulty, including a period of time from 1789 to 1814 when the church was used only for funerals and for Holy Communion three times a year. Across the years, St. John's continued through good times and bad times. Dedicated rectors and faithful members kept this space sacred and alive so that people could continue to worship where generations of Richmonders have worshipped.

Today, this sacred space, both for God and country, has been preserved and continues to serve the faithful with the motto: "Serving God, each other, and the community." A writer observed, "The church has stood the storms of adversity, it has escaped the ravage of fire and, today, clothed in its garb of white in beautiful contrast with shrub and flower, she invites the world-weary to 'come ye apart and rest awhile from the cares of life and breathe that odor of sanctity which is only found on holy ground'."

Today, when you walk around the cemetery next to the church and reflect on those who died so long ago, you can imagine a day when a young man proclaimed liberty for the colonies. He could not have known that, in a little church on Church Hill, he had created a new nation: the United States of America.

An unknown author wrote these words about the church: "Long may this old church stand here, linking the glorious past, crowned with its joys and sorrows, to the present, and preserve to us the examples of good men and women devoted to country, devoted to God."

May it be so!

4

Monumental Episcopal Church

*Whereas ye know not what shall be on the morrow. For what is your life? It is
even a vapour, that appeareth for a little time, and then vanisheth away.*
—James 4:14 (King James Version)

In the days before movies, television and radio, the theater was an
important source of entertainment for Richmonders. It was not unusual
for actors and actresses to come from Europe and from across America to
produce a play in the city. One of the best-known actresses to perform there
was Elizabeth Poe, the mother of Edgar Allan Poe, who became a famous
poet and author. In 1811, Richmonders attended the Richmond Theater,
which was located on the lot at H (Broad Street) and Twelfth Streets.

The theater was a small, brick building and provided an intimate venue
for theatergoers. Records indicate it was ninety feet in length, fifty feet in
width and thirty feet high, with room for offices. The brick exterior of the
building gave a false sense of security. Unfortunately, there were narrow
door frames, dark lobbies, winding stairways and only three exits. Although
it was a good place to see a play, it was a horrible place to be in case of a
fire. Because it was built at a time when there were no fire codes to protect
patrons, it was a firetrap.

The night of December 26, 1811, was a time of festivity. It was the day
after Christmas, and the Richmond Theater was filled with theatergoers.
Many wealthy and distinguished Richmonders were in the crowd that filled
the drafty building that night. One observer wrote, "Many young girls from

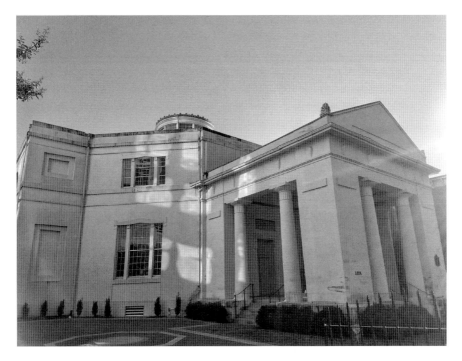

Exterior of Monumental Church, built as a memorial to the seventy-two souls who perished in the Richmond Theater fire of December 26, 1811.

Richmond's most affluent families were in attendance dressed in the dresses they had gotten for Christmas."

By the time the curtain went up, about five hundred men, women and children had packed the theater, which had an orchestra section, a huge performance stage, three levels of box seats and remote balcony seats. Ironically, the best seats for seeing a play were the worst seats if a fire broke out and escape was necessary.

The first play had finished, and the audience was watching the last play of the evening, Matthew Gregory Lewis's pantomime *Raymond and Agnes*, or *The Bleeding Nun*. But the audience never saw the end of the play. Before the second act, a stagehand was told to raise the chandelier, lit with candles, over the stage. The stagehand pulled the rope that went through two pulleys. Slowly, the chandelier rose above the stage, and the candles swung toward the highly flammable backdrop. Seeing the problem, an attempt was made to lower the chandelier, but the candles had already set the backdrop on fire. Then the fire reached the ceiling of the building and set it ablaze. In spite of the fire, the second act began.

 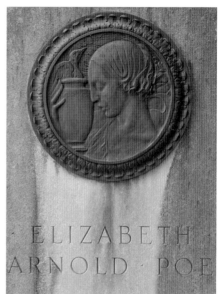

Left: Statue of Edgar Allan Poe, famed Richmond resident, on the grounds of the capitol building.

Right: Grave of Elizabeth Poe, mother of Edgar Allan Poe, in the St. John's Episcopal Church Yard.

As a costumed actor knelt before a painting of a woman on a curtain, flakes of burning material fell on the stage, followed by a shower of sparks. The actor saw the developing inferno and shouted, "The house is on fire!" Screams of "Fire, Fire, Fire" echoed through the building. Within five minutes, the whole roof had turned into a sheet of flames. Fire bells began to ring as flames, choking smoke and burning material fell like rain upon the audience. With so many people and so few exits, the escape routes were soon jammed with terrified people who were blinded by the smoke. Within ten minutes, the entire theater was engulfed in flames, and over five hundred people faced death.

Richmond relied on a volunteer fire department. One company was the Union Fire Company of Richmond. For equipment, the company used a hand-pumped engine, axes and ladders. When they responded, they could not extinguish the fire because the blaze was out of control. This was a battle that the firefighters could not win.

The panic of being trapped in the theater seized the audience, whose laughter turned to screams. The efforts to escape took many forms. A

number of people tried to go down the stairs, but the stairs were soon jammed with people and escape was virtually impossible. Some of the people fell down and were trampled to death by those trying to escape. Clothes caught on fire and engulfed the wearer in excruciating pain. One woman was afraid to jump, and the crowd watched her burn alive. It was a sight no one would ever forget. Many people faced the prospect of either burning to death or jumping out of a window to the ground two or three floors below. If they jumped, some would be injured; some would be killed; and some would escape unhurt. The stench of burning flesh filled the night air.

Gilbert Hunt, a slave blacksmith, emerged as a true hero, as did Dr. James McCaw. Dr. McCaw led twelve women to a window and dropped them down to Hunt, who caught them. After saving the women, Dr. McCaw jumped from the window. He survived but sustained permanent injuries.

Many of those who had escaped went back into the burning building to try to save a loved one, only to lose their own lives. Governor George W. Smith escaped with his wife and then went back for his son. When he could not find his wife outside of the theater, he went back into the flames to look for her and was burned to death. His wife and son survived.

There are many contemporary accounts that capture the horror of that December night in Richmond. The Reverend John D. Blair said, "And from those who escaped from the house or ran thither upon the alarm of the Bells, you heard frantic cries, the anxious inquiries. Where is my wife? Where is my husband? Where is my child? Where are my parents? And from some, already fatherless, where is my dear mother?"

Asbury Christian wrote:

> *The frantic screams of women and children for help, and the loud voices of men trying to direct their friends and loved ones to a place of safety, combined with the awful crackle and roar of the fast devouring flames, made the former scene of beauty and mirth one of indescribable horror. The rushing crowd, crazed with fright, soon blocked the narrow stairways and lobbies, then those who found themselves shut within the seething cauldron of fire trod upon others in their frantic efforts to escape.*

"I saw several persons falling from the windows to the street in full blaze," one observer noted. Another man recalled, "Many of the dead were found at the foot of the narrow, winding staircase, which led from the boxes, and in the lobby immediately below the box seats."

A newspaper editor who was in attendance wrote the following:

> *How can we describe the scene? No pen can paint it; no imagination can conceive it. A whole theatre wrapped in flames…a gay and animated assembly suddenly thrown on the very verge of the grave…many of them, oh! How many, precipitated in a moment into eternity…youth and beauty and old age and genius overwhelmed in one promiscuous ruin…shrieks, groans, and human agony in every shape.…[T]his is the heartrending scene that we are called upon to describe.*

The fire burned through the night. By morning, only charred timbers, scorched bricks and burned bodies remained. Most of the casualties of the fire were women, and many were teenagers.

The remains of the dead, rich and poor, slave and free, black and white, young and old, were placed in two mahogany boxes. The bodies had been so badly burned that most of the dead could not be identified. The Reverend Buchanan, at the funeral, told of the joy of the theater and then said, "It is now a funeral pyre! The receptacle holds the relics of our friends; and in a short time, a monument will stand upon it to point out where their ashes lay." Then the boxes were slowly lowered into the theater pit in one common grave and covered with dirt and cinders. An observer said, "The whole scene defies description. A whole city bathed in tears! How awful the transition on this devoted spot. A few days ago it was a place of joy and merriment—animated by the sound of music and the hum of a delighted multitude. Now it is the receptacle of the relics of our friends. "

The Reverend John Blair's sermon at a memorial service offered these thoughts, "Prepare to meet thy God, O Israel. In the memory of the oldest of us, there never has been a more awful warning of the uncertainty of human life than this which is given us now."

Following the disaster, Richmond's Common Council proclaimed a four-month prohibition on amusements, ending Richmond's social season. Many cities joined Richmond in mourning the dead. The U.S. Congress, on behalf of the entire nation, wore black for a month and suspended all entertainment. People across the United States moaned the loss of seventy-two people. One of the greatest disasters for the young republic had happened in Richmond.

It was decided that an appropriate memorial would be a house of worship. A committee headed by Chief Justice John Marshall raised the funds to build a church on the site of the theater. Richmonders purchased pews to acquire the necessary money to construct the church.

The memorial church was designed by Robert Mills, who designed the Washington Monument and the building that became the White House of the Confederacy. Architectural historians have described the church as follows: "The church was a masterpiece of Neoclassicism. The church is condensed octagonal shape capped by a dome with a large protruding portico. It is one of the clearest examples of Greek revival in the county." A spire was planned for the building, but it was never added. No other Richmond or Virginia church has such a dome. There are various symbols in the church that remind the worshippers of the purpose of the building. But no reminder is as meaningful as the monument on the portico inscribed with the names of the seventy-two people who died in the conflagration. Whenever I go into the church, I am reminded of the purpose for which it was built and the memories that remain within its walls.

Interestingly, this church was built during the War of 1812 and completed in 1814, the year the war ended. Since most of the pew holders were Episcopalians, it was consecrated as an Episcopal church. Monumental Church held its first services on May 4, 1814. Those at the first service were mostly relatives of the people who had died. And one of the children who worshipped in the new church was Edgar Allan Poe.

The *Richmond Enquirer* reported, "This magnificent building was first opened for the morning service read by the Reverend Buchannan and a beautiful and impressive Discourse came from the lips of the Reverend Wilmer on the Duties of the Ministry and of the Laity. The Vestry of the church appointed the Reverend David Moore as Rector of this parish." The paper concluded, "What wonderful transitions! A theatre, the resort of the animated and the gay, the voluptuous and the young—beheld, in a few short months, it disappears—and in its place, arises a Temple dedicated to the worship of the Living God. By what wonderful revolutions is this change affected." John Marshall was a pew holder, as well as John Allan, the stepfather of Edgar Allan Poe. One Sunday, the Marquis de Lafayette, of Revolutionary War fame, attended a service.

I can still remember when the John Marshall High School Corps of Cadets would attend Monumental Church on the Sunday closest to Veteran's Day. My brother, Robert, was the first captain and led the corps into the church. As part of the service, the corps would repeat the Cadet Prayer, as follows:

O God, our Father, Thou Searcher of men's hearts, help us to draw near to Thee in sincerity and truth. May our religion be filled with gladness and may our worship of Thee be natural. Strengthen and increase our admiration

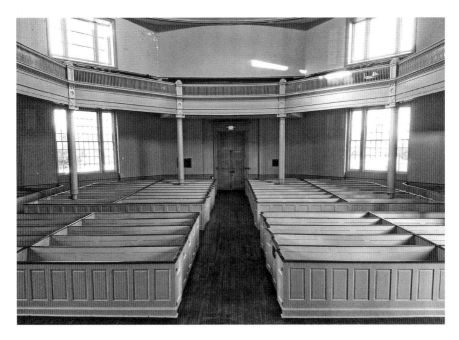

Interior of Monumental Episcopal Church showing the pew rented by John Marshall, chief justice of the United States, 1801–35.

for honest dealing and clean thinking, and suffer not our hatred of hypocrisy and pretense ever to diminish. Encourage us in our endeavor to live above the common level of life. Make us to choose the harder right instead of the easier wrong and never be content with a half-truth when the whole can be won. Endow us with courage that is born of loyalty to all that is noble and worthy; that scorns to compromise with vice and injustice and knows no fear when truth and right are in jeopardy. Guard us against flippancy and irreverence in the sacred things of life. Grant us new ties of friendship and new opportunities of service. Kindle our hearts in fellowship and new opportunities of service. Kindle our hearts in fellowship with those of cheerful countenance, and soften our hearts with sympathy for those who sorrow and suffer. May we find genuine pleasure in clean and wholesome mirth and feel inherent disgust for all coarse-minded humor. Help us in our work and in our play to keep ourselves physically strong, mentally awake and morally straight, that we may better maintain the honor of the Corps untarnished and unsullied, and acquit ourselves like men in our effort to realize the ideals of John Marshall in doing our duty to Thee and to our Country. All of which we ask in the name of the Great Friend and Master of Men. Amen.

Staircase at Monumental Church.

As the years passed, more and more people moved west, and Monumental was soon struggling to survive. Eventually, the church was given to the Medical College of Virginia Foundation as a religious center for all denominations. The Reverend A. Ronald Merrix was the last rector of the church, and he offered this prayer as the church was about to close:

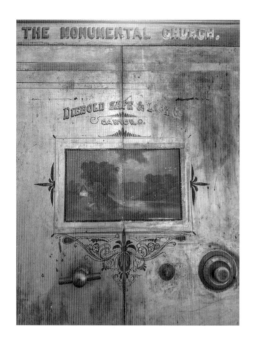

Left: Left behind when the church was deconsecrated, this safe, where valuables were kept, is a reminder of earlier times.

Right: Urn at the entrance of Monumental Church beneath which lie the remains of the theater fire victims.

> *O Lord, who has charged thy Church to preach the Gospel to the whole creation, and to make disciples of all nations, inspire us with thy Spirit and presence, that we may not fail thee in the fulfillment of thy purpose. As thou hast warned us that thou wilt require much of those to whom much is given, grant that we may strive more earnestly to extend the blessings of thy love and goodness; and, as we have entered into the labors of others, so to labor that in their turn other men may enter into ours; to thy glory and the extension of thy kingdom on earth, the same Jesus Christ our Lord. Amen.*

The church is now owned by the Historic Richmond Foundation.

The next time you see Monumental Church, remember those who died on that horrible December night when a conflagration lit up the city and the screams of the dying were heard throughout downtown Richmond and remember that their remains rest in peace beneath the church.

St. James's Episcopal Church

Be ye Doers of the Word, and not Hearers only.
—James 1:22 (KJV)

Richmond's population was moving west away from both St. John's and Monumental Episcopal Churches. On July 10, 1831, a group of Episcopalians met to discuss the building of a new church in the western part of Richmond. A letter was written to Bishop Channing Moore requesting permission to start a new church "central to those ready to become members of it." Four years later, a lot for a church was obtained at the corner of Marshall and Fifth Streets, and the cornerstone was laid on April 2, 1838. The *Richmond Enquirer* reported, "Yesterday was laid the Corner Stone of St. James's Church. The first rector was the Reverend Doctor Adam Empire, the president of the College of William and Mary and an Episcopal priest."

The cornerstone contained a leaden box in which were placed a Bible, a prayer book and other items. When the church was completed, it was pronounced to be "The temple of the living God." In fact, the building looked like an ancient temple with six stone pillars across the front. Mary Wingfield Scott observed in her book, *Richmond Neighborhoods*, that, perhaps, because St. James's sat low to the street, "It was appealing and intimate rather than imposing." The brick walls were covered with stucco, and the roof was made of wooden shingles. It was also recorded that the inscription over the rear of the pulpit carried a biblical injunction: "Be ye Doers of the Word, and not Hearers only." These words have become a part of the heritage

of St. James. The church was only a block from Richmond's slave market, and the rector took a real interest in African Americans and built a gallery in the church for their use.

In 1855, the Reverend Dr. Joshua Peterkin was named rector, and even today, he is remembered for his service to St. James. Like most ministers, he visited his parishioners on a regular basis to discuss their spiritual well-being. In these days, Richmond was small, and parishioners lived near the church, so a visit from the minister was a routine event.

As the Civil War drew closer, Dr. Peterkin made the controversial remark that "separation in some mode or other [from the Union] would be better…for the promotion of real happiness of the people." It was not long before the ravages of war touched St. James's. Members were killed, food was scarce and life was difficult.

The cornerstone of St. James's Episcopal Church contains relics from its first seventy-five years.

Perhaps the most notable event at St. James during the war was the funeral of Major General J.E.B. Stuart. As the great cavalry commander lay dying, Dr. Peterkin sat with him and together they sang "Rock of Ages." The funeral service, held at St. James on May 13, 1864, was conducted by Dr. Peterkin and Dr. Minnigerode of St. Paul's Episcopal Church. Following the service, there was a procession to Hollywood Cemetery without escort or music. It was a slow procession along an all-too-familiar route for those who "gave their last full measure of devotion" to the Confederacy.

The agony of war came to an end for St. James on April 2, 1865, when the sexton came into the church during communion and handed a note to General Samuel Cooper, who immediately left the church. The note advised him that Richmond was going to be evacuated. Later in the day, the Confederate forces set Richmond ablaze, but St. James was spared. Following Lee's surrender, Dr. Peterkin wrote the following letter to his congregation: "I wish I could this day, take you individually by the hand, and invoke upon

you the blessing of God, for the new portion of time upon which we have just entered." Dr. Peterkin died in 1892. He was described in the Richmond newspapers as a "living epistle…illustrating the beauty of holiness and the wonderful possibility of a life of goodness." The comment was made that "he was first because he was best; he was most loved because he loved most." He was laid to rest in Hollywood Cemetery.

Less than ten years after Lee surrendered, St. James's congregation began to discuss the need for a new location. The rationale was as follows: "So many of our people have moved uptown, and our church is so completely surrounded by the streets and stores that close about the Market-House, that unless we strengthen ourselves by securing some new position, we may be weighed down by these disadvantages in the next few years, and find ourselves unable to maintain the service of the church." In spite of the need, more than thirty years would pass before the decision to move west was accomplished.

In 1901, the congregation realized that the current church was costing a great deal of money to maintain and had become even more inconvenient for the membership. On April 6, 1910, the vestry approved the purchase of a vacant lot at the southwest corner of Birch and Franklin Streets. The lot was purchased from the University of Richmond, which had formally occupied the area. Numerous reasons, both old and new, were given for the relocation. Reasons included the encroachment of stores and markets; a street railroad being built on Fifth Street, which meant a lot of noise; and the area where the church was located had become unattractive, even on Sunday. In addition, the location was dangerous for children to cross the street to go to Sunday school, many members no longer lived near the church and there was the need for a church in the growing West End of Richmond. It must be remembered that most people had to walk to church or ride in a wagon pulled by horses.

On July 5, permission was given by Bishop Gibson to sell the old church to Moses and Isaac Thalhimer on the condition that the building be demolished. The congregation did not want the building to be used for secular purposes.

The new church was designed in an auditorium style because it was felt that an auditorium with a ceiling provided better acoustics than a Gothic building. This design was in keeping with the English Renaissance style of architecture, which was familiar to Episcopalians in Virginia. The nave was similar to the nave in the old church, and the columns also reminded the congregation of the old church. There is also a tradition that the church was modeled after St. Martins-in-the-Field in England.

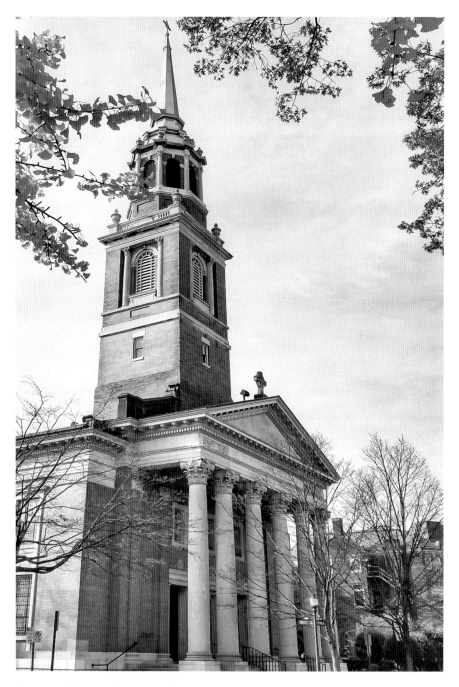

The "new" (circa 1913) Episcopal church with its lovely spire graces the corner of Birch and Franklin Streets.

On May 7, 1912, the cornerstone of the new church was laid. The newspaper reported, "The city's rectors, in their ecclesiastical robes, stood with bare heads. Bishop Gibson, with his own hand, cemented into place the cornerstone, cut from solid stone, in which were placed relics taken from the old church which had served the congregation for seventy-four years."

On September 12, 1912, the last service was held at the old church—a church filled with memoires, where many prayers had been offered and where people were urged "not to be hearers only." The first service in the new church was held on June 22, 1913. One description was as follows: "Probably the most striking feature of the exterior is the graceful spire over the entrance. Built of brick and strong, it will remain a landmark for many years."

St. James has been blessed with some excellent rectors, including the Reverend Dr. Churchill J. Gibson, who led the parish beginning in 1928. Dr. Gibson had a real sense of humor. When the City of Richmond started a campaign to rid the city of rodents, Dr. Gibson arranged for the chimes to play, "Three Blind Mice." He also had the chimes play "God Save the King" when Winston Churchill and General Dwight D. Eisenhower passed in front of the church.

When he retired in 1957, the Richmond newspaper wrote that Dr. Gibson would be missed. "He was called Richmond's favorite rector with a good sense of humor, but when he was at the altar, in a sick room, or when he counseled the troubled, there was no question that God stood at his shoulder."

St. James has remained a landmark on Franklin Street just a block from the monument to Major General James Ewell Brown Stuart, who was so closely attached to the church and who died in defense of Richmond. This church has been a sacred space for many Richmonders.

It should not be forgotten that the words "Be ye Doers of the Word and not Hearers only" were painted in gold leaf over the chancel. The words attract the attention of the faithful and are an admonition that people of God live their religion all week and not just on Sunday morning.

St. Paul's Episcopal Church

O Lord, our heavenly Father, the high and mighty Ruler of the Universe, who dost from Thy throne behold all the dwellers upon earth; most heartily we beseech Thee, with Thy favour to behold and bless Thy servant, The President of the Confederate States and all others in authority.
—*Book of Common Prayer used in the Confederate States of America.*

In 1843, St. Paul's Church was organized by many of the members of Monumental Church. Monumental was built as a memorial to those who died in the theater fire and was not in the most desirable location to meet the needs of Richmond's population, which continued to move west. Indeed, for a number of years, there was a growing feeling that the Monumental congregation wanted to move to "another church building, higher uptown that was necessary to their comfort and convenience," according to the Richmond newspapers.

In the Richmond newspaper, the following notice appeared: "Meetings of the gentlemen who have given their bonds for the purpose of securing the erection of a new church for the Monumental congregation are invited by the Vestry to [attend a meeting] to be held in Monumental Church....The object of the meeting is to appoint a building committee." A lot was secured at G Street (now Grace Street) for the new church. The vestry determined to name the church St. Paul's and to model it after St. Luke's Church in Philadelphia. Thomas S. Stewart, St. Luke's architect, designed a near replica for Richmond. On October 13, 1843, the cornerstone for the new church was laid.

By the end of 1845, the majority of the Monumental congregation planned to move to St. Paul's, which could seat one thousand. It was the largest church to be built in Richmond at the time of its construction. One writer commented that "St. Paul's is unique in that it was full grown at birth...with a rector, vestry and parishioners all ready to enter a new church on Grace and Ninth Streets."

On Friday, November 14, 1845, the *Richmond Whig* reported on the consecration of St. Paul's: "The congregation assembled to witness the dedication was very large and nearly [filled] all the pews of the elegantly spacious building. Both up and down stairs were well-filled." The writer concluded by commenting, "This new church is not only an ornament to our

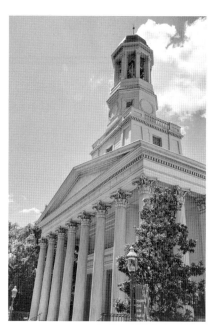

St. Paul's Episcopal Church has a storied past and is a treasure-trove of notable art.

city of the highest order, but is likewise a monument reflecting credit upon all who were concerned in its erection."

The records of St. Paul's described it as follows: "The building is in the temple form, resting on an elevated rustic basement, with the façade on Grace Street. It was considered a masterpiece of Greek revival style." Its steeple reached 225 feet in the air. Another account described St. Paul's as "an elegant architectural pile—a noble ornament to the city. It stands at the intersection of Grace and Ninth Streets, very conspicuously adjacent to the public square, in full view of the capitol, on such elevated ground that its tall spire is the first object in the city seen by the approaching traveler." One parishioner commented, "I have rarely, if ever, crossed the threshold of a church in which there is more comfort or refined elegance than is to be found in St. Paul's in Richmond." Pew number 132 was purchased by Virginia Pegram, whose family would play a significant role in one of the saddest days in the history of St. Paul's.

In 1856, the Reverend Dr. Charles Minnigerode, a native of Germany and former professor at the College of William and Mary, was named rector of St. Paul's. Dr. Minnigerode would serve the church through the

tumultuous years of the Civil War. He also brought the Christmas tree tradition from Germany to America and spoke with a German accent, although he had an excellent command of the English language.

St. Paul's was less than twenty years old when the War Between the States engulfed the American nation. Of all of Richmond's churches, none was more closely associated with the Southern Confederacy than St. Paul's. President Jefferson Davis worshipped there, as did Robert E. Lee when he was in Richmond. Virginia Pegram's three sons were all in the Confederate army. On many Sundays, St. Paul's was filled with soldiers in gray and many women dressed in black to symbolize that they had lost a loved one.

Mary Chesnut wrote the following in her diary about St. Paul's: "These were days that tried men's souls; no one knew what a day would bring forth. Every Sunday Mr. Minnigerode cried aloud in anguish his Litany from pestilence and famine, battle, murder and sudden death, and we wailed on our knees, Good Lord deliver us." But the tragic war continued, and casualties mounted. The members sat on hard pews, because the pew cushions had been donated to Confederate hospitals.

On a Sunday early in 1865, Dr. Minnigerode said to his congregation,

The lessons of the last year may be humiliating and sad, and we all, more or less, have been suffering from the haste which is so inconsistent in the true believer; the prospect of the future may be dark; it is all the more necessary that we should arm ourselves for its coming days with that faith which alone enables us to stand in the evil day, and having done all, to stand.

He tried to prepare his congregation for the inevitable defeat by reminding them of the importance of faith which "is the theme of the Christian pulpit."

Of the many weddings and funerals held at St. Paul's Church during the war, none captured the tragedy of the war more than the marriage of Hetty Cary and John Pegram. On January 19, 1865, Hetty Cary, a woman known as the "Belle of Richmond," and Brigadier General John Pegram, a handsome, gallant Confederate officer, were married at St. Paul's. Their marriage was the culmination of a storybook wartime romance.

John Pegram, the son of Virginia Pegram, was from a distinguished Virginia family, a graduate of West Point, a military hero and the fiancé for three years of Hetty Cary. At the wedding, the beautiful Miss Cary walked down the aisle of the candlelit church with a slow, stately step. A member of the congregation noted that "her complexion of pearly white, the vivid roses on her cheeks and lips, the sheen of her radiant hair and the happy gleam

of her beautiful brown eyes seemed to defy all sorrow or fear." John Pegram and Hetty Cary stood together in front of the priest and pledged their love to each other with the words: "Until death us do part." Then, they left the church as one to face an uncertain future in a war-ravaged nation.

On the morning of February 6, a messenger arrived at the quarters of General Pegram near Petersburg, Virginia, and warned him that the Union troops were moving to tighten their hold on Petersburg. Hetty quickly made coffee and prepared breakfast for her general. Before he left, she carefully wound his watch.

While leading a charge later in the day, General Pegram was struck by a Union bullet. He fell from his horse and died on the snow-covered ground. His blood painted the snow red. For John Pegram, the cruel war was over. Upon hearing the news, it was said that Hetty "turned to stone."

The next day, Hetty Pegram accompanied her husband's body back to Richmond. She rode in a cold boxcar next to his coffin. At some point, she removed his watch, which was still ticking—a sad reminder of their last tender moment together. At the funeral, it was commented that Mrs. Pegram was "like a flower broken at the stalk." She returned to St. Paul's Church as a grieving widow—but a widow who everyone still remembered as a lovely bride.

Exactly three weeks after their marriage, General Pegram's coffin, crossed with victor's palms, was placed on the same spot in the chancel of St. Paul's where he had stood to be married. In front of a full church, the same priest who had married the couple intoned the service for the dead. A diarist noted, "Again St. Paul's has been opened to receive the soldier and his bride—the one coffined for a hero's grave, the other pale and trembling, though still by his side in widow's garb." After the service, General Pegram's body was carried to Hollywood Cemetery. His war charger was led behind the hearse, which was followed by a band whose wailing was never to be forgotten by those who heard it. Several weeks later, John Pegram's brother William Ramson Johnson Pegram was killed while commanding an artillery battery. Mrs. Pegram lost two sons in the service of the Confederacy; only one son came home. It has been said that people "lived on the edge," never knowing what tomorrow would bring. It was a time when people clasped their hands in prayer and prayed that their loved ones would come home.

In April 1865, President Jefferson Davis left the church during the service after the sexton gave him a note advising him of the fall of Petersburg. When the president left, the congregation knew that tragedy awaited the people of Richmond.

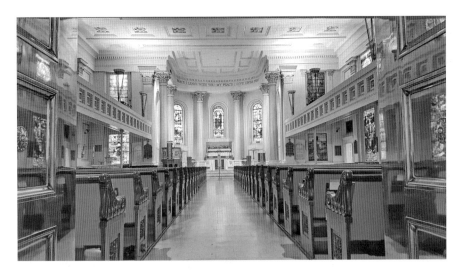

A view of the spot in the chancel where Hetty and John Pegram were married in January 1865 and his coffin lay three weeks later.

Since it was built, there have been many interior changes in St. Paul's church. Of special note is the reproduction by Tiffany of Da Vinci's *Last Supper*, as well as the other Tiffany stained-glass windows that add a special ministry in glass. When you walk into the church, you feel that you are in God's house. The major exterior change is the removal of the steeple, which was replaced by a dome.

Across the years, many famous people have worshipped at St. Paul's. It was on Mother's Day 1954 that President Dwight D. Eisenhower and his wife, Mamie, attended services at St. Paul's with the Richmond Light Infantry Blues, who were celebrating their 165th anniversary. Rector Robert Brown's sermon contained the following message:

> *The world is full of well-meaning people who spend their lives in a concern for little things and for reaping and gathering into barns. The tragedy is that most of them know it. They cannot even delude themselves about the senselessness and emptiness of their lives. One of the most imposing threats to our national morale could be an increasing blindness to our purpose as the children of God.....Now, as you have seen from all of this, what I am pleading for on this Mother's Day is a transferal from the childhood faith we once had in our mothers to an adult faith in our Father who is in heaven.*

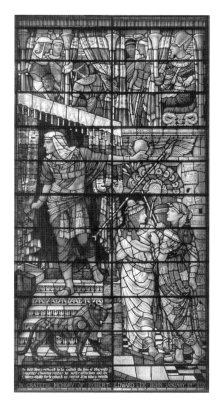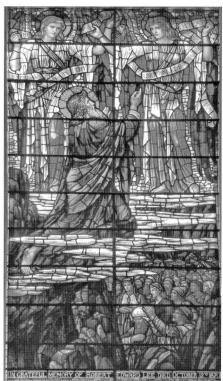

Left: At St. Paul's Episcopal Church, a stained-glass window of Moses leading the Israelites from Egypt represents young Robert E. Lee rejecting a commission in the Union army.

Right: "Moses shown the Promised Land" memorializing an older Lee leading the South.

President and Mrs. Eisenhower seemed to like the sermon. The hymns sung were "Onward, Christian Soldiers" and "Faith of Our Fathers." It was reported that the Eisenhowers sang both hymns. Following the service, the president's party had lunch at the Virginia House in Windsor Farms and then headed back to Washington. I will never forget standing on Chamberlayne Avenue at Brookland Park Boulevard with my father to watch President Eisenhower drive by. I can still remember seeing him in a large black limousine and smiling. This was the only time I ever saw a president in person. I was fourteen years old.

Spotswood DeWitt was in my company in the Thomas Jefferson High School Corps of Cadets. Upon graduation, he attended the United States

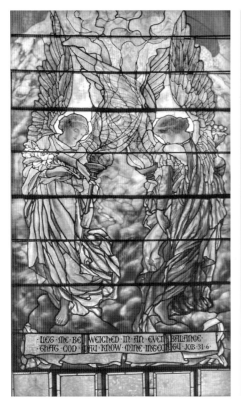

Left: A memorial window for Jefferson Davis, "The Angels of Goodness and Mercy." It has the quotation from Job 31:6: "Let me be weighed in an even balance that God may know mine integrity."

Right: Frederick Wilson of Tiffany Studios designed "Paul Before Herod Agrippa," representing the sentiment that Davis was wrongfully condemned.

Military Academy at West Point and died at the age of twenty-four in Vietnam. I remember walking from my office to St. Paul's for his funeral. When I saw his flag-draped coffin, I could not help but remember the many times we drilled together at Thomas Jefferson. His life was cut short by a bullet that denied this nation one of its finest young men. It was difficult to leave the church where so many heroes had had their funerals and return to my law books. After all these years, I still remember him.

Throughout the years, St. Paul's has continued to be a dynamic congregation. It has held its Community Lenten Series since 1897 and has a vibrant outreach ministry. I recall attending a Lenten Service led by William Sloan Coffin, who was the chaplain at Yale University. I once

heard him speak at Yale against the Vietnam War. I thought it was ironic that next to the pulpit was a plaque in honor of Nathan Hale, Yale Class of 1773, who died, saying, "I only regret that I have but one life to lose for my county." I found Coffin's message at St. Paul's meaningful and helpful. St. Paul's sponsors many events that benefit all of Richmond, but it also holds the memories of those who died in uniforms of gray. And through the years, its mission statement has been "Proclaiming Christ in the heart of the city." And the church does proclaim Jesus Christ throughout the city, into the halls of government and throughout the world.

Pegram Johnson, PhD, a retired Episcopal priest and a member of the Pegram family, offered these thoughts about St. Paul's Church:

> *Walking into St. Paul's can be an overwhelming experience. For years I sat near the memorial table for the Pegram "boys" up front on the left. So many ghosts, I think the real hero, however, was the mother, Virginia Johnson Pegram, who lived for another quarter century having buried her two sons a short distance away. I don't think the ghosts ever really leave their home places where they have experienced trauma.*
>
> *Inscribed on the stone in honor of Virginia Johnson Pegram, mother of three sons and two daughters, over in Hollywood Cemetery, are the following words: "To live in hearts we leave behind is not to die." That is my feeling as a retired priest communicant at St. Paul's.*

St. Philip's Episcopal Church

The day following, Jesus would go forth into Galilee, and findeth Philip,
and saith unto him, "Follow me."
—*John 1:43 (KJV)*

African Americans were usually brought to America as slaves. They were, frequently, packed into slave ships, and many did not survive the voyage. It has been said that a trail of sharks followed the slave ships to devour the bodies of those slaves who had died and were tossed overboard. Crying babies were frequently fed to the sharks. Such cruelty to human beings or even animals is inconceivable, but it happened. In spite of the horrors of slavery, many slaves became Christians and practiced the faith of their owners despite the horrible situations in which they found themselves. Fortunately, there were Christians who welcomed them into their churches. The Reverend Dr. Joshua Peterkin, the rector of St. James's Episcopal Church, took a sincere interest in the African American community. He provided pews in St. James's Church beginning in 1842 for the African Americans.

It was at St. James that St. Philips, the black Episcopal congregation in Richmond, was created. Through the contributions of the Episcopal churches in Richmond, a church for African American Episcopalians was built in 1861 on North Fourth Street, not far from St. James. Tragically, the church was burned along with many Richmond buildings when the Confederates evacuated the city in 1865. For the next several years, the church members met in private homes.

This building, formally used by Epiphany Episcopal Church, has been the home of St. Philip's Episcopal Church since 1959.

In 1869, St. Philip's was reorganized, and a small, frame building with a white picket fence was erected at the southwest corner of Leigh and Foushee Streets with funding from the diocese, as well as from the congregation of St. James's and the family of the Confederate general

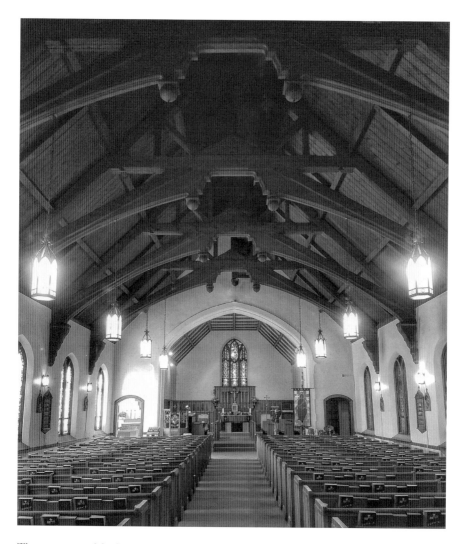

The sanctuary of St. Philip's has been consecrated by the love, faith and commitment of generations of Richmonders.

J.E.B. Stuart. In 1898, this building was replaced with a brick structure located at Leigh and St. James Streets with some furnishings donated by St. James's congregation.

Although the church had an African American congregation, the priests were white. This changed when the Reverend Thomas W. Cain became St. Philip's first African America priest. In 1920, the church was changed from mission status to full church status. And in 1959, the congregation

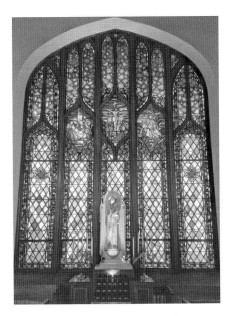

Glowing stained glass in the sanctuary of St. Philip's Episcopal apprises the viewer of the presence of God.

purchased the church formerly used by the Epiphany Episcopal Church, located at the northwest corner of Essex Street and Hanes Avenue. The first service in the building was in November 1959, and the church still meets in the same building.

In June 1963, tragedy struck one of the members of the parish. Douglas P. Evans was a Richmond firefighter assigned to Engine Company 9, Richmond's all-black fire station. Along with Captain Harvey S. Hicks II, Evans was killed in the line of duty while trying to rescue a man. His funeral was held at St. Philip's with a congregation filled with firefighters from Richmond and beyond, including an all-black fire company from Winston-Salem, North Carolina. Although he did not know it, his death helped to integrate Richmond's fire department.

St. Philip's Episcopal Church has survived fires, the Civil War, discrimination and a host of other trials that might have destroyed a church that lacked commitment to its members and its members to the church. St. Philip's is the oldest historically African American church in Virginia.

Today, the church has five priorities: worship and music, outreach and mission, pastoral care, Christian formation and parish life. The parish "follows the way of Christ to serve the community and foster spiritual growth through worship, hospitality, Christian formation, and outreach."

The current rector, the Very Reverend Phoebe A. Roaf, the twenty-second rector of the church, shared these thoughts with me: "The church building we occupy was constructed in 1929. There is something sacred about worshipping in an old building. You know that you are on hallowed ground because the very walls of the building are soaked in prayer. The clergy and laypeople feel the prayers of former generations during the liturgy. St. Philip's is one of those old churches where it is easy to discern the presence of the Lord."

GRACE EPISCOPAL CHURCH

Amazing Grace! How sweet the sound
That saved a wretch like me!
I once was lost, but now am found;
Was blind, but now I see.
—John Newton

Three years before the Civil War, Richmond was expanding rapidly toward the west, but there were no Episcopal churches in that area. The leadership of St. Paul's Episcopal Church suggested that a new church was needed to meet the spiritual needs of those in that rapidly developing area of the city. Transportation was a challenge, and getting to a downtown church could be difficult, so building a church for the people in the West End was a logical decision.

To meet this need, a lot was purchased at the northwest corner of Main and Foushee Streets that was 60 feet wide and extended 147 feet along Foushee Street. A lecture room was the first building constructed, and it was soon being used for services. The church building was completed in the fall of 1858, and Bishop John Johns consecrated the church and "praised the simplicity, beauty and convenience" of the building. Indeed, it was an impressive brick building built in the Romanesque style. The new church, named Grace Street Episcopal Church, was admitted into the diocese in 1858. It was no longer a mission of St. Paul's.

The Civil War had an effect on the new parish. Membership was down, lives were lost and inflation shattered the church's financial stability. Members of the congregation were given envelopes in which to make their gifts to the church. The use of envelopes replaced the practice of renting pews to members of the church.

In 1872, Bishop Whittle preached at the church. He concluded, "Christianity is righteousness, peace and joy in the Holy Ghost. Except a man be born again he cannot see the Kingdom of God. The manifestation of God's grace is the same today as it was in the days of St. Paul."

In 1874, a unique controversy developed focusing on the posting on the church door by the rector, Francis M. Baker, an invitation for all believers to come to the church. The reason for the notice was that the rector felt that the "location of the church in an aristocratic section of the city led many people to form incorrect conceptions of the people who were desired there." One woman said that "she felt like a poor boy in a parlor in most Episcopal churches." However, the governing body of the church objected to this invitation. The future of the rector was put to a vote; he won the vote but resigned. His efforts to increase the diversity of the congregation had cost him his position. Before he left, the vestry noted, "The severance of the relations of long-standing causes us as individuals more pains than we can suitably express."

But there was an even more significant event taking place. In 1874, a new Episcopal congregation was established in Richmond that would have a profound impact on Grace Church. The new church would eventually be called Holy Trinity Church.

Over the years, the neighborhood along Grace Street changed from residential to business, which resulted in a decline in membership in Grace Church. Also, the small seating capacity caused additional problems. Facing the decline in membership, Grace Church eventually merged with Holy Trinity Church, which had been founded in 1874 and was only eight blocks away.

9

MOORE MEMORIAL CHURCH/HOLY TRINITY EPISCOPAL CHURCH

O God, give me clean hands, clean words and clean thoughts.
Help me to stand for the hard right against the easy wrong.
Save me from habits that harm.
Teach me to work as hard, and play as fair in thy sight alone as if the whole world saw.
Forgive me when I am unkind, and help me to forgive those who are unkind to me.
Keep me ready to help others at some cost to myself.
Send me chances to do a little good every day, and so grow more like Christ.
Amen
—prayer said by Ann Cosby Williams as a child

Just as St. Paul's had played a major role in establishing Grace Church, St. James's played a significant role in creating Holy Trinity Church. The Reverend Dr. Peterkin of St. James's Church "had advocated the establishment of a mission chapel in the vicinity of the Old Fair Grounds [Monroe Park] which was outside the city limits, and a lot was purchased on Laurel Street facing Monroe Park." A simple frame chapel was built, and the first sermon was preached by Dr. Peterkin on July 24, 1840. By 1879, it was declared a separate church; and it was decided to name the chapel Moore Memorial Chapel in honor of Richard Channing Moore, Bishop of Virginia from 1814 to 1841.

By 1885, it had been decided to build a church of granite, and the new building was completed in 1887. The design of the church was known as Late French Gothic, and stone for the church came from a quarry along Riverside Drive. A reporter praised the church's "handsome interior with its vaulted wooden ceiling, its walnut pews and wainscoting, and its brass lectern." The sanctuary is designed so that your eyes focus on the altar and remember the Holy Sacrament—a reminder of the sacrifice of Jesus, who died on a cross of wood. The first sermon in the new church was delivered in 1888. Additions were made to the building over time, and in 1894, the church was named Holy Trinity after considering other names, including St. Luke's and St Peter's.

Later, the church added a graceful granite tower 110 feet high. The plan was for the tower to be taller than the steeple on Pace Memorial Methodist on Franklin Street, but this did not happen. The tower has never had a bell. While construction was taking place on the tower and other additions, the members of Holy Trinity accepted an invitation to worship at Grace Church. In 1894, the congregation of Holy Trinity returned to their new church, which could seat around one thousand people. When all the debts were paid, the church was consecrated by Bishop Gibson on October 1, 1907.

In 1910, there was a unique service at Holy Trinity. In memory of the death of King Edward of England, a service was held at the same time the funeral was held in England. It was a simple service with a number of clergy participating. The hymns selected were "O God, Our Help in Ages Past," "Peace, Perfect Peace," "Blest Be the Ties That Bind" and "Ten Thousand Times Ten Thousand."

World War I drastically reduced the attendance at the church because many men went "over there" to fight. The solution for Holy Trinity Episcopal focused on a merger with Grace Episcopal Church, which also had reduced membership.

GRACE AND HOLY TRINITY
EPISCOPAL CHURCH

Joyful, joyful, we adore Thee,
God of glory, Lord of love;
Hearts unfold like flow'rs before Thee,
Op'ning to the sun above.
Melt the clouds of sin and sadness;
Drive the dark of doubt away;
Giver of immortal gladness,
Fill us with the light of day!
—Henry J. Van Dyke

On November 7, 1923, the newspaper reported that the vestry of Holy Trinity met "to consider a communication from Grace Church," relating to a consolidation of the two congregations. The plan was to abandon Grace Church but retain the "Grace" in the name of the consolidated church. Both congregations supported the merger because it was felt that the merger would add strength to both congregations and that a larger church membership could accomplish more.

On June 1, 1924, the congregation of Grace Church assembled for the final time at the old church and then walked west to Holy Trinity Church where they found the congregation of Holy Trinity waiting for them. A ten-year-old girl named Grace always remembered that the two congregations stayed separate for a few minutes—one in Monroe Park and one on the steps of Holy Trinity. She recalled that one person took a step forward and the rest

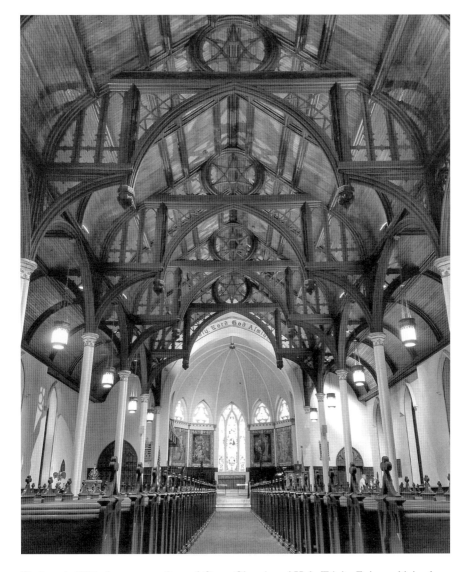

On June 1, 1924, the congregations of Grace Church and Holy Trinity Episcopal joined together in Holy Communion and became one body of believers.

followed. The two congregations entered the church for the first time as a united church, and Grace and Holy Trinity became a reality. After entering the church, the two congregations communed together. At the evening service, the rector spoke on the subject of cooperation and conciliation. This was an appropriate topic, as not all members were in favor of the merger.

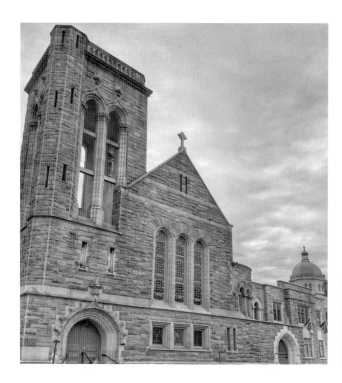

Strength in numbers and mission was the worthy goal of uniting two churches to become Grace and Holy Trinity Episcopal Church.

A bishop of the Episcopal Church, who was not named, made the following interesting observation about church members to the newly formed congregation: "Many city parishes are made up of people who do not know each other and do not want to. By contrast, many country parishes are made up of people who do know each other and are sorry they do." This was an interesting and, hopefully, false analysis.

Across the years, Grace and Holy Trinity has been a fixture in the Fan District. At one time, the church used this motto: "Discipleship through Service, Worship, Education, Evangelism, Pastoral Care, Parish Life and Stewardship." It has expanded several times and continues to be a vital force for good in the Fan District and beyond. The parish has provided support for the Virginia Commonwealth University students who walk by it every day, as well as for its own parish. The core values of the church are as follows:

> *Seeking: We are each on a personal journey, seeking in community to understand God and what God is calling us to do.*
> *Serving: We serve God, both within and outside of Grace and Holy Trinity Church.*
> *Caring: We care about our neighbors and each other.*

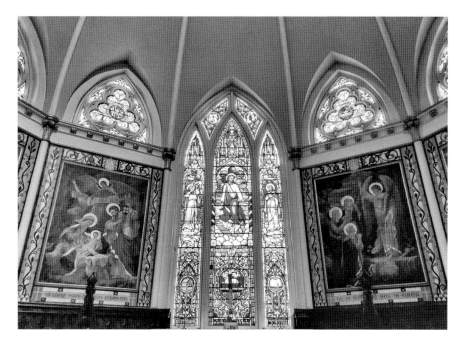

The exquisite artwork in the chancel of Grace and Holy Trinity reflects the light and joy of the Christian message.

To seek, serve and care are certainly important goals for a church.

After the tragic shooting at Virginia Tech, I stood with faculty, staff and students of Virginia Commonwealth University in Monroe Park across from the Cathedral of the Sacred Heart and Grace and Holy Trinity. As the bells tolled for each person who had died on that horrible day, I looked at those churches and remembered that God is still in his Holy Temple and that one day there will be peace on earth.

THE BAPTISTS

The Baptists trace their history back to Switzerland around 1520. Unlike the Episcopalians who baptized infants, the Baptists baptized young adults. Believing Jesus was baptized by immersion, they practiced believer's baptism, which put them at odds with some other Christian denominations. Indeed, some Baptists were executed for their beliefs.

As early as 1698, there were Baptists in Virginia. They came to Virginia from several areas, including England and Maryland. But all Baptists did not believe the same thing. There were Independent Baptists, Snake-Handling Baptists, Original Baptists, Pre-Millenarian Baptists, Post-Millenarians, Non-Missionary Baptists, Baptists, the Seventh Day Baptists, the Six-Principle Baptists, the Dunkers, the Church of God Baptists, the Free Will Baptists and the Hard-shell Baptists. The various and diverse groups eventually put aside many of their differences, but from 1768 to 1778, forty-three Baptist pastors in Virginia were committed to prison, since freedom of religion was not the law in the state.

The Episcopal Church was the established church when the Baptists came to Virginia. Even if you were not an Episcopalian, you still had to pay to support the established church. The Baptists, Presbyterians and many other religious groups resented this obligation to support a church they did not attend. In light of this, Thomas Jefferson and James Madison argued for the separation of church and state, and in 1786, the Virginia General Assembly "detached the Episcopal Church from the state of Virginia," making it the first state to separate church and state. The Virginia Bill for Religious Freedom reads as follows:

Be it enacted by the General Assembly, That no man shall be compelled to frequent or support any religious worship, place, or ministry whatsoever, nor shall [he] be enforced, restrained, molested or burthened in his body or goods, nor shall [he] otherwise suffer on account of his religious opinions or beliefs, but that all men shall be free to profess, and by argument to maintain, their opinions in matters of religion, and that the same shall in no way diminish, enlarge or affect the civil capacities.

First Baptist Church

Only to be what He wants me to be,
Ev'ry moment of e'ry day;
Yielded completely to Jesus alone,
Ev'ry step of this pilgrim's way.
—Norman J. Clayton

The first organized Baptist movement in Richmond came in June 1780, shortly before the Statute of Religious Freedom was enacted and near the end of the American Revolution. A number of families organized a church at Boar Swamp outside of Richmond under the ministerial leadership of Joshua Morris. He is known for writing: "Preach the word, be not careful about the concerns of this life, for he who feeds the ravens when they cry will not let you suffer."

Ten years later, there was a meeting at the home of John Franklin, located on the northeast corner of Carrington and Pink Street in Richmond's East End. Franklin's has been described as a small wooden building containing a single room, with a shed attached. Facing on Carrington Street, the building probably measured sixteen or eighteen square feet in size. It is also possible that religious services were held in other private homes, as well as some public buildings.

For example, records suggest that a service was held at the home of a Mrs. Miller at Eighteenth and Venable Streets, because it was a larger house and its location was more convenient for the congregation. The church also

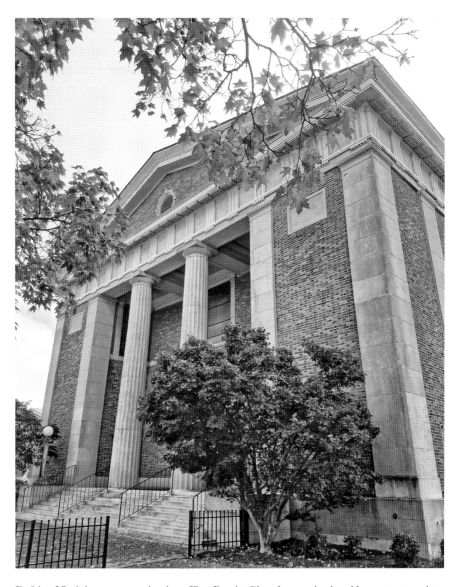

Defying Virginia statutes at the time, First Baptist Church organized and began to grow into the venerable congregation found on Monument Avenue today.

met in the Henrico County Court House, in the Masons' Hall, in the new Capitol Building and in the First Market Building. The services at the First Market Building were very close to the city jail, and the sermons could be heard by the prisoners. Perhaps some were converted to Christianity by hearing the preacher.

From this humble beginning in a private home, Richmond's First Baptist Church was born. This was to be the second organized church in Richmond, the first being St. John's Episcopal Church on Church Hill.

Little is known about the early years of the new Baptist church. But it is known that worship services were held on an irregular basis. The first formal church building was constructed at, or near, the northeast corner of Cary Street between Second and Third Streets. The building, termed the "Baptist Meeting," is listed in the City Assessor's book of 1798 as being located on lot 659. In all probability, the building was a modest house, perhaps built by church members. Although it probably did not look like a church, it was a place of worship for the Baptists of Richmond. Styles Ellyson wrote: "I remember the old First Church on Cary Street. The building stood back about ten feet or a little more from the street, and we approached it by wooden steps to an elevation of approximately four feet from street level. It was a one story building with a gable roof which was about 20 feet from the ground."

In the early 1800s, land was given to the church at the northeast corner of H (Broad) and College Streets. The church was built on a lot that was about forty feet by forty feet and could accommodate a large congregation. It was the first church built in Richmond's Court End District. Across the years, the church was enlarged to accommodate a growing congregation. The church played a significant role when it was used as a place for the dead and the dying following the Richmond Theater fire of 1811. One of its members, Gilbert Hunt, was a real hero and saved many lives in the fire.

The Baptists continued to expand, and both blacks and whites worshiped together in the same sanctuary. Although worshiping together was certainly positive for race relations, the church was overflowing with members, and there were more blacks than whites. After protracted discussions, it was determined that the black Baptists were to retain the existing church—which would become known as First African Baptist Church—while the white members secured a lot at the northwest corner of Broad and Twelfth Streets.

The new First Baptist Church was dedicated on October 17, 1841. The *Richmond Whig* described the church as follows: "The building occupies a commanding and central location; it is a spacious, commodious, and notable structure, erected, we learn, in the most permanent manner." The writer continued: "We may safely affirm that in chasteness of design, in solidity of structure, in beauty of execution, as well as in convenience and extent, it is not surpassed, if indeed it is equaled, by any House of Worshippers in the Old Dominion. It is an ornament to our city." It could

Left: Originally consigned to become cannon metal, the First Baptist Church bell was saved by a generous parishioner.

Below: The glorious window of Christ's baptism adorns the front of the chancel above the baptistery.

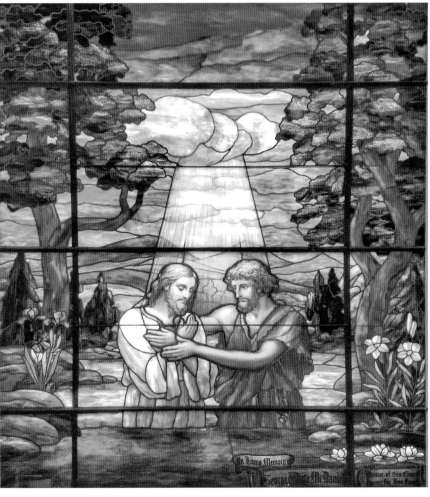

seat about 1,200 worshipers. The ceiling was gleaming white, and the pews had blue cushions. Worshippers were asked not to scratch the pews and to be careful in their use of tobacco. The original building was enlarged several times.

During the Civil War, the church building served as an emergency hospital for Confederate soldiers, and the pew cushions were sold to the Confederate government to be used as mattresses for the wounded and dying soldiers. Also, the church bell was offered to the Confederate government to be melted into a cannon. This was a reversal of the admonition to turn swords into plowshares. Fortunately, James Thomas Jr. told the congregation that he had redeemed the bell by paying the value of the bell in gold to the Confederate government. (The bell is now located at First Baptist Church on Monument Avenue.) When fires engulfed Richmond at the end of the Civil War, First Baptist Church was saved. The Richmond newspaper reported that its "tall steeple at Twelfth and Broad Streets stood like a sentinel against the sky at the top of the hill."

In 1928, the membership determined that it was in its best interest to sell the old church and build a new one at Monument Avenue and the Boulevard. Like many churches, the decision was made to move to the west to follow the membership. The old church is now the Hinton Student Center at the Health Science Division of Virginia Commonwealth University.

The doors of the new church on Monument Avenue and the Boulevard were first opened on December 10, 1928, and remain open to this day. The church has been described as being of Greek Classic architecture. And its large auditorium gives the worshipper a clear view of the minister, the choir and other worship activities.

The dedicatory service opened with the Doxology, and the sermon title was "Christ, the Power of God," delivered by the Reverend Dr. George W. Trust of Dallas, Texas. The guest minister affirmed his faith in the miracles in the Bible, the Deity of Christ and the Virgin Birth. But the greatest miracle of all was found in the personality of Jesus, and the miracle of Christ transcends every other miraculous incident in the Bible. The church was filled to capacity. Other programs were held throughout the week, with speakers including Dr. Frederick William Boatwright, president of the University of Richmond; the Reverend Dr. Solon B. Cousins, pastor of Second Baptist Church; and the Reverend Dr. George T. Waite, secretary of the Virginia Baptist Board.

First Baptist has always maintained a strong Sunday school program. Martha Jane attended the Sunday school in the 1940s and 1950s. As a child,

her earliest recollections are being told of God creating all the animals, those that walked on land, flew through the air or swam or resided in the waters that covered the earth. The love of God—so immense and so generously given to man—filled her with a desire to give something back. Hymns sung by the young people included: "Jesus loves me, this I know; 'cause the Bible tells me so"; and "Oh, how I love Jesus, Oh, how I love Jesus, Oh, how I love Jesus, because He first loved me."

Martha Jane remembered, "As I grew older, I was given a Bible, as were the others in my age group. We then learned the order of books in both the Old and New Testaments, and began learning about, and in many cases, memorizing blocks of Scripture. With the kind, upbeat manner with which the lessons were presented, going to church several times a week was something I really looked forward to doing. Like many young people, I learned the love of God in the First Baptist Sunday school."

Frequently, churches are known by the pastors who serve them. For generations, First Baptist was identified with the Reverend Dr. Theodore F. Adams, who was well known in the city. I was a member of the Thomas Jefferson High School Corps of Cadets, and every January on the Sunday closest to Lee-Jackson Day, the corps would go to First Baptist, as Dr. Adams was the chaplain of the Corps of Cadets. In unison, the corps would repeat the following prayer written by Dr. Adams:

> *Our Father—we turn to Thee in faith as we lift our common prayer. Thou art the creator of the world, the giver of life, the author of truth, and the God of righteousness and peace. We thank Thee for the blessings of life that are ours and for the privileges and responsibilities thou hast given us. Always be loyal to truth, faithful to every trust, alert and eager to serve our community and our country.*
>
> *Humbly we acknowledge our dependence upon Thy goodness and love. Forgive us our sins and our failure to live up to the best we know. Create in us clean hearts and renew a right spirit within us. Help us in school and at home, at work and play, to be loyal to the ideals of Thomas Jefferson and to the traditions of the corps. May we face life with courage to be true to our convictions, and to consecrate ourselves anew to the service of God and country, and to the realization of brotherhood and peace for all mankind.*
>
> *Grant that in serving others we may find the lasting joys of life for ourselves and that we may continue to grow in wisdom and in stature and in favor with Thee and our fellowmen. Help us ever to renounce the cheap,*

the false, and the ignoble in life; and lead us always in the way of right and truth and life everlasting. Let the words of our mouths, the meditations of our hearts and the deeds of our lives be acceptable in Thy sight, O Lord, our strength and redeemer. Amen.

Although over fifty years have passed since I last heard Dr. Adams preach, I can recall a story he told to the Corps of Cadets about General Lee. It seems that two lawyers were arguing in the judge's chambers in Roanoke, Virginia, and using all kind of foul language. Slowly, the judge got up, walked to the wall and removed a picture of Robert E. Lee. He then placed the picture face down on his desk. Shocked, the lawyers asked why the picture had been removed. The judge said, "General Lee did not like that kind of language when he was alive, and I do not think his picture should be exposed to it."

I also attended First Baptist for a memorial service following the assassination of President John F. Kennedy. The service brought a measure of peace to my troubled soul. I was not alone in my grief, and I was not alone in seeking the help that can only come from being in God's sacred space.

Truly God has blessed this church. It began in a house and grew into one of the best known and most recognizable churches in the city. Its several ministries have touched many people, including me. I was in the hospital with severe health issues and, for no reason, I turned on the TV and became transfixed by the sermon of the Reverend Dr. James Somerville. I will always remember the peace his words brought to me—peace that was made possible by a group of Baptists who met in defiance of Virginia law years ago and built a church that still works to bring the Kingdom of Heaven to Richmond, Virginia, and beyond.

13

First African Baptist Church

Swing low, sweet chariot,
Coming for to carry me home,
Swing low, sweet chariot,
Coming for to carry me home.
—author unknown

On Thursday evening, July 1, 1841, the Baptists of Richmond met to propose the organization of an African Baptist Church of Richmond as an outgrowth of First Baptist Church. Its members included both slaves and freemen. Although the congregation was black, under Virginia law, the minister had to be white. There was a concern that a black minister might ferment a revolt like that of Nat Turner or Gabriel Prosser.

Before the church divided, some outstanding black members, including both slaves and freemen, attended First Baptist. One well-known member was Maggie L. Walker, who became a famous Richmond businesswoman and a leader in the Richmond black community. Henry Brown was a member who was known for escaping slavery by having himself nailed into a wooden box and shipped to Philadelphia, thus gaining his freedom. Perhaps the best-known member was Lott Carey (also recorded as Cary), who was born a slave, bought his freedom, sold his property in Henrico County and became a missionary to Liberia. When asked why he would leave the comfort of his home in America to go to Africa, he responded, "I am an African, and in this country, however meritorious my conduct

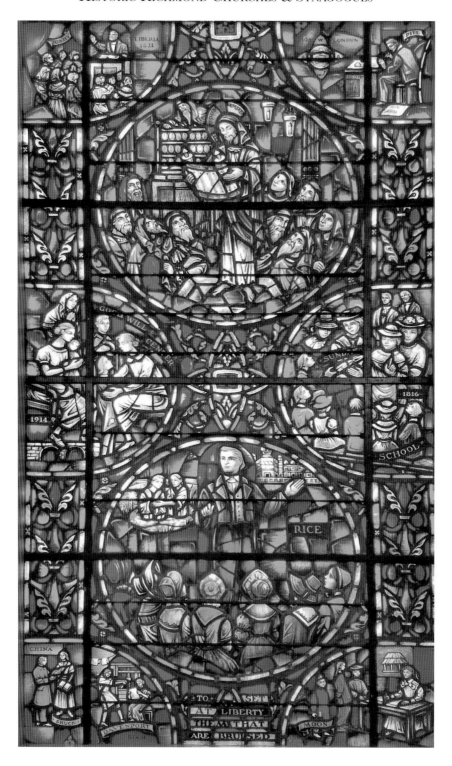

and respectable my character, I cannot receive the credit due to either. I wish to go to a country where I shall be estimated by my merits, not by my complexion, and I feel bound to labor for my suffering race." Cary was killed in an accident in 1828. John Jasper, who would one day become one of Richmond's most famous preachers, was also baptized at the church.

Whites and blacks had worshipped together, with the black members constituting a majority of the members. Although there was some occasional tension between the races, the congregation generally worked well together. When the white members built a new First Baptist Church because of overcrowding, the black members retained the old church and added the word African to the title of the church to distinguish it from the white church. Jefferson Davis, the president of the Confederacy, once spoke at the church to recruit members of the congregation for the Confederate army, as did Judah Benjamin, a high-ranking Confederate official.

Above: When the integrated First Baptist Church outgrew its building, black members formed the First African Baptist Church. For seventy-five years, this building housed one of the oldest black congregations in the world.

Opposite: Located at First Baptist Church, this window depicts the accomplishments of members and includes Lott Cary, who attended First Baptist before First African Baptist was established.

Dr. Robert Ryland, the president of Richmond College of the University of Richmond, was the white minister assigned to the church. According to the *New York Times*, "He believed that slavery was the best way to convert Africans to Christianity." Some sermons focused on the ideas "Obey your master; be a good servant." St. Paul was also quoted as saying "Servants be obedient to them that are your masters…Submit to them with fear and trembling." Religion was used as a device to keep slaves peaceful and not prone to rebellion.

Although the congregation was not permitted to have a black minister, black members were permitted to offer public prayers. Dr. Ryland commented that

> *not a few of them have a remarkable facility and power in prayer, and awaken the devout emotions of the audience by their own importunity. They are learning to avoid habits of whining, snuffing, grunting, drawling, repeating, hiccupping, and other vulgarities in prayer, and to understand that God, an infinitely pure and mighty being, should be addressed somewhat in the same manner, as a subject would address an august sovereign: that is, naturally, earnestly, reverently.*

Dr. Ryland also felt that the church should be a place of study. He commented, "After all, it is truth preached and not the preaching that enlightens and saves the souls of men." Dr. Ryland concluded his remarks by stating, "People should be made to know that the gospel of Christ is available to salvation only so far as it is apprehended by the intellect, felt by the heart, and practiced in the daily life." He served the church from 1841 to 1865. Following the Civil War, in 1867, the Reverend Dr. James H. Holmes, who was born a slave, became the first black pastor and served the church for over thirty years. He was much loved by the congregation. In 1874, plans were being made to demolish the church and construct a new one. *Harper's Weekly* reported, "the members of the First African Baptist Church in Richmond, Virginia, with true lack of American veneration for old things and old buildings, are preparing to demolish and rebuild their ancient house of worship, the oldest colored church in America, if not in the world." The eloquent words accomplished nothing.

In 1876, the original building was demolished, and a new church was dedicated in the late 1870s. Of Greek Doric temple design, it was much like the nearby First Baptist Church with its white columns that flanked a

recessed entry. Many Baptist churches, be they black or white, were built using this design.

The congregation voted to relocate again in 1953 and offered to sell the existing church to the Medical College of Virginia (now Virginia Commonwealth University). First African Baptist Church moved to the former Barton Heights Baptist Church in Richmond's North Side in 1955. Old First Baptist is still used by the Health Science Division of Virginia Commonwealth University.

Through the years, First African Baptist Church has remained a beacon of hope during times of change. The church asserts that it is a "Community of love." It further states, "We are a church that brings glory to God and is open to the world. We are a family that loves and encourages each other. Our love for each other is a direct result of God's love for us." And through trial and tribulation, God has loved this church. It should be remembered that all of the African American churches in Richmond can trace their history back to this one.

14

Second Baptist Church

Suffer the little children to come unto me,
and forbid them not for of such is the Kingdom of God.
—Luke 18:16 (KJV)

New churches are organized for many different reasons. Sometimes a group gets angry and leaves one church to establish another church; sometimes the preacher becomes an issue; and sometimes a part of the congregation wants to go in a certain direction that is not consistent with the will of the church. Second Baptist is no exception. It was established in part because of the Sunday school. In 1816, two young men, David Roper and William Crane, organized a Sunday school program to provide religious instructions to both whites and blacks. The first meeting took place in the second story of a shoe store owned by William Dabney and located on the south side of Broad Street between Eighth and Ninth Streets.

However, the Sunday school soon moved to a gallery at First Baptist but was in no way connected with that church. Learning of the presence of a Sunday school, some people at First Baptist disapproved, and a vote was taken to remove it from the church.

In view of the tensions, a meeting was held on April 14, 1820, at 107 North Third Street in Richmond. Those present felt that God was leading them out of First Baptist to establish a new Baptist church to be called Second Baptist. At their request, a number of members of First Baptist Church were reluctantly given letters of dismissal, although the church was not pleased with their decision.

Right: In a basic Colonial Williamsburg style, this historic church's new location is the farthest west of any of the earliest churches that migrated across Richmond.

Below: The original Second Baptist Church building was transported to King William County to be rebuilt as the Sharon Baptist Church.

Second Baptist had several meetings at several different locations, and on May 5, 1820, the church was formally organized. The congregation met for the first time on June 25, 1820, for worship in a school room. The second meeting was held on July 2 in a large room on the second floor of a building on the northwest corner of Main and Eleventh Streets. The church was formally constituted on July 11, 1820. Over time, the ill feeling between First and Second Baptist dissipated, and it was written that the "misunderstanding is signed to oblivion."

On May 25, 1821, the church voted to obtain a permanent house of worship, and on November 23, 1821, a lot on Eleventh Street, between Main and Cary, was purchased. In April 1822, the foundations of a brick building were laid, and construction got underway.

A church had emerged from a Sunday school program, but all was not peaceful within the church. A member was excommunicated for playing shuffleboard and then denying it. Other members were condemned for drinking whiskey, buying lottery tickets, dancing and attending the fair. In October 1822, the new church was completed, and the first sermon used the text from 1 Peter 2:5: "Ye also, as lovely stones, are built up a spiritual house and holy priesthood, to offer up spiritual sacrifices." Since it did not have a baptistery, baptisms took place in the James River in the area of Ninth Street on the north side of the river.

Second Baptist built a new church in 1840 at the corner of Main and Sixth Streets, and it was beautiful. It had classic columns and a broad gallery. There was a steeple and a bell that was rung to summon worshippers to services. Richmonders considered it to be one of the most beautiful churches in the city. The new church was occupied in May 1841 and was fully utilized for the first time on January 1842. (The previous church was dismantled and rebuilt on the original plan in King William County, where it is known as Sharon Baptist Church.)

The church welcomed both black and white members and endeavored to meet the spiritual needs of both races. But tensions developed, and in 1845, the African American members left to create Second African Baptist Church, which became a flourishing church. Second Baptist supported the new church.

During the Civil War, Confederate soldiers frequently attended Second Baptist Church. To support the Southern cause, the church donated its bell. The bell was to be cast into a cannon to be used in defense of the public and was to be called the Second Baptist Church Battery. It seems a little strange to name a weapon of war after a church, but these people

Dedicated in 1906, the third incarnation of Second Baptist Church stands at the corner of Adams and Franklin Streets.

were living in very difficult times. Members of the congregation donated their new pew cushions and made bedding and bandages for Confederate hospitals. During the great Richmond fire at the end of the war, the church was not harmed.

Second Baptist seemed to have survived the war financially, since in 1870, spittoons were placed in the church. But in 1896, a severe storm hit Richmond with winds of over eighty miles per hour. The steeple of the church was blown down and never replaced. There was also some interior damage.

Needing more space and desiring to move west, the church built another building at Adams and Franklin Streets, with the groundbreaking on May 7, 1904, and it was finished in 1905.

This new church was dedicated on February 11, 1906. The sermon text was "The Latter Glory of the house shall be greater than the former" (Haggai 2:9). The Richmond newspaper described the church as follows:

> *The beautiful new church building which is indeed an ornament to the city, standing as it does in all of its grandeur and beauty, with its ten magnificent*

Corinthian columns. Every cent of the cost has been subscribed....The building is fitted up with all modern conveniences including class, choir, mission rooms, church parlor, kitchen, and vault. The main auditorium, which likewise is thoroughly up-to-date, having no gallery or middle aisle is one of the most beautiful in the south, and has to be seen to be appreciated.

In 1938, Reverend Clarence W. Cranford became pastor of Second Baptist. He began his ministry with the slogan "Second Baptist is out to win for Christ." After three and a half years, he left to become the pastor of Calvary Baptist Church in Washington, D.C. In Washington, he became friends with the pastor of New York Avenue Presbyterian Church, the Reverend Dr. Peter Marshall, who was chaplain of the U.S. Senate. Dr. Marshall died early on the morning of January 27, 1949. One of his last requests was for Dr. Cranford to deliver the Morning Prayer for the Senate, a prayer Dr. Marshall had already written. To a stunned Senate, Dr. Cranford prayed this prayer:

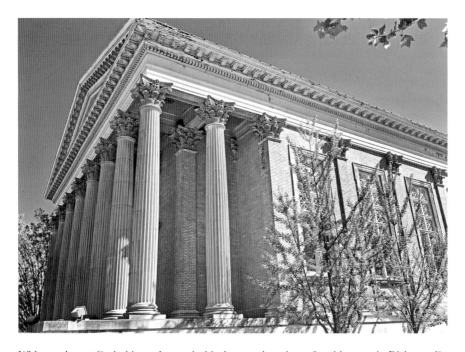

With ten elegant Corinthian columns, is this the grandest piece of architecture in Richmond?

Deliver us, our Father, from futile hopes and from clinging to lost causes, that we may move into ever-growing calm and ever-widening horizons.

Where we cannot convince, let us be willing to persuade, for small deeds done are better than great deeds planned.

We know that we cannot do everything. But help us to do something. For Jesus' sake. Amen.

As the congregation continued to move west, the church membership discussed moving to the western part of the city to be closer to the membership. After considerable discussion, ground was broken for the new church at River and Gaskins Roads on July 17, 1966. But there was a problem with this location. It was close to Henrico Fire Station 17, and fire engines tend to use their sirens when responding to a fire. To keep peace between the county and the church, pine trees were planted to block the view of the station from River and Gaskins Roads. The station was designed to complement the church, and sirens would be used sparingly when leaving the station during services and at night. The new church building was dedicated on October 15, 1967.

Second Baptist is known for many things, particularly its work in the larger church. It hosted the first meeting of the Baptist General Association of Virginia in 1823; the state Baptist newspaper, the *Religious Herald*, was established at Second Baptist; and a committee was established at the church that eventually created the University of Richmond. Second Baptist has been a force for good in the community.

In its early history, Henry K. Ellyson addressed the congregation by stating that the "Crowning grace is brotherly love whose sacred ties have so bound heart to heart that from the beginning until now we have had this unmistakable evidence that we are the sons of God." The same can be said today of Second Baptist, which remains a loving community transformed by Christ for unbounded service.

SECOND AFRICAN BAPTIST CHURCH

Mine eyes have seen the glory of the coming of the Lord,
He is trampling out the vintage where the grapes of wrath are stored,
He hath loosed the fateful lighting of His terrible swift sword
His truth is marching on.
—Julia Ward Howe

The history of Second African Baptist Church is not significantly different from that of other black congregations that left white churches.

In 1821, African Americans attended Second Baptist Church, which was predominately a white congregation. As time passed, more and more African Americans joined Second Baptist. After worshipping together for a number of years, the African American members felt they could be of greater service to God and man if they had their own church. Accordingly, about fifty African American members withdrew from Second Baptist in 1846 and created what was called the Oregon Hill African Mission, but technically, it was Second African Baptist Church.

Ironically, Second Baptist members had slaves build a chapel for the new congregation on Byrd Street between Second and Third Streets. Unfortunately, the wooden building was destroyed by fire in 1866 following the end of the Civil War. The congregation then moved its worship services to Dill's Bakery until they could build a brick building at the same location as the destroyed church. The cornerstone for the new building was laid in 1866.

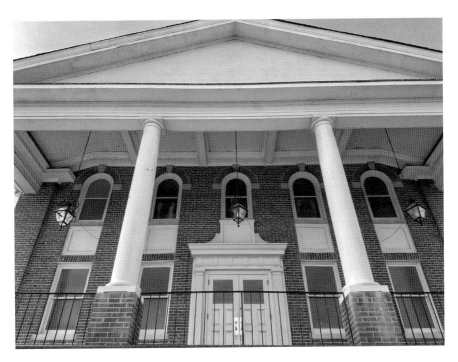

Second African Baptist Church on Idlewood Avenue has been a force for good in the community since its inception.

In addition to a new church, the church had its first African American minister, the Reverend Pleasant Bowler. A debate was held in the new church on the topic "Which should a man have the most affection for, his mother or his wife?" The argument got so hot that someone fired a pistol in front of the church, and a small riot ensued. It was also in 1866 that the new church severed its relations with the white church and at some point dropped the word "African" from its name. There were now two Second Baptist Churches that could be identified by location, but not by name.

In the 1870s, there were several splits in the African American church that created two new churches: Moore Street Baptist and Sharon Baptist. The loss of African American members by Second (African) Baptist to these new churches was made up by a number of members joining the church during a revival. In the 1880s, women requested the right to vote for the pastor; the request was defeated by a vote of 60 to 2. The reason was St. Paul's statement in 1 Corinthians 14:34, "Let your women keep silence in the churches, for it is not permitted unto them to speak; but they are commanded to be under obedience, as also saith the law."

The congregation won a major victory in 1910 when they were able to convince a judge that a proposed bar near the church would be wrong. It was argued that "the majority of the congregation would pass close to the proposed location of the bar on their way to church." The judge said, "I appreciate the efforts of these people to uplift their race, and I must sustain them, even though I have no doubt that the bar would be orderly."

The church also dealt with its own members. In 1922, it was recommended that men should remove their hats in church during funerals. They could wear them for other services.

In the late 1930s, the membership was concerned that the state penitentiary was expanding and getting closer to the church. Accordingly, the church purchased Park View Baptist Church at Idlewood and Randolph Streets. On Easter Sunday 1940, the congregation held the first service in their new church home. The church was described as being of Gothic design with a balcony on three sides of the church. The interior walls were painted green, and the woodwork was light oak, which matched the pews that had been brought from the old church. The organ was also moved from the old church.

There was a problem in the new church. It seemed that some members were leaving before the offering was collected. A woman suggested that someone be stationed in the rear of the church to catch the people who were leaving before the offering was collected.

In 1940, the pastor of the church was the Reverend Dr. Joseph T. Hill, who was a leader in the African American community. During a political contest between Richmond's Mayor J. Fulmer Bright and Gordon Ambler, Reverend Hill spoke about the election by saying, "I hope my people will not think that Mayor Bright is a Negro hater, or that Ambler is a Negro lover." He continued by asserting that "Mayor Bright was a fine man." He then said, "When we register and vote, we will learn how lovely Mayor Bright is to us as a group. A politician needs votes, not sentiment." Dr. Hill did not have a problem with speaking out on political issues.

In 1981, the church was renovated, and the congregation met at the Empire Theater on Broad Street. In the fall of 1982, the members marched back to their church. The newly renovated church had increased seating capacity, a lighter interior and a rebuilt organ, along with other improvements. From this one church, many churches have been established. Today, Second Baptist lives by its motto: "The Church that Cares and Shares." Truly, this church has cared for its faith community and shared its resources to lead people to Jesus Christ.

GRACE BAPTIST CHURCH

What grace, O Lord, and beauty shone
Around Thy steps below;
What patient love was seen in all
Thy life and death of woe!
—*Edward Denny*

On February 21, 1833, the minutes of a meeting at Richmond's Second Baptist Church recorded the following: "Whereas in this city, north of Seventh [Fifth] Street, on which stands the Second Presbyterian Church, there is no place of public worship except the Catholic Chapel and a small Methodist Church." Therefore: "Resolved: That it is expedient that exertions be made by this church [Second Baptist] to raise another church and congregation with a view to the furtherance of the Kingdom of Christ, to worship in some suitable place to be provided not further East than Fourth Street nor so far from H Street (Broad Street)—say between M.T. Valentine's Store and Bacon Quarter Branch." Several members of Second Baptist left to create a new church on Shockoe Hill in 1833. Once again, the religious community was moving west to follow the people who were leaving the downtown area.

A group of Baptists gathered in a home on Duval Street on December 2, 1833. Following prayer and a meeting, they decided to establish a church to be called Third Baptist Church of Richmond to meet the need for a Baptist church in the West End. First Baptist was at Fourteenth and Broad Streets,

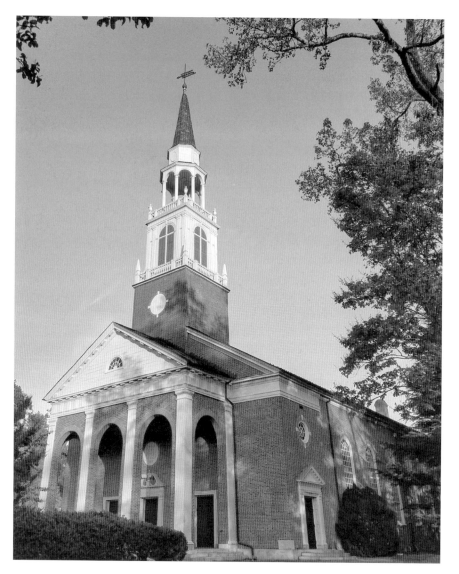

After two fire tragedies in its history, Grace Baptist rose like a phoenix in its new location.

and Second Baptist Church was at Eleventh and Main Streets. But there were no Baptist churches in the western part of the city. At this time, Monroe Park was at the western edge of the city.

Third Baptist Church was formally established on December 6, 1833. Although it was organized by Second Baptist, there is a story that "an

afflicted lady" requested prayer meetings in her home. From these prayer meetings, Third Baptist evolved, according to church lore.

The first formal act to establish a new church was to secure a lot at the northwest corner of Second and I (Marshall) Streets. The written contract for the new church stated that the land was purchased "As a site for a meeting house, for the use of the Society of Christians known by the name of the Third Baptist Church."

The Reverend Henry Keeling was chosen as the first pastor of the church. Following the selection of the pastor, the "brick house of worship" was completed on the corner of Second and Marshall Streets. The two-story-tall church, which measured forty by fifty feet, was dedicated on May 23, 1834. According to one person, "The building is a neat and convenient edifice with galleries, situated in the part of our city in which a place of worship was much needed."

Third Baptist was growing at such a rapid rate that the church could no longer accommodate its membership, and it was decided to purchase a lot at Grace and Foushee Streets. In 1845, the congregation started to build a church that was "large enough for every demand, convenient for speaker and hearer, of pleasing appearance within and without, and had every necessary provision for a Sunday school, but at the same time, was free of unnecessary and expensive ornaments." The large church, like many churches, had columns and was described as Greek Revival, which was very popular in Richmond. Until the new church was completed, Second and Third Baptist met together.

On May 10, 1846, the new church was dedicated, and significantly, the name of the church was changed from Third Baptist Church to Grace Street Baptist Church. The text for the dedication was "Lord, I have loved the habitation of thy house, and the place where thine honour dwelleth." In 1852, the minister was the Reverend Dr. Jeremiah Bell Jeter, one of Richmond's most famous ministers. However, he disliked church music and would not allow the members to buy an organ.

This new building was used from 1845 to 1890, when it was torn down in order to build an even larger church. From 1890 to 1891, the church met in a temporary building at the corner of Pine and Grace Streets. The new church building was at the same location as the old church and was used from 1891 to 1896. The new church was considered the most beautiful church in the city, and the service of dedication was a day-long event.

On February 25, 1896, the minister went to the church to prepare for a funeral service. When he arrived, he saw smoke—the church was on fire. A

fire alarm was turned in from Box 127 at First and Broad Streets, but it was too late. Comments from the newspaper suggested the magnitude of the fire: "The church is in ashes"; "Grace Street's splendid new building destroyed"; "Only Fragments of the Walls Tell the Story of Desolation and Ruin"; "Not a single article saved"; "The Handsome Furnishings Consumed." The writer continued: "Grace Street church, the largest, most imposing, and perhaps, most costly house of worship in Richmond with its magnificent new organ and its elegant furnishings was reduced to ashes." It was a three-alarm fire, and every piece of fire equipment in the city responded, except for two pieces held in reserve. The building was a total loss, and the people who saw it destroyed before their eyes felt a great sadness.

A special meeting was held at First Presbyterian with several clergy present, including Rabbi Edward Calish of Temple Beth Ahabah. The request was made that "all who love the Lord, and believe that you can follow him in the darkness as well as in the light, will please stand up." Almost all stood up and then they sang the Doxology. Afterward, Rabbi Calisch said to Dr. Hatcher of Grace Church, "This is one of the most wonderful manifestations upon which I have ever looked." Later, he said, "I have heard that there is no power in the name of Jesus, and I have said so myself; but I will never say so again."

It was decided to build a temporary church near the corner of Grace and Belvidere Streets and to begin a campaign for a new building. On January 6, 1901, the congregation moved into their new church at Foushee and Grove Avenues. It was described as a "church of architectural beauty with its handsome brown stone trimmings, its round walls, its lofty and beautiful spire, and its massive doors and numerous windows is the admiration of all of Richmond."

It was reported that "The Grace Street people have taught us all how to bear a great burden gracefully, how to carry on a great enterprise to a brilliant success in the face of appalling difficulties, and in the midst of the most serious discouragements. They have a right to rejoice; and they did rejoice." At the dedication, the words of Haggai were read: "The Latter Glory of this house shall be greater than the former, and in this place the Lord of hosts will give peace." To preserve the beauty of the church it was decided that "all persons using the auditorium for marriages after 5 o'clock p.m. must use cards of admission, have ushers to preserve order, and see that the audience does not stand upon the seats."

Grace Baptist had high standards for membership. Members could be excluded for immoral conduct, neglect of the church and its services, failure

to contribute money, profanity, lying, drunkenness, gambling, defrauding and lack of Christian character. In 1914, the church was able to persuade the state fair not to sell hard liquor.

In the 1920s, a discussion again took place about moving the church farther west. In 1923, the opportunity to purchase the Calvary Baptist Church located on the southeast corner of Grove Avenue and the Boulevard arose. On the first Sunday in March 1923, the Grace Street Church began holding services in the newly acquired building. Many members of Calvary Baptist stayed and joined Grace Street Baptist. In January 1925, the name of the church was changed to Grace Baptist, dropping the word "street."

In 1946, tragedy again struck Grace Baptist Church. On January 26, fire broke out in the church in the area behind the organ, and the entire interior of the church was destroyed. The newspaper reported on the incident:

> *The flames destroyed the main part of the building, burning through the roof and destroying all furnishings in the main assembly room. Water added to the damage. The fire was a three-alarm fire with eight fire companies responding. Before the roof collapsed, a passerby ran into the church and saved many articles, including the communion service, the lectern, the Bible, books, and other artifacts that he could carry away.*

Soon people rallied to help the church locate a new meeting place, and the Byrd Theater was made available to the congregation. As funds for the repair increased, the question was whether to repair the old church or move west and build a new church. After the congregation decided to move west, the old church was sold to the Sir Moses Montefiore Jewish Congregation.

Still without a church home, the congregation moved to Thomas Jefferson High School, which could accommodate all of the church's activities.

The congregation finally built a magnificent church in Windsor Farms that was dedicated on April 23, 1950. The purpose of Grace Baptist "is to exemplify the presence of God as a diverse and authentically Christ-like family who worships, learns and grows in a genuine faith, cares for one another, and responsibly goes about God's loving work in our world." The church stands tall amid an affluent neighborhood and reminds all that we should love God and keep his commandments. And this church is also a reminder that Christian people can overcome adversity if they trust and love the Lord.

LEIGH STREET BAPTIST CHURCH

Thy hallowed past we come to greet,
Leigh Street, dear old Leigh Street,
To lay our tributes at thy feet,
Leigh Street, dear old Leigh Street.
—Mrs. Earle Sibley

My grandfather ran a grocery store at Twenty-Fifth and P Streets. During the summer, I would go with him as he made home deliveries in an old orange truck. I can remember the service station that was across the street from the store and the lunchroom down the street, as well as the plumber's shop. Even after sixty years, I can still smell the odor of the dead fish coming from the fish store. I also recall the big white Baptist church down the street. Many of his customers were members of the church and would come into the store and talk about the Sunday sermon.

Leigh Street Baptist was established to meet the needs of the Baptists in Church Hill. The other three Baptist churches were located in what was becoming the downtown part of Richmond. Although it is not a problem today, it was a major problem for the Baptists to go from Church Hill to downtown Richmond because of the need to cross Shockoe Valley, which could be virtually impassable during rainy or bad weather. Today, bridges and roads obscure the problems that Broad Street Hill used to cause when people walked and rode in carriages pulled by horses that had difficulty going through the mud to get to the church.

Home of a diverse congregation in Church Hill, Leigh Street Baptist has been in the same building since 1854.

To meet the spiritual needs of those in Church Hill in 1852, Reuben Ford, a Baptist missionary, was preaching every Sunday, visiting the homes of the people during the week and praying with and for them. But the people were still without a church building.

Eventually, the congregation purchased a lot at the corner of Twenty-Fifth and Leigh Streets and began to construct a church. Some members of the church had seen a picture of a Baptist church in Philadelphia that was designed by Samuel Sloan, a Philadelphia architect. It was a Greek Revival brick structure with a portico with six Doric fluted columns.

Unfortunately, there were not enough funds to build the entire church, so they started with the basement. By Christmas 1853, the basement of the church was completed, and a worship service was held there. The church was completed in 1854, and Leigh Street Baptist was formally constituted as a Baptist church on July 30, 1854.

The church began to grow as people began to move to Church Hill, but members had to live Christian lives. A man who owned a distillery was denied membership. Dancing and attending the theater were prohibited along with gambling and a host of other perceived vices.

People who attended Leigh Street heard a variety of sermons. In one sermon, the Reverend John J. Wicker condemned the use of the electric chair in Virginia. About the chair, he commented,

> *The chair deserves to die. It came from hell and has in it nothing but the elements of the infernal region. Justice and mercy are one. You cannot have one without the other. This state has no right to do that which an individual cannot do....The state does not exalt justice by committing murder. When the State begins to treat the criminal as an unfortunate brother, it will go far toward changing the hearts of bad men.*

And on December 7, 1941, after the Japanese attacked Pearl Harbor, the Reverend Charles A. Maddry stated that the "attack was the result of a series of aggravated incidents to which both parties are responsible." This was not a popular comment to make.

The church continued to grow in spite of the exclusion of certain members who did not meet the church's concept of proper behavior. Additions were added to the church in 1911, 1917 and 1930. Leigh Street also had the reputation of giving support to other churches.

Today, Leigh Street Baptist has the distinction of being the oldest Baptist church in the city to continuously occupy the same building. The church is known as being a strong supporter of the Church Hill community and is known as the "Church of the Helping Hand."

And unlike most churches, a hymn was composed about Leigh Street Baptist.

"Dear Old Leigh Street"
Tune: "Maryland, My Maryland"

Thy hallowed past we come to greet,
Leigh Street, dear old Leigh Street,
To lay our tributes at thy feet,
Leigh Street, dear old Leigh Street.
Of all the churches in the land
For thee, we proudly take our stand;
To love and serve with heart and hand
Leigh Street, dear old Leigh Street.

In treasured hours of childhood days
Leigh Street, dear old Leigh Street,
We learned to prize thy heavenly ways,
Leigh Street, dear old Leigh Street.
So now we tell with gladsome sound
Within thy walls we Christ have found;
Oh, may this spread the world around,
Leigh Street, dear old Leigh Street.

You've sent to various parts of earth,
Leigh Street, dear old Leigh Street,
Daughters and sons of noble birth,
Leigh Street, dear old Leigh Street.
On a marble slab their names appear,
Their deeds are held in mem'ry dear,
Great souls without reproach or fear,
Leigh Street, dear old Leigh Street.

And daughter churches, too, are thine,
Leigh Street, dear old Leigh Street,
Each one of them a holy shrine,
Leigh Street, dear old Leigh Street.
May we who serve in rank and file
Serve God always with song and smile
And help to make our church worthwhile,
Leigh Street, dear old Leigh Street.

Mrs. Earle Sibley

Dr. Solon B. Cousins, who was a professor at the University of Richmond when I was a student, wrote the following about Leigh Street Baptist Church: "And for all of us, history sends us back to Caesarea Philippi, and with great gratitude and a sense of exultation, we hear again our Lord, the Lord of the Church, saying, 'Upon this rock, I will build my church and the gates of hell shall not prevail against it.'"

Truly, Leigh Street Baptist Church has been a rock for Church Hill.

PINE STREET BAPTIST CHURCH

I love to tell the story of unseen things above,
Of Jesus and His glory, of Jesus and by his love.
I love to tell the story, because I know 'tis true;
It satisfies my longings as nothing else could do.
—Katherine Hankey

Sometime prior to 1849, there was a meeting at the home of Baylor Martin for Bible study. Martin, who lived on the southeast corner of Maiden Lane and Church Street, was a deacon at Second Baptist, and it was not unusual to have Bible studies in people's homes.

Following a series of meetings, the people at these Bible studies purchased a lot in June 1849 on the northeast corner of Church and Rowe Streets, and a small brick chapel was built. It was known as the Chapel and dedicated in 1849. Described in the Richmond paper as the Oregon Chapel, it was a "neat edifice situated on the summit of Oregon Hill and is a favorite place of resort for the denizens of that rural neighborhood."

On February 3, 1850, members of the congregation formed themselves into a Colony of Baptists and in that same year, this group of Baptists, many of whom were members of Grace Baptist, organized an independent Baptist mission.

Several efforts were made to build a larger church, but the Civil War put these plans on hold. The congregation worshipped in the same church throughout the Civil War and, like most churches, offered the church's bell

to the Confederate government. But the Confederate officials did not take the bell until May 1864.

At a meeting in 1864, the congregation planned a "new house of worship to replace the dilapidated building." Another justification for a new building was that "the church was located in a noisy and otherwise disagreeable neighborhood and was not sufficiently accessible." The name selected for the new church was Belvidere Hill Baptist Church. However, selecting a name was easier than keeping the sexton. When he was asked to clean the spittoons prior to the service, the sexton quit.

Action was taken, and a lot was purchased at the corner of Spring and Pine Streets. The plans called for a brick church; these plans were abandoned, and a wooden building was constructed in 1871. When the new building was occupied, it was renamed Pine Street Baptist. However, it was still too small to meet the needs of the growing congregation.

In 1879, a lot at the southwest corner of Pine and Albemarle Streets was purchased. It was a tremendous challenge to raise funds for the new church, but in 1883, the church took possession of the basement of the building. Finally, in 1888, the church was completed and opened for worship. The church has continued to serve its congregation from this location ever since, although many additions and interior changes have taken place.

When the Reverend Joshua Hutson visited a family in 1905, he asked them to close their eyes while he led them in prayer. As the minister started to pray, he felt the hot breath of a dog that was about to remove the minister's rather large nose. Calmly, he held the dog's mouth shut and finished the prayer. Since everyone had their eyes closed, no one knew how close the minister came to losing his nose in the service of the Lord.

A revival was held at the new church in 1906, and one sermon that attracted a lot of converts was titled "Heaven on Earth." There were so many people trying to get into the church that many had to be turned away. On one occasion, the minister said, "I don't know what you will do unless you bring a nail and hang yourself up on it." Another well-remembered sermon was preached on April 21, 1912, a few days after the RMS *Titanic* sank in the North Atlantic with a great loss of life. The Reverend J.B. Hutson pointed out that of the Seven Wonders of the World, only the pyramids remained. The rest had been destroyed. The *Titanic* was also a great wonder and claimed to be unsinkable, and it, too, was destroyed. He then said,

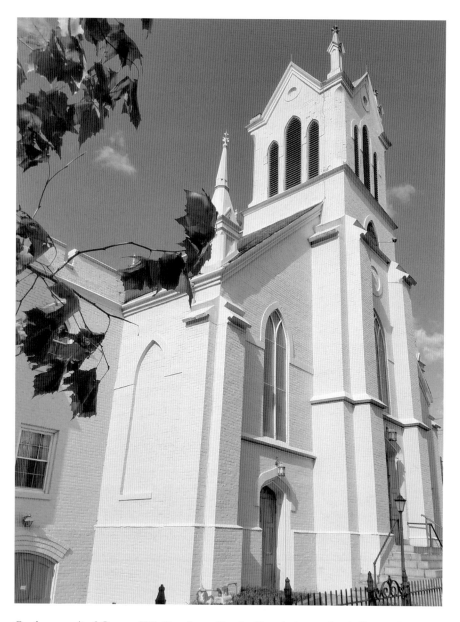

On the summit of Oregon Hill, Pine Street Baptist Church rises to the challenge of being a beacon to the community.

O thoughtless voyager upon the high seas of time, the day is surely coming when you will find nowhere to stand, and nothing beneath you but the yawning, bottomless pit. In the final hour with that joyful hosts, you would give the whole world to say,

"On Christ, the solid rock, I stand,
All other ground is sinking sand."

"O man, O woman, do not wait for the last hour, when the winds blow cold and the ice is thick, but seek ye the Lord while He may be found, call ye upon Him while he is near."

He then concluded by saying, "In the last moments, their thoughts turned toward the other world and while the lights were going out, and the peerless ship was going down, the band played 'Nearer, My God, to Thee, Nearer to Thee!'"

On Christmas 1925, a sermon was preached by the Reverend I.T. Jacobs on the Wise Men. He made the observation, "Wisdom consists in knowing God and His plan and purpose in life. The fear of the Lord is the beginning of freedom." The minister concluded by saying, "The life once touched by the power and presence of the King of Kings lives in constant obedience and accord to the divine will. Followers of King Jesus, do your best to make your life count the most for Christ during the coming year."

Through the years, Pine Street Baptist has continued to meet the spiritual needs of the residents of Oregon Hill and beyond. The church has published a document titled "The Foundation of Pine Street Baptist Church." It reads as follows:

Pine Street Baptist Church in the historic Oregon Hill community of Richmond, Virginia, is an urban church with a heart for worship, missions, ministry, and fellowship. For over 150 years, Pine Street has sought to bear witness to its faith in Jesus Christ. Committed to a love of God and a love of one's neighbor, we seek to live out our faith in such a way to bring honor and glory to God. In an ever changing world, Pine Street believes that the timeless message of God's love is able to speak to the hearts and lives of people today.

Pine Street Baptist Church is known as a "Beacon on a Hill." Seeing the church is a reminder that there are still people who worship God and seek to follow His will.

19

Ebenezer Baptist Church

Here I raise my Ebenezer,
Here by Thy great help I've come;
And I hope, by Thy good pleasure,
Safely to arrive at home.
—Robert Robinson

In the Old Testament, the story was told of how the Philistines were defeated by the Children of Israel through the intervention of God. It was written that Samuel took a stone and set it between "Maspeth and Shen, and called the name of it Ebenezer (stone of help), saying, "Hitherto hath the Lord helped us" (1 Samuel 7:12). This stone was a reminder that God helped the Israelites in their battle against the Philistines.

Ebenezer is an appropriate name for a church, since it is a reminder that God helps all of us and we can turn to Him in times of trouble. And Ebenezer was the name chosen by one of Richmond's most distinctive churches. It stands like an Ebenezer in Richmond's Jackson Ward.

The story of Ebenezer Baptist Church can be traced back to the year 1855, when the congregation of First African Baptist Church had grown so large the church building could not accommodate all of the members. And it was determined that a church needed to be built to serve the Jackson Ward neighborhood. Accordingly, Dr. Robert Ryland was charged with finding a place for a new church At a meeting in 1858, Benjamin Harris, a committee member, told of a "vision he had experienced in which a man

with outstretched arms appeared on a body of water (the future location of the church) and said: 'I have chosen this spot from the foundation of the world as the place for the fishing of men's souls.'" This spot would be the site of the new church at Leigh and Judah Streets.

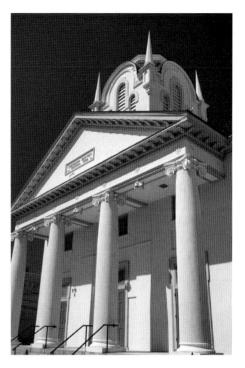

Fittingly named Ebenezer, this congregation has been a "stone of help" in Richmond for almost 160 years.

The initial church membership consisted of free blacks and slaves living west of Second Street and north of Broad Street. The church was dedicated in 1858 as Ebenezer Baptist Church. The first church building was a wooden structure, but it was soon replaced by a brick building. Over time, it has been rebuilt, redesigned and enlarged to emerge as the present unique structure we see today. As was required in the days before the Civil War, the minister was a white man. Following the Civil War, the Reverend Peter Randolph, an African American, became the church's first black minister.

Ebenezer, like all black churches, held services at a time of rigid segregation in Richmond following the Civil War. Segregation laws, which were called Jim Crow laws, provided for the segregation of the races in public places, including schools, public transportation and restaurants. It can be said that Richmond had a caste system long after the Civil War provided equality for all people.

When the Reverend Richard Wells—who served the church for over thirty years and was the pastor emeritus—died in 1903, the Richmond newspapers used his death to attack the attitudes held by the North in the early 1900s toward the treatment of African Americans in the South. The reporter wrote,

> *The lie, if we may be permitted to use a strong term, so often made in the north that all Negroes look alike to the Southern people, that all Negroes, no*

97

matter how worthy they may be, are despised and ill-treated by the Southern whites. Of course, we do not recognize the Negro in social circles; of course, we do not permit Negroes to rule over us; but respectful Negroes are treated with respect and every respectable Negro in the South will testify to the fact. As a rule the Negro, just as the white man, is treated with all the respect and consideration that he deserves.

As Ebenezer continued to grow, the church had to expand. In 1915, Charles T. Russell, the first black architect in Richmond, changed the style of the church from Victorian Gothic to a Neoclassical design, which was his preferred style. One interesting fact was that the city building inspector condemned all church steeples because they were being blown down in storms and presented a hazard. The removal of the steeple from Ebenezer accounted for the unique four spires as the highest part of the church, instead of the steeple, which was part of the original design.

Ebenezer provided a spiritual home for African Americans, but it did much more. It was the site of the first public school for blacks in Richmond; the church organized Hartshorne Memorial College for black women and helped to found the Richmond Colored Young Men's Christian Association.

Today the mission of the church is as follows: "We are a redeemed people of God, through Jesus Christ, empowered by the Holy Spirit to love one another, to become good stewards of all His resources and the minister to all humanity in his name."

Yet it should always be remembered that worshippers in this and other black churches have come a long way from the days of slavery. James Weldon Johnson wrote these lines:

Stony the road we trod,
Bitter the chastening rod,
Felt in the days when hope unborn had died;
Yet with a steady beat,
Have not our weary feet
Come to the place for which our fathers sighed?

Ebenezer is like a mighty stone in Jackson Ward that reminds us all of the power and love of God and of the human spirit. Its doors are open to all people. You will feel welcome at Ebenezer Baptist as I have been when I visited there.

SIXTH MOUNT ZION BAPTIST CHURCH

If you is what you was, you ain't
—John Jasper

Not many churches have achieved fame because of a sermon, but that is the case of Sixth Mount Zion Baptist, located in Richmond's Jackson Ward. There have been many great preachers throughout history: In 1620, John Robinson prayed for the Pilgrims heading for the New World by saying "For I am very confident the Lord hath more truth and light yet to break forth out of his Holy Word." Jonathan Edwards said, "You are thus in the hands of an angry God; 'tis nothing but his mere pleasure that keeps you from being this moment swallowed up in everlasting destruction." Billy Graham taught, "Humility is putting down pride. Smash pride, step on it, crush it, mash it, break it, and above all, expose it—not in the other fellow but in yourself." And John Jasper of Richmond, Virginia, proclaimed, "De sun do move."

When you drive through Richmond on Interstate 95, you will notice that the highway makes a slight detour around an old brick church. That church is Sixth Mount Zion Baptist Church; it was founded by a black preacher named John Jasper. If you attend a meeting of Richmond's city council, the meeting will be called to order using a gavel made of wood from the house in which John Jasper died. If you talk to an older minister who attended the University of Richmond, he might recall a time when ministerial students there were called "Jaspers" in honor of John Jasper.

Who was John Jasper? He was black, illiterate and a slave. He was born on July 4, 1812, in Fluvanna County, Virginia. At the age of ten, he was waiting tables, and at twelve, he was an assistant gardener. His teenage years were spent as a coal miner and a tobacco factory worker. During these formative years, John Jasper gave no indication of being a godly man. Then his life changed.

On July 4, 1839, John Jasper was sitting on a bench in Capitol Square when he had a strange feeling. He repented of his past sins, converted to Christianity and started to proclaim the gospel like the apostles of old. Convinced that the call came straight from God, he said, "My sins was piled on me like mountains; my feet was sinking down to the regions of despair; and I felt that of all sinners I was the worst. I thought that I would die right then, and with what I supposed was my last breath, I flung up to heaven a cry for mercy."

Since black preachers had to be supervised by white preachers, John Jasper was limited as to the churches where he could preach. In spite of this, he served churches in North Carolina and Southside Virginia and conducted services for wounded Confederates in Richmond's Civil War military hospitals. One of his favorite texts was from the sixth chapter of Revelations, "And I saw and beheld a white horse, and he that sat upon him had a bow, and a crown was given unto him and he went forth conquering and to conquer."

The end of the Civil War made John Jasper a free man. He continued to preach, and in 1867, he became the first black man to organize a church following the end of the war. With only nine members, he held services in a converted Confederate horse stable on Brown's Island in the James River. It was called Sixth Mount Zion because the congregation liked the name. No one seems to know where the "Sixth" came from, but Zion is a term used for Jerusalem. The old stable could hold horses but not John Jasper's rapidly growing congregation.

In about a year, the church had moved to an old carpenter shop on the corner of Fourth and Cary Streets, where the congregation stayed for two years. Then they purchased a little brick church on the corner of Duval and St. John's Streets. Soon John Jasper's fame had spread, and once again, his followers had outgrown their church building. John Jasper was no longer content to move to another old building and decided to build his own church. His congregation responded with the funds, and Sixth Mount Zion Baptist Church was born.

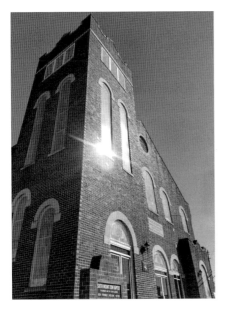

Bathed in sunlight, historic Sixth Mount Zion Baptist Church was founded by the renowned preacher John Jasper, who delivered the famous "De sun do move" sermon.

The new church was completed on the site of the old church. Sixth Mount Zion is one of the few nineteenth-century churches that can be attributed to an African American architect, Charles T. Russell. It is a significant example of African American ecclesiastical architecture or, as sometimes termed, the Gothic Revival style. The congregation continued to grow, as John Jasper was an inspiring preacher and his sermons captivated and motivated his congregation.

Although John Jasper lacked a formal education, he had learned to read and had memorized most of the Bible. When he preached, he did not give a stilted lecture using detailed notes—Jasper gave a performance. His voice boomed, his hands gestured, his message went forth and sinners were brought to God. John Jasper was a fundamentalist who resolved any conflict between the Bible and science in favor of the Bible. This belief led him to preach his most famous sermon.

The stage for the sermon was set when two members of Jasper's congregation asked him whether or not the sun moved. Jasper responded by preaching a ninety-minute sermon titled "De Sun Do Move." In this sermon, he reminded his flock that Joshua had asked God to stop the sun in order to give him more daylight in which to slay the enemies of Israel. Reverend Jasper reasoned that God would not have to command the sun to stop if the sun was standing still already; therefore, the sun does move. He spoke as follows, "I don't say the sun stopped; 'taint for Jasper to say that. But the Bible, the book of God, says so." John Jasper believed that God had power over the earth and the sun and could do what he wanted with them. After the sermon, he polled his flock to determine if they were convinced that the sun moved. He won a unanimous vote in favor of his interpretation that the sun does, indeed, move.

This was John Jasper's most famous, if not his best, sermon. He preached it 253 times in many southern, as well as northern, cities. Perhaps the

ultimate honor occurred when the Virginia General Assembly stopped its session to hear this African American, who was born a slave, preach "De Sun Do Move."

More than a pulpit orator, John Jasper tried to lead his congregation through the difficult days of Reconstruction; he developed educational programs, fostered social service projects and encouraged good race relations. By the time of his death, John Jasper had preached to more people than any other southerner of his generation.

In March 1901, John Jasper died. His final words were "I have finished my work; I'm waiting at the river, looking across for further orders."

This preacher, who was born a slave, died a legend. His legacy was so great that his church was saved from destruction when the Richmond Petersburg Turnpike was constructed. Indeed, the sun might not move as John Jasper suggested, but the bulldozers turned aside to save his church.

Today, the church he founded has these core values: hospitality, relationship building, biblically based learning and community impact. I am sure that the wandering spirit of John Jasper rejoices in what Sixth Mount Zion has accomplished—and will accomplish—with the help of Almighty God.

Pastor Tyrone Nelson, the current pastor of the church, offered these observations:

> I have been honored to serve as the pastor of the Sixth Mount Zion Baptist Church over the course of the past decade. One hundred fifty years of preaching, teaching, singing and community involvement has kept the church connected to the community that it serves. From Jasper, Peyton and Brown to ministry in the twenty-first century, the ministry of our ancestors guides the priestly and prophetic message of the present and the future.

Jennifer Spann, a member of the church, provided these comments about Sixth Mount Zion.

> I am a member of Sixth Mount Zion Baptist Church (The Mount), and I love being a part of this great congregation. Here are just a few reasons why I love my church. I love my church because as a member of the Mount, we as a congregation don't just go to church; we realize that we are the church. We at the Mount believe that God has called us to empower people to live a Christ-centered lifestyle. We are taught by the preaching, teaching and studying of God's Word that we are to be doers of God's Word and

First to be authorized by the United Sates to make slave marriages legal, the Reverend John Jasper ended years of devout service in 1901 and was interred at Woodland Cemetery.

not just hearers. This means that our ministry is not just in the church, but outside of the church. The Mount encourages me, as the Word does, to not be conformed to this world, but to live in such a way that makes a positive impact on this world. Sixth Mount Zion is not afraid to speak from the pulpit on those issues of life that affect all people from all walks of life. I love my church because the leadership, including my Pastor, Tyrone Nelson, work along with the people. And on a more personal note, I love my church because we are a family growing, learning and worshipping our Lord together. I love Sixth Mount Zion Baptist Church.

In 2017, Sixth Mount Zion celebrated its 150th anniversary. The church continues to empower people to live a Christ-centered lifestyle.

21

THE CATHOLICS

Prayer to my guardian angel:
Angel of God, my guardian dear, to whom God's love commits me here.
Ever this day at my side, to light and guard, to rule and guide.
—Catholic prayer contributed by Holly Clary

Of all Christian denominations, the Catholic Church is the largest. Its members are in every nation. From Europe, the Catholics came to America and began to settle in Virginia.

It has been written that Catholics were not particularly welcome in colonial Virginia. No priests were permanently assigned to Virginia, and there were very few Catholic families in the area. In the winter of 1781–82, Father Dubois came to Richmond with letters of introduction. He celebrated Mass in Richmond in the Hall of the House of Delegates in the state capitol.

In 1798, Father T.C. Mongrand was the first priest assigned to Richmond, but not much is known of his work. Father Xavier Michel was sent to Richmond in 1811. Lacking a church, Father Michel said Mass in private homes or rooms he rented. It is known that Mass was said in homes on the south side of Main Street between Twentieth and Twenty-First Streets, in a room in the Union Hotel on the southwest corner of Main and Nineteenth Streets and in a house on Main Street between Thirteenth and Fourteenth Streets. The Catholic Church began to grow in Richmond.

THE ROCKETTS CHURCH (SAILOR'S)

Be attentive, O Lord, to our supplications, and bless this ship and all who sail hereon, as you blessed Noah's ark in the deluge. Stretch forth your hand to them, O Lord, as you reached out to Peter when he walked upon the sea. Send your holy angel from heaven to watch over it and those on board and keep it safe at all times from every disaster. And when threatened perils have been removed, comfort your servants with a calm voyage and the desired harbor. And having successfully transacted their business, recall them again when the time comes to the happiness of country and home. You who live and reign forevermore. Amen.
—*Prayer for a ship from* Collectio Rituum

The first Catholic chapel was called the "Rocketts Church" or "The Chapel." It was part of a warehouse located at Main and Twenty-Seventh Streets and was in use beginning around 1815. Mass was said by visiting priests from Washington and Baltimore, and because so many sailors attended the services, it was not long before it was called the "Sailor's Church." The chapel was the only place Catholics had to worship in Richmond, and it was not adequate for the growing needs of the faithful.

On July 11, 1825, Pope Pius VII made the Commonwealth of Virginia into a diocese with its see at Richmond, and Reverend Patrick Kelly was named the first bishop of Richmond. With a bishop, Richmond needed to build a cathedral that contained the seat of the bishop. But this was in the future.

The left window, found at St. Peter Church, commemorates St. Vincent de Paul, who is the patron saint of Richmond.

In 1825, the Catholics moved into a frame chapel built at the southwest corner of Marshall and Fourth Streets. This chapel was about the size of a large room and was the first church built in Richmond surmounted by a cross. But there was a problem. The church was built on land willed to the Catholic Church; but in 1832, the Supreme Court ruled that the will could not be honored, because the organization benefiting from the will did not exist when the will was written. It has also been suggested that the Supreme Court feared giving too much power to a church and that there were allegations that the gift violated the state constitution. The Catholics were evicted from the land and the church in 1832, but a brighter future arose from this adversity.

According to many authorities, the congregation left the church and rented a room on the east side of Eleventh Street between Broad and Capitol Streets, which was across from the state capitol.

Some clergy make a profound difference. Such was the case of Father Timothy O'Brien, who arrived in Richmond in 1834. When he arrived, he felt that Richmond "appeared to be one of the most aristocratic towns in the world." One of his first efforts was to secure funds for a cathedral in Richmond. In this effort, he was successful in spite of having to deal with Richmond aristocrats. St. Peter Cathedral is his enduring legacy.

23

St. Peter Cathedral

*And I say to thee: That thou art Peter, and upon this rock I will build my church,
and the gates of hell shall not prevail against it.*
*—The Confession of St. Peter; Mark 8:27-30; Luke 9:18-20; John 6:66-71
(Douay-Reims)*

The Catholics purchased a lot at the northeast corner of Eighth and G (Grace) Streets and then signed a contract for a "mechanic" to build a church. It was called St. Peter after the apostle whose comment resulted in Jesus saying, "On this rock, I will build my church."

The church was planned on the model of the Church of Saint Philippe du Roule in Paris. On May 25, 1834, the cornerstone was laid, and the new church was dedicated in 1835. St. Peter is a beautiful structure and was the first church built on what is now Grace Street. The *Richmond Enquirer* reported, "Should the taste become more generally diffused, our city will present a strikingly beautiful appearance." Its location put it very close to Capitol Square.

At the dedication, Mass was sung, confirmation was administered and the ceremony ended with a homily that was found to be "able, judicious, and liberal." Richmond now had its first cathedral, which was the see of the bishop. The first parishioners at St. Peter were Irish immigrants who were digging the James River and the Kanawha Canal beside the James River.

The Richmond City Council changed the name of G Street to Grace Street in 1844. According to many accounts, the name was changed because

The chancel of St. Peter is the embodiment of a sacred space.

of the large number of churches on Grace Street, of which St. Peter was the first. It would soon be joined by St. Paul's Episcopal and Centenary Methodist. Following the completion of St. Peter, other Catholic churches were established, including St. Mary's for German Catholics on Marshall Street and St. Patrick's for the Irish, which was within a block of St. John's Episcopal on Church Hill.

Then tragedy struck the nation. On April 21, 1861, America was plunged into the great Civil War. A Pastoral Letter was issued by the bishop in which he ordered a prayer for peace and said, "The fortunes and fate of our beloved country are now trembling on the scales....Our chief hope is in the merciful providence of God." At St. Peter, the priest admonished his congregation to "stand firm in the assertion of their rights."

But there were more than prayers. The "Montgomery Guards" was composed of men from St. Peter, and the priest blessed the guardsmen's pikes, which were ancient weapons used for dress occasions. The ceremony

Detail of the chancel of St. Peter Catholic Church shows the crucifixion painting and one of two impressive angel sculptures.

took place in the basement of St. Peter. However, the men of St. Peter soon discarded their pikes for muskets and rifles and served the Confederacy from First Manassas to Appomattox. In Richmond, Masses were reduced because of a lack of sacramental wine due to the Union blockade. Two prominent Confederates who worshipped at St. Peter during the war were Secretary of the Navy Stephen Mallory and General Pierre Gustave Toutant Beauregard, a well-known Confederate general.

Following the war, James Gibbons was named the fourth bishop of Richmond in 1872. He is probably the best known of the bishops who served Richmond. Bishop Gibbons was present when St. Peter celebrated its golden jubilee in 1884. It was one of the most beautiful ceremonies ever held in the city. In one of his books, he wrote, "Christianity has dominated all modern history. Its morality, based on the loving kindness of an Eternal Father and the mystic brotherhood with the God-Man, has renovated the face of the earth." In another book, he wrote, "The ideal

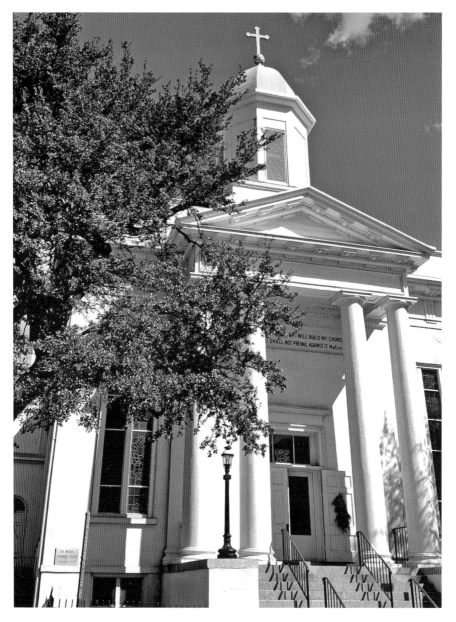

Richmond's first cathedral, St. Peter, was also the first church to bless Grace Street with its presence.

of the individual Christian is the imitation of Jesus Christ, the image of the invisible God."

There was a movement to tear down St. Peter and build a new cathedral. Fortunately, the lot on which St. Peter was built was too small for the proposed new cathedral. St. Peter was saved for future generations. And there was other good news; Bishop Gibbons was created a cardinal-priest of the church, becoming only the second American to attain the rank of cardinal at that time. He took as his motto *Emitte spiritum tuum*, "Send forth thy spirit."

As Richmonders moved west, St. Peter was being left behind. Houses of the faithful were replaced by buildings. Then something like unto a miracle happened. Mr. and Mrs. Thomas Fortune Ryan of New York paid for a new, much larger cathedral. To be known as the Cathedral of the Sacred Heart, its cornerstone was laid in 1903. With the dedication of the new Cathedral of the Sacred Heart in 1906, St. Peter became a parish church. But it was more than a parish church.

Father Magri had this to say about the former cathedral:

> *Dear old Saint Peter! Thou venerated temple of God! Thou earthly abode of the Most High! Thou hallowed by the feet of saintly men and saintly women! Salve! To thee do we come! Our feelings today are those of tender love, the love of the child for its mother. And, as we enter into thy sacred portals…our gratitude prompts us to cry out "This is the house of God! This is the gate of heaven!"*

Within sight of the capitol and amid an endless flow of traffic, St. Peter still stands like a rock that sustains the faith of those who pass by it on their way to the capitol and to work. Passersby who might face difficult challenges are reminded that God is still in control.

ST. MARY'S CATHOLIC CHURCH

The Bells of St. Mary's
Ah, hear they are calling
The young loves, the true loves
Who came from the sea
—*A. Emmett Adams and Douglas Furber*

German Catholics came to Richmond in the 1840s and settled in the downtown area around Fifth Street in what had become a German community. Many of them came to work on the James River and Kanawha Canal or the railroad. They attended St. Peter Church, as it was the only Catholic church in Richmond. Unfortunately, many of them did not understand English; therefore, it was difficult for them to participate in the service. They could not go to confession and be understood or understand what the priest was saying. It was not a good situation for the newly arrived Germans. It has also been suggested that the Irish and the Germans did not get along with each other.

Initially, the Germans worshipped in the basement of St. Peter, but they wanted their own church with the Mass offered in German. They let it be known that they were not comfortable worshipping in the basement. The Catholic leadership supported their request. A church leader said, "No portion of our population is more devout, and more united than our German Catholics."

In the early 1840s, there were several meetings in an effort to secure a Catholic church where German was spoken. Many people agreed that

they deserved their own church, and it was decided to form a separate congregation for German Catholics. The effort was underway, but progress was slow.

To offer encouragement to the Germans, Bishop Whelan of Richmond met with the German Catholics in the basement of St. Peter. He "urged them to continue their unity and praised them for the sacrifice they had already made for the support of the Jesuit priest who came from Washington once a month to lead German services."

In 1848, the work of gathering the Germans into a separate congregation began when Father Francis Braun, SJ, came to minister to the Germans in Richmond in the German language. Father Braun would say Mass at St. Peter and preach from time to time in German.

The first place of worship for the Germans was a house on Sixth Street near the market. The Germans furnished the house, and it was called "The Chapel." The German Catholics were very happy to get a German-speaking priest and their own house of worship. The Catholic leadership was also grateful, as some of the Protestant churches had German-speaking clergy and were attracting some German Catholics away from the Catholic Church. But the new church was too small for the congregation.

After many delays, St. Mary's Roman Catholic Church was dedicated in December 1851. Located at Fourth and Marshall Streets, the Germans now had a church home. The church was a beautiful building surmounted by a cross. The new church was blessed in honor of the Immaculate Conception of the Blessed Virgin Mary, thus the name St. Mary's. In 1856, the church held a bazaar and raised $700 for a new organ, and the congregation redecorated the interior of the church.

The congregation posed a challenge for the priest, as some members spoke High German, some spoke Low German and some were not Germans. In 1860, St. Mary's was turned over to the Benedictines to supply priests, and they labored faithfully for the church for most of its existence.

During the Civil War, many German Catholics from Richmond served with distinction. However, one man said that since he was a foreigner, he should not have to fight. Bishop McGill said that "it was his solemn duty to take up arms for the land in which he intended to reside and made him promise to enter the army, which he subsequently did."

Over the years, the appearance of the church changed, as it was enlarged to accommodate more worshippers. Initially, it was described as a simple rectangular building of modified Classical style, except for the belfry. Later,

the church was said to take on certain Italianate influences in the entrance, the windows and the tower. The interior had a central aisle, and there were arches above the altar.

In 1901, the church celebrated its golden jubilee. The sermon, given in English, was considered a masterpiece. The bishop complimented the Germans "for the sacrifices they had made, and the generosity they had shown in contributing toward the remodeling of the church." The service ended with the singing of "Grosser Gott," by Ignaz Franz. The first verse in English is as follows:

> *Holy God, we praise Thy Name;*
> *Lord of all, we bow before Thee!*
> *All on earth Thy scepter claim,*
> *All in Heaven above adore Thee;*
> *Infinite Thy vast domain,*
> *Everlasting is Thy reign.*

Something very unusual happened in 1904. The priest, Father William Mayer, OSB, seemed to be in good health and was saying the Stations of the Cross as part of a Lenten service. According to a witness, "He arrived at the third station, where, just after reading the words: 'Jesus falls for the first time under the weight of the cross,' the priest fell down on the floor. Several men in the congregation tried to help him get to a seat." Taken to his residence, a physician was summoned, but he could not save the dying priest. His death under these circumstances was an unforgettable experience for the congregation, but the priest died serving his God and God's people.

Like many downtown churches, St. Mary's faced a gradual decline in membership as the original German community moved away, learned English and joined Catholic churches closer to their homes It was determined that Mass would continue as long as there were German members, but the membership kept dropping. In 1961, St. Mary's Church was sold to the Joseph W. Bliley Funeral Home to be used as a parking lot. The old German church that meant so much to so many people was demolished. The altars where so many prayers had been said were buried in the basement of the church. The second-oldest Catholic church in Richmond was no more.

Its name was given to a new Catholic church in the West End of Richmond. And its bell was saved. It is now at the Bliley Funeral Home on

Augusta Avenue as a reminder of a church that was once the spiritual home to Richmond Germans.

Although the church has gone, it is important to remember the zeal of the German Catholics who worked so long and so hard for a house of worship so that they could worship God in their own language and with the German Catholic community.

St. Patrick's Catholic Church

If I have any worth, it is to live my life for God so as to teach these peoples;
even though some of them still look down on me.
—St. Patrick

Just as the Germans wanted a church of their own, the Irish had a similar need. The Irish community had expanded into Church Hill, and many of them worked in the tobacco factories that were nearby or on the railroad. In the days before modern transportation, many of the members found it difficult to get to St. Peter, which was several miles away.

To meet the need of the Irish in early 1859, Bishop John McGill purchased four lots on the eastern side of Twenty- Fifth Street between Broad and Grace Streets. Bishop McGill laid the cornerstone for the new church on June 12, 1859, the feast of Pentecost. After laying the cornerstone, he preached a sermon "explaining and defending the ceremonies of the Catholic Church."

The *Richmond Whig* reported, "The cornerstone of a new Catholic Church to be created on Twenty-Fifth Street, between Broad and Grace Streets was laid. The attendance at the ceremony was large, and offerings of about $250.00 were collected." The church was completed and dedicated in 1861, although it was apparently used before it was completed.

Built of brick, the church has been described as pseudo Gothic. The nave is very wide, with a high vaulted ceiling with open trusses supporting it. One of the outstanding features of the church are the front stairs, with a cast-iron railing that leads to the sanctuary. According to some authorities, the steps

Many Irish people immigrated to America during the potato famine, of which this window is a stirring reminder.

were made of granite from the nearby canal and were pulled up the hill by the men of the congregation. These steps created a very impressive entrance to the church.

The church was called St. Patrick's, which was appropriate given St. Patrick is the patron saint of Ireland. And many Irish immigrants attended the church. Closely associated with St. Patrick is the shamrock. According to legends, St. Patrick used the shamrock, a three-leafed plant, to illustrate the three persons of the Trinity. It could well be true that he held up the shamrock to illustrate the Trinity to people who would not have understood God in three persons, and the church members at St. Patrick's made frequent use of the shamrock in decorations.

Father John Teeling was the first pastor of the new church, and he has a place in legal history. In 1859, he was ordered by the court to reveal what a dying woman had revealed to him in a confession. The woman died from wounds inflicted by her husband, but Father Teeling refused to disclose what had been revealed to him in her confession. Father Teeling's position was upheld by the court with the language that "the minister cannot be compelled to divulge his knowledge resulting from such confessions." This became known as Teeling's Law.

This church has always had a close association with St. Patrick's Day. In 1903, an Irish Smoker, which consists of pipe smoking, drinking, talking and eating, was held at the church. It was reported that everything was Irish, including Irish pipes, Irish tobacco, shamrocks and the guests. Father O'Reilly, a great Irishman, was the speaker. In a speech, it was pointed out by the priest that St. Patrick was a great saint who spread the word of God.

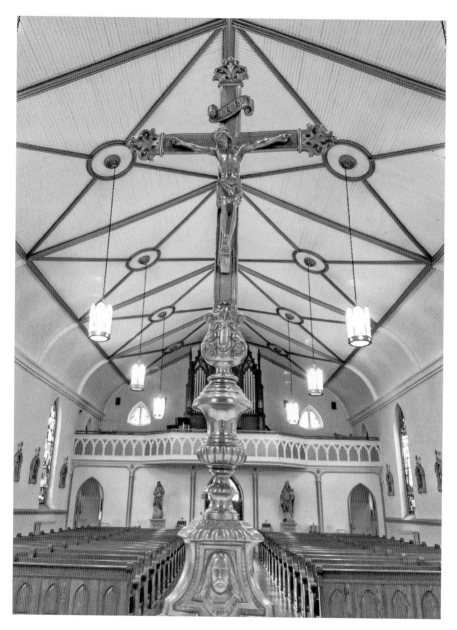

Above: This elegant crucifix in St. Patrick's Church speaks of the strong faith that brought Father Teeling to defend the sanctity of the confessional.

Opposite: The Sisters of Charity window memorializes the educational and charitable work of Blessed Elizabeth Seton, the first American-born saint. Mother Seton founded many religious communities that continue their work today.

The *Richmond Times-Dispatch* reported in detail a St. Patrick's Day celebration in 1910. The paper reported, "The celebration of the day was begun with services in St. Patrick's Church which was packed to the doors." There were five clergy participating in the ceremony and fifty acolytes lighting the candles. But St. Patrick was the center of attention.

In 1914, the bishop of Richmond spoke at the St. Patrick's Day celebration at the church. The bishop asked the children of the church "never to stray from the altar which that venerable and venerated son, St. Patrick, of the church was reared so many hundred years ago." The service closed with the singing of the song "Come Back to Erin." The words are as follows:

> *Come back to Erin, Mavourneen, Mavourneen,*
> *Come back, Aroon, to the land of thy birth;*
> *Come with the shamrocks and springtime, Mavourneen,*
> *And it's Killarney shall ring with our mirth.*

On October 13, 1925, attention was directed to the church because of the funeral of Thomas Mason. He was the engineer on the train that was entombed in the tunnel under Church Hill when it collapsed. He was buried in Mt. Calvary Cemetery. I have visited his grave and thought of his painful death in a crushed locomotive. If you are in a reflective mood, you can hear the priest say, "O Lord, we commend to you the soul of your servant, Thomas, that, having departed from this world, he may live with you. And by the grace of your merciful love, wash away the sins that in human frailty he has committed in the conduct of his life. Through Christ our Lord. Amen."

In 1931, the following appeared in the *Richmond Times-Dispatch* when St. Patrick's Day was celebrated:

This Gothic-style entrance of St. Patrick's Catholic Church is ornamented with graceful cast-iron railings.

When St. Patrick drove the snakes out of Ireland, there is strong reason to believe that some of them succeeded in swimming across the Atlantic Ocean and that they discovered America before Columbus did. We are still waiting for our St. Patrick who will come and drive out of America the snakes of hypocrisy and counterfeit piety, and the false religion of minding other people's affairs. I would like to see him drive out the serpents which erected their hate into religion. I would like to see St. Patrick triumph over and destroy those moral magicians who seek to offer us as human sacrifices to their false idols. We are a fallow field for the labors of this heroic saint.

The next year, there was no St. Patrick's Day celebration in Richmond. The city was in the midst of a depression, but there was a solemn high Mass. In 1942, the United States was at war. Once again, the celebration was a high Mass to celebrate St. Patrick's Day. There was no mention of any parties. In 1975, there was a St. Patrick's Day celebration at the

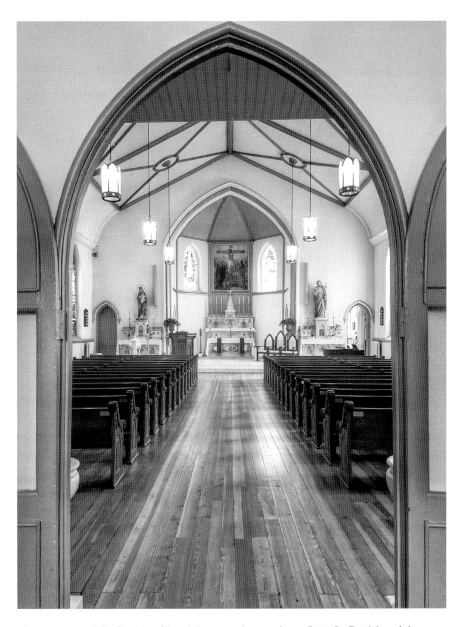

The sanctuary of St. Patrick's Church is a sacred space that reflects St. Patrick and the faithfulness of the Irish people.

church, but a lady said, "It is not like it used to be, that's for sure. The old Irish families that live in this area have moved away or are dying out, and the younger ones don't celebrate the way their parents did."

Even though the type of celebration has changed, St. Patrick's Church is still the center of Richmond's St. Patrick's Day festival, which has become a tradition. Hundreds flock to the old church to remember the saint who drove out the snakes from Ireland, and St. Patrick's Church has never forgotten its heritage. Its beautiful sanctuary is a sacred space that makes it easy to feel the presence of Almighty God and to recall St. Patrick, whose contributions will always be remembered.

St. Patrick's remains a vibrant congregation after all of these years. It focuses on the motto: "Encounter the love of Christ and His church."

THE CATHEDRAL OF THE SACRED HEART

Lift high the cross,
The love of Christ proclaim,
Till all the world adore
His sacred name.
—*George William Kitchen and Michael Robert Newbolt*

Like a rock for all ages, the Cathedral of the Sacred Heart has stood overlooking Monroe Park for over one hundred years. This building—with the reminder "If Ye Love Me Keep My Commandments" (John 14:15) carved over its massive oak doors—has been a beacon of faith for all people for generations. When built, it was surrounded by a residential neighborhood at a time when horses and carriages were the primary modes of transportation, when men tipped their hats as they passed in front of a Catholic church and women would not enter it without a hat adorned with everything from ostrich feathers to the finest felt.

Now the cathedral stands at the entrance to Virginia Commonwealth University and is circled by cars, buses and students laboring under backpacks and carrying laptops. Although its surroundings have changed, the cathedral remains a sacred place. There is no other church like it in Richmond.

The Cathedral of the Sacred Heart was the Diocese of Richmond's second cathedral. The first was St. Peter Cathedral, located in downtown Richmond at Grace and Eighth Streets. But as Richmonders moved west, it soon became evident that a new cathedral was needed to be closer to the westward moving population.

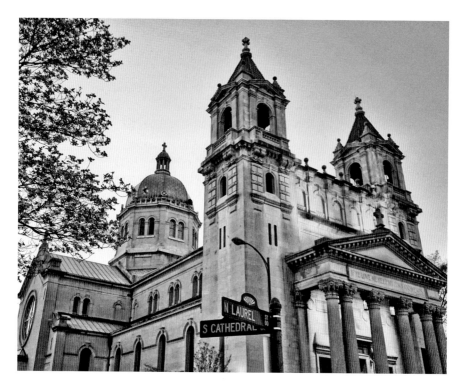

The grand Cathedral of the Sacred Heart rises from a cornerstone cut from a rock where Jesus walked.

Bishop John McGill purchased one of the lots facing Monroe Park in 1867. This lot would eventually be the site of the new cathedral. However, the plans were slow to develop because of the difficulty in raising funds, as well as some opposition to moving the cathedral from its downtown location. These issues would stall the building of a new cathedral for many years. But the vision did not die. On November 17, 1882, it was finally decided to build a new cathedral. Still, the fundraising drive continued to flounder.

But the need would soon go away. In 1883, Bishop John J. Keane was thinking of the new cathedral while visiting the Holy Land. He wrote, "While there I procured a corner-stone for the proposed cathedral, which was cut under my own supervision from the solid rock of Mount Olivet, within the enclosure of the Garden of Gethsemane." This stone could have been a silent witness to the prayer of Jesus when he prayed "Saying, Father, if thou be willing, remove this cup from me: nevertheless not my will, but thine, be done." The stone was brought to Richmond in 1883; the diocese now had a cornerstone for the proposed cathedral and a site but little money.

Undeterred by the lack of funds, Bishop Keane purchased a second lot adjoining the first because property there was "so rapidly advancing in values, and because it was being so rapidly bought up that soon there would be no chance of securing a fitting site." With a site now large enough for a cathedral, the bishop continued his efforts to raise the necessary funds.

Meanwhile, the lot on which the entrance to the cathedral now stands was leased to John E. Toler for eight years "to be used as a florist establishment." The bishop reasoned, "There is no prospect of our building a church there within that period, this revenue from the rent is very desirable." At some point, the flower garden owner added a greenhouse. The cathedral remained only a vison.

At the same time, the need for a church in the West End intensified, and something had to be done. However, instead of building a cathedral, the Diocese of Richmond erected Sacred Heart Church on the southwest corner of Floyd Avenue and Brunswick Streets in 1887. The site of the proposed cathedral continued to be a greenhouse.

Then the vision became a reality. In 1901, Mr. and Mrs. Thomas Fortune Ryan of New York donated $500,000 to build the new cathedral. As far as is known, Richmond's Cathedral of the Sacred Heart is the only cathedral to be built with the donation of a single family.

Plans for the new building were drawn by Joseph H. McGuire of New York, and June 4, 1903, was set for the laying of the cornerstone. The *Times-Dispatch* reported, "Long before the hour fixed for the opening of the service, people began to congregate around the foundation of the church. But many [people] soon crossed the street to escape the heat. In the cool shade of the trees of Monroe Park many of them sought refuge from the blazing face of the sun."

At the home of Judge and Mrs. Samuel B. Witt, 828 Park Avenue, church dignitaries and prelates vested for the service. They then joined a procession of other members of the clergy and the laity that had begun at Sacred Heart Church. The whole procession moved two by two down Floyd Avenue to the construction site.

A great white cross marked the place where the main altar was to be located. Thousands stood in the heat to observe the laying of the cornerstone, "the smooth, white stone cut and wrought years ago in the Garden of Gethsemane." One reporter wrote, "The corner stone was laid by His Excellency, the Most Reverend Diomede Falconio, Apostolic Delegate to the United State of his Holiness, Pope Pius X. Accompanying him during the ceremony was Richmond's Bishop, Augustine Van De Vyver."

Three times Jesus uttered, "If this cup cannot pass by, but I must drink it, your will be done." Mathew 26:42. This stone's provenance is on the Mount of Olives of Christian remembrance.

The stone was given a final blessing and put in place. Afterward, people tried to touch it or pick up pieces of stone flakes. A metal box placed in the stone contained copies of the Richmond papers, coins from that year and a parchment inscribed in Latin, a portion of which read, "Dedicated to the Sacred Heart of Jesus."

Appropriately, the cathedral was built from Virginia granite and Indiana limestone. With a copper dome and the roof in the form of a Latin cross, the cathedral was 206 feet long by 114 feet wide. Its seating capacity was 1,150. It also contains a crypt.

Architecturally, the cathedral has been described in many ways. One writer described it as "a dome and porticoes structure in the Italian Renaissance style." Another reporter wrote, "The basement is of Virginia granite, the superstructure of Indiana limestone with the roof of copper

and unglazed green tile." Another compared it to St. Paul's in London, which was designed by Sir Christopher Wren, and the scholarly classic style of the Baltimore cathedral designed by M. Latrobe. "But the treatment of the portico and towers in the Richmond cathedral is different, and is very distinctive." When completed, the cathedral was one of the largest churches in the United States.

The Cathedral of the Sacred Heart was consecrated on Thanksgiving Day, November 29, 1906. As visitors made their way there, they saw "standing forth great and gray in the morning light, the cathedral with its towering cross loom[ing] majestic and grand in the distance." Another writer exclaimed, "Beneath the full beauty of a perfect autumnal sky, the massive doors of the cathedral were thrown wide yesterday admitting to the sanctuary the most notable gathering of high dignitaries ever assembled upon Southern soil."

His Excellency, the Most Reverend Diomede Falconio, who had laid the cornerstone, led the service of consecration. Afterward, there was a Pontifical Mass, described as "the most imposing service held in Virginia." Richmond now had a cathedral of its own: the Cathedral of the Sacred Heart.

If the walls of the cathedral could speak, what a story they could tell,

A sculpture of Jesus in the cathedral stands above the beloved symbol of the Sacred Heart.

what a sermon they could preach. The cathedral was less than ten years old when the RMS *Titanic* struck an iceberg, and the loss of life was appalling. In his homily following the tragedy, Bishop Denis J. O'Connell said, "The noble heroism of the men who sacrificed their lives to save the weak is an act of religion and piety." The cathedral walls echoed when military convoys passed nearby as World War II erupted on December 7, 1941. During the war years, the cathedral welcomed men and women in their nation's uniform.

These same walls have heard the cries of babies being baptized and the cries of those coping with the agony of the human condition. The walls have witnessed everything from the

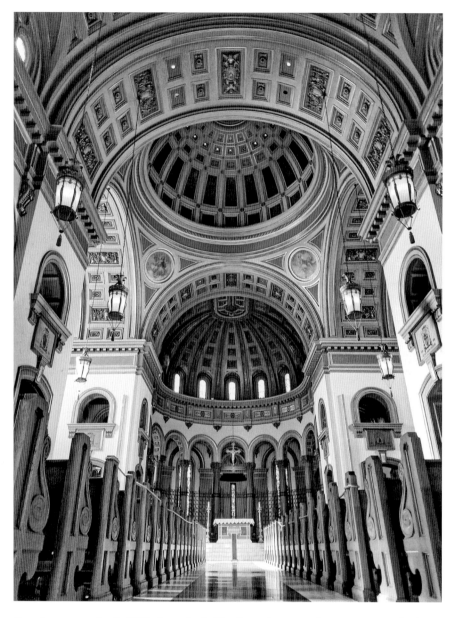

Since its consecration in 1906, the cathedral has been the scene of many august gatherings.

sacrament of the Mass, the joys of marriage, confessions of the repentant, the ordinations of priests and the funerals of the faithful with the hymn "Lift High the Cross" being sung. Every step taken in the cathedral preaches a "sermon in stone," a reminder that although God cannot be contained within the walls of a building, a building can certainly provide a glimpse of the majesty and love of the Creator.

Although the exterior of the cathedral has remained largely unchanged, the interior has not. Walls have been painted, coats of arms have been added, confessional booths have been removed, a new baptismal font installed and new stained-glass windows added. In response to the mandates of the Second Vatican Council (1962–65), a new altar was built that allowed the priest to face the congregation. Vatican II also changed the language of the liturgy from Latin to English. *Pater noster, qui es in coaelis* became "Our Father, who art in heaven." Thus, the cathedral has remained the spiritual home of the faithful for over one hundred years.

Residents of the Fan still hear the ringing of the cathedral's bells, passersby see the great lighted dome, the rich and the poor still enter the cathedral to attend Mass and all who do so are moved by the beauty of this sacred place. Surely, the cathedral is symbolic of the affirmation of St. Peter, "Thou art Peter, and upon this rock I will build my church; and the gates of hell shall not prevail against it." Matthew 16:18 (KJV). Certainly, the cathedral will remain a rock for the ages.

DISCIPLES OF CHRIST

As a child I was frequently taken to visit Smyrna Christian Church in King and Queen County, Virginia. My father had grown up in the church and would frequently go back for services and to visit the cemetery. He told me of being baptized in a creek and pumping the pump organ. As a child, I did not know a thing about the Disciples of Christ, except that they had communion every Sunday, which was very different from the church we attended in Richmond. I also did not know the rich history of the Smyrna church at which both Thomas and Alexander Campbell, the founders of the Disciples of Christ, had preached sermons. It is said they took a special interest in the church.

These visits with my father introduced me to the Disciples of Christ, a church that played an important role in the history of Richmond churches and in my family. One member of my family, who was a member of the church, was mentioned in a local history book. It seems that Bob Griggs, my great-grandfather, invested in the telegraph so that his children would be entertained by watching the telegraphs run down the line.

The Disciples of Christ, or Christian Church, came to Richmond when the minister of First Baptist in Richmond invited a guest minister to preach without knowing anything about what he might say. The First Baptist minister learned the hard way that someone should ask a guest minister what he might tell the congregation before he speaks from the pulpit.

Thomas Campbell, who was the guest minister, preached several times at First Baptist in the early 1830s. Although a Baptist, he eventually left

the Baptist Church and was instrumental in the founding of the Christian Church (Disciples of Christ). Over and over again, Campbell was invited to preach at First Baptist, and more and more members of the congregation liked his message. He was an excellent speaker who soon attracted a loyal following within First Baptist Church.

There are no records of what he said, but he generally included the following topics in his sermons: Baptist identity and Christian faith; the nature of the true church; the reality of divine grace; the need for unity among all Christians; the literal acceptance of the Bible; baptism by immersion; and communion every Sunday. He summed up his beliefs by stating, "Where the Bible speaks, we speak; where the Bible is silent, we are silent," and as he later asserted, "No creed but Christ, no book but the Bible, no name but the Divine." These ideas appealed to many of the Baptists who heard them.

Sycamore Church

And as they did eat, Jesus took bread, and blessed, and brake it, and gave it to them, and said, "Take, eat: this is my body." And he took the cup, and when he had given thanks, he gave it to them: and they all drank of it. And he said unto them, "This is my blood of the new testament, which is shed for many."
—Mark 14:22–23 (KJV)

On February 14, 1832, a meeting was called at First Baptist Church and the following resolution was passed:

> *Whereas it is evident that a party has arisen in this church entertaining opinions of Scriptural doctrines and church government materially different from those of the great body of this church and all the Regular Baptists in Virginia, and whereas out of these discordant opinions and views, a state of feeling has grown, very unfavorable to the peace and honor and piety of the church. Therefore, Resolved, that the church earnestly and affectionately recommends to those who have embraced these new doctrines and opinions, to withdraw from us and become a separate people, worshipping God according to their own sense of propriety.*

This resolution was a way of separating the followers of Campbell from the Baptists who remained faithful to the minister at First Baptist. In February 1832, about sixty members of First Baptist and two members from Second Baptist joined together to establish Sycamore Church, later called

the Seventh Street Christian Church. The preaching of Thomas Campbell had cost First Baptist some of its most faithful members.

Thomas Campbell wrote a covenant on March 2, 1832, following the departure of his followers from First Baptist. The covenant states: "We the undersigned immersed believers, having agreed to unite together as a church to be called the Church of Christ on _____ Street, Richmond, do for the satisfaction of all concerned declare as follows:

1st That we receive and hold the scriptures of the Old and New Testament as containing a true and perfect revelation of the divine Will, able, through faith, to make us wise to salvation, thoroughly furnished for all good works, and the New Testament as the only and sufficient rule for the Worship and Government of the Christian Church.

2nd That thus receiving and holding the sacred Volume, we stand pledged, through the grace of God promised us in Christ, to study to conform to all its holy precepts and examples.

3rd That conscientiously recognizing the constitutional unity of the body of Christ, we extend our fellowship to all who have been immersed upon a scriptural profession of Faith in Christ and are walking orderly, according to his law, enjoined by His holy Apostles upon the believers."

It was believed that the covenant was signed by the majority of the members of the new church.

The first meeting of those who had been separated from First Baptist was held at the home of Joel Bragg near the corner of Second and Broad Streets. Meanwhile, the Baptists asserted that those who followed Campbell were "subversive of the true spirit of the Gospel of Jesus Christ, disorganizing and demoralizing in their tendency." They were also accused of "throwing into wrangling and discord, churches long blessed with peace and prosperity." And it got worse. It was said that "they are a dogmatic sect, who live only in the fire of strife and controversy, and seek to remain in connection with existing churches, that they may with greater facility obtain material for feeding the disastrous flame." It was also stated that the "cause of truth and righteousness requires a separation from them."

In spite of these diatribes, the Disciples of Christ continued to grow, and the congregation decided to build their own church. Accordingly, a church was founded by Thomas and Alexander Campbell with members who had withdrawn primarily from First Baptist. To build a church, a lot was purchased on the east side of North Eleventh Street, between Broad and

Marshall Streets, in May 1832. This was the first church in Virginia known as a Disciples of Christ or Christian Church. The new congregation met in the city hall and later at the state capitol while the new church was under construction.

Records indicate that the first service in the new building was held on March 24, 1833. The new church was to be called Sycamore Church "from the sycamore tree which throws its refreshing shade over the entrance to its doors." The building occupied a large lot and was located in a very desirable location because of the surrounding neighborhoods. This auditorium was spacious and could seat six hundred people. Made of brick, it was considered to be a beautiful structure and dignified in every way.

Over time, improvements were made to the church, including galleries, a baptistery, the installation of gas and water and a furnace. The church was strict in attendance, and it was not unusual to be dismissed from the church for missing too many services. Others were dismissed for "indulging in ardent spirits, dancing, visiting the theatre, walking disorderly, speaking disrespectfully to the preacher, and refusing to apologize." It could be seen that the members of the Disciples of Christ had to practice their faith.

During the Civil War, the church was used as a hospital. The ladies of the church first used the lecture room in the rear of the church for this purpose. Then they expanded to the Sunday school. There were as many as thirty patients in the church at one time. While the women of the congregation administered to the wounded and dying, the men of the congregation served in the Confederate army. These were difficult times, but the church survived. Even though the members were operating a hospital, the church continued to have its regular services.

Following the Capitol Disaster in 1870, when the floor of the Virginia Court of Appeals fell into the Hall of the House of Delegates, killing and maiming many people, the Commonwealth of Virginia was in a difficult position. A meeting place for the House of Delegates was needed. Accordingly, Sycamore Church was sold to the state, and after the repair of the capitol, the church was used as a courthouse. In the absence of a church building, the Disciples of Christ met at the Universalist church on Mayo Street. Of course, many members resisted the sale of their former church, which held many memories for the people who called themselves Disciples of Christ.

SEVENTH STREET CHRISTIAN CHURCH

Soft as the voice of an angel,
Breathing a lesson unheard,
Hope with a gentle persuasion,
Whispers her comforting word:
Wait till the darkness is over,
Wait till the tempest is done,
Hope for the sunshine tomorrow,
After the shower is gone.
—Septimus Winner

The displaced congregation of Sycamore Church built a new church on land at Seventh and Grace Streets, and Sycamore Church was renamed Seventh Street Christian Church. The first stone was laid in the construction process in April 1871. Made of granite, the Gothic church had a large steeple, which is a story unto itself. While it was under construction, some high wind blew down the scaffolding around the steeple and almost destroyed it. Another problem arose when some church members learned that the steeple at St. Paul's was taller than theirs, and they were not pleased. Finally, the steeple was removed in the early twentieth century due to an order from the city, as many steeples were being blown down in wind storms.

The *Daily Dispatch* described the church as a "handsome, granite, church edifice." The first meeting in the new church was held in the basement in May 1873, and the dedicatory sermon was delivered soon after by the

Reverend Joseph Z. Tyler, the pastor of the church. His text was Matthew 26:8, "But when the disciples saw it, they had indignation saying to what purpose this waste?" He closed with the assertion of two points that were basic to the Disciples of Christ. He stated that in some denominations, "we do not find the Bible practically regarded as all-sufficient in matters of faith, and all authoritative in matters of practice. Nor do we find the people of God united as they should be. To accomplish these results, we are laboring as a people." The church was filled to overflowing, and many people had to stand outside. During a later service, the minister said, "If we take the unseen out of this world, we have a dead world." A prayer that was said by many people during the early days of the church is as follows;

Backward, turn backward,
O, time, in your flight,
And make me a child again,
Just for tonight.

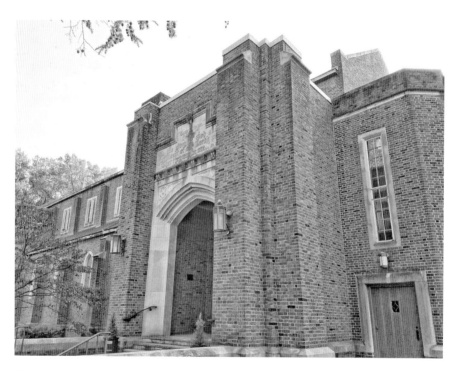

The imposing entrance of this church is on Grove Avenue; it still retains the Seventh Street Christian Church name.

Although it was a church building that met the needs of the membership, the congregation kept moving farther west, and transportation became an issue. The church, like many downtown churches, eventually moved west to be closer to the membership. The old church building was sold to the Thalhimers Department store in 1944, and the congregation held its final services in the sanctuary in September 1946. When the congregation left the church, they left behind an electric sign that they had placed in front of the church in 1921. The electric sign was apparently a first for a Richmond church. The congregation met in the Albert Hill School until a new church building was completed at Malvern and Grove.

The new sanctuary was a beautiful building of Gothic design. Like Gothic churches, it seemed to pull you into the worship service. Although the church was now on Grove Avenue, it was still called Seventh Street Christian.

Just as Sycamore trees have many branches, many Disciples of Christ churches have branched out from Seventh Street Christian and now serve various areas of the city. Yet, Thomas Campbell must get the credit for preaching a message that attracted a dedicated following and established a new denomination in Richmond. He was a man of God who preached his convictions.

Dr. William E. Blake Jr. is an emeritus history professor at Virginia Commonwealth University as well as a Disciples of Christ minister. He responded to my request that he reflect on being in the pulpit of Seventh Street Christian Church.

> *I don't know how early in my life that I learned that Third Christian Church (Disciple of Christ) was the first offspring of Seventh Street Christian. I may not have learned it until I read it in a book in my Father's library, titled* A Century with Christ: A Story of the Christian Church in Richmond. *It was published in 1932.*
>
> *I was reared in Third Christian and did always hear that Seventh was the oldest and premier Disciples Church in Richmond.*
>
> *The highly esteemed Reverend F.W. Burnham, who gave his massive library to Seventh, was the minister in my growing up years. Burnham became minister in June, 1931. To me, Seventh was the "National Cathedral" of Disciples Churches. That I would someday stand in its pulpit, even on an "interim" basis, would have come to me only in some bizarre dream if at all.*
>
> *I am both honored and humbled to be giving sermons and leading the church in which the pioneers of the movement that produced the Disciples*

preached— namely Thomas and his son, Alexander Campbell. Neither was the regular minister of Seventh's mother church, "Old Sycamore," But both tended its birth and wrote the documents that expressed its early faith.

My emotion is now sadness as I speak on Sunday mornings. A church, which on the eve of the building of the Seventh and Grace Street Church, had 497 members, now in its present neo-Gothic structure, erected in the mid-twentieth Century, struggles to have fifty members present on Sundays. My prayer and hope is that Seventh can experience some modern day restoration miracle.

Like Dr. Blake, I have been troubled about how church attendance has declined over the years. In generations past, people attended church on a regular basis and were sometimes known by the church they attended. Now, many pews are empty, and some churches have closed. It is my prayer that a miracle will awaken people to the peace that comes from worshipping on Sunday mornings and to learn that "we do not need to worry about tomorrow because God is already there."

THE METHODISTS

Now I lay me down to sleep,
I pray the Lord my soul to keep.
If I should die before I wake,
I pray the Lord my soul to take.
—child's prayer contributed by Burrell Stultz

God is good,
God is great,
Now we thank him for our food.
—child's prayer said by Frances Pitchford Griggs

When you drive west down Broad Street, you pass St. John's Church, which is familiar to everyone because of Patrick Henry's speech. But close to this edifice at Broad and Twentieth Street is a church with a long history that almost everyone has forgotten. People pass it without realizing that the origins of this church can be traced back to England to a people called Methodists, and that from this church, Methodism spread across Richmond and the surrounding area. The original name of the church was Trinity Methodist, and it is known as the "Mother Church of Richmond Methodism."

The Methodist Church was a reform movement within the Church of England. It was founded by John Wesley, a student at Oxford University, who was part of the Oxford movement made up of deeply religious students.

The group was called "Bible Bigots," "Bible Moths" or the "Holy Club." Other leaders of the group were John's brother Charles Wesley and George Whitefield. On May 24, 1738, while attending a service on Aldergate Street in England, John Wesley heard Martin Luther's Preface to the Book of Romans being read. Upon hearing it, he felt that his "heart was strangely warmed." Luther's belief in justification by faith guided John Wesley's life and ministry.

As the Methodist movement developed, John Wesley did the preaching, Charles Wesley wrote the hymns and George Whitefield became an outstanding evangelist. However, this movement could not be contained in Europe. In the early 1760s, the Methodists began to come to America. Francis Asbury, a leader in the American church, served his Lord for forty-five years by organizing a number of Methodist churches in America.

During the American Revolution, many Methodists sided with England, which did not endear them to the colonists who were fighting for their independence. In fact, many Methodists returned to England before independence was won at Yorktown, Virginia.

Methodism grew after the war, and Francis Asbury and Thomas Coke were named the first bishops in the United States. Traveling through the country on horseback, they carried a Bible and saddlebags filled with sermons. They preached wherever there were people and held camp meeting and revivals. Camp meetings were especially popular in Virginia. It was reported that when Francis Asbury ran the Methodist Church, there was one circuit in Virginia that caused him a problem. According to a news story, the "ladies were so fascinating that all the young preachers sent there were soon taken captive [married]." The newspaper reported as follows: "Bishop Asbury thought to stop this by sending thither two decrepit old men, but, to his great surprise, both were married the same year." He then wrote, "I am afraid the women and the devil will get all my preachers!"

Richmond was an appointment on a circuit for some years, and the Methodist circuit rider was a familiar figure in the city. Indeed, Virginia has been called the "Cradle of Methodism" because of the work of those men who rode across the state to preach the Word of the Lord.

When Thomas Coke came to Richmond in 1787, he preached in the Henrico County Court House at Main and Twenty-Second Streets. Although many churches used the courthouse, the Methodists were asked to leave because neighbors complained about their singing and shouting. However, the sermons might have helped the inmates in the nearby jail to change their way of living. Following the eviction from the courthouse, various houses were used as house churches.

Sometimes, the minister preached in places other than houses. In 1791, Thomas Coke delivered a sermon in the Virginia State Capitol. He also preached in a barn called Parrott's barn, or the Stable Church, on lower Main Street near the First Market. On November 29, 1797, the newspaper announced that "Dr. Coke, Bishop of the Methodist church, intends to preach in Richmond on the 3rd of December, 1797." The Methodists had established themselves in Richmond.

TRINITY METHODIST CHURCH

Love diving, all Loves excelling,
Joy of Heav'n to earth come down!
Fix in us Thy humble Dwelling,
All Thy faithful mercies crown.
—Charles Wesley

The first Methodist church built in Richmond was constructed in 1799 at the northeast corner of Nineteenth and F (Franklin) Streets. Then, in 1828, the congregation built a new church called Trinity on F (Franklin) Street between Fourteenth and Fifteenth Streets.

Tragedy struck the church in 1835 when it was destroyed by fire. The *Richmond Whig* gave a detailed account of the fire. Apparently, the fire started near the pulpit and could have been extinguished with a couple buckets of water. But there were no buckets, and the fire spread rapidly. The newspaper reported, "The fire bell of the night watch sounded the alarm at an early moment." The newspaper continued, "The Company, Jefferson No. 1, we understand, was on the spot soon after the first alarm, but lacked the necessary equipment to extinguish the fire." The church was completely destroyed—nothing was saved.

But the church was rebuilt the next year using public subscriptions of over $9,000 along with congregational donations. This church building was used until 1862, when the congregation built a church at Twentieth and Broad Streets for the growing congregation.

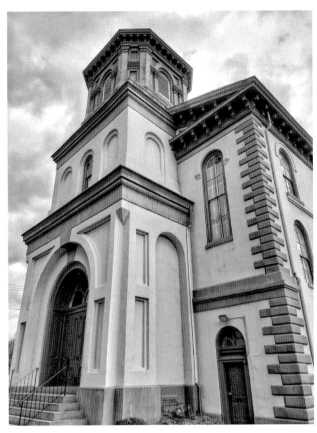

Left: From this building, the original Trinity Methodist Church, Methodism extended through the Richmond area.

Below: Trinity sells pumpkins each autumn, a unique way of supporting the mission of the church.

Trinity was designed by a Richmond architect, Albert L. West, in what was referred to as an Italianate stucco brick structure. "It has a three-stage central tower with an octagonal third stage that rises above the ridge of the gable roof." Although parts of the church were dedicated in 1869, the tall, slender steeple was not added until 1873. The steeple was visible throughout most of the city at a time when tall buildings did not exist.

The new church was used until the congregation split to form another church because the congregation was too large for Trinity. The Methodists retained Trinity Methodist at Broad and Twentieth Streets and built Broad Street Methodist at the corner of Tenth and Broad Streets near Monumental Episcopal Church.

But Richmonders were moving west, and Trinity's membership began to decline. The congregation had plans to dismantle Trinity and move it and its tall spire to the West End. But this did not happen.

Today, the old church is used by the New Light Baptist Church, but it still reminds people that a congregation of Methodists first worshipped there. And it should remind them of their ministers who rode horses across Virginia to preach the gospel.

In 1945, the Trinity Methodist congregation moved to Forest Avenue and Stuart Hall Road, a very long way from the old church in Church Hill. A frame building was built on the site to be used as a sanctuary. Then in 1967, Trinity had a groundbreaking ceremony for a new church building that was consecrated in 1968. The church had only seventeen members when it moved to the West End, but at the time of the consecration, it had almost two thousand members. It has continued to be one of the largest churches in Richmond's West End.

Today, Trinity United Methodist has many programs to meet the needs of the congregation. It offers both traditional and modern worship services, and its mission is "to make disciples of Jesus Christ for the transformation of the world." Trinity will always be special to me, as my family has bought Halloween pumpkins from them for many years. Each pumpkin was given the name of a major or a minor prophet. Selling pumpkins might be unusual for a church, but it is another way to support its mission and provide a community service at the same time. I suspect John Wesley would approve of this endeavor.

Broad Street Methodist Church

Come unto me, all ye that labour and are heavy laden, and I will give you rest.
—Matthew 11:28 (KJV).

Whereas Trinity Methodist was built on Church Hill, Broad Street Methodist was built on Broad at Tenth Street, which is about ten city blocks from Trinity. It has been suggested that Trinity was built for the members in the East End and Broad Street for those in the West End. Today, the West End is many miles west of where Broad Street Methodist Church was built.

The new church was designed by Albert L. West, who was a devout Christian and had read the Bible through many times. Completed in 1858, the church was described as a splendid and spacious structure. It was "a monument to the genius of the Reverend James A. Duncan, its founder and first pastor, and to the liberality of his devoted and lifelong friends." Finished just before the Civil War, the church attracted a large congregation. Both Jefferson Davis and Robert E. Lee attended services in the new church, although they were Episcopalians. A steeple was added following the Civil War.

Broad Street Methodist was also known for hosting temperance meetings. In the 1870s, the Sons of Temperance, Friends of Temperance, Templars of Honor and Temperance and Cadets of Temperance all met there along with other groups opposed to the use of ardent spirits.

In 1933, a memorable and, perhaps, regrettable service was held at the church. The problem began in Norfolk, Virginia, at the Ocean View

Methodist Church when Reverend Shipman accepted two glasses of eggnog in the home of a steward of the church at a Christmas celebration. Initially, he was expelled from the ministry for drinking eggnog but was then reinstated by an appeal board in Nashville after a lengthy hearing. In spite of winning the appeal, he left the Methodist ministry.

The case took an unexpected turn when Broad Street Methodist was holding a farewell service for their minister, the Reverend Dr. Fred R. Chenault, and Mr. Shipman was in attendance. Just as the closing hymn was to be sung, Shipman interrupted the service and described Reverend Chenault "as the victim of a most diabolical prejudice and jealousy on the part of the ecclesiastical politicians of the Methodist Virginia Conference." He further claimed "that there was an effort to make Broad Street Methodist a secondary church in Richmond Methodism." He claimed as evidence the refusal of the bishop to return the Reverend Dr. Chenault to Broad Street Methodist. Dr. Chenault finally stopped the speech by saying "I appreciate the words of praise, but I cannot share in your words of criticism concerning anyone." The official board also stated that Shipman's comments were made without the sanction of the church leadership. This was Dr. Chenault's last service at the Broad Street Church before he moved to another church, and to have a church service interrupted in such a way was most unusual. One can only wonder what the congregation thought about this outburst. I am confident it was unsettling.

But before Dr. Chenault left Richmond for Danville, he was honored by the African American pastors of Richmond. He was the first white minister to win the "Distinction of an Appreciation Service." The pastors termed him "a lover of humanity and an ardent disciple of the truth." At the service he was "hailed as a friend of man regardless of color, and one who exemplifies in his private life the doctrine that he preaches." This was the highest honor the African American pastors could bestow on a person. It spoke volumes for the character of this man of God.

His last comments to the congregation at Broad Street Methodist that he had served for so long were as follows: "We, therefore, pray that the things we have done, the ideals we have cherished, the life we have sought to live, the purpose we have gloriously pursued, but never realized—that all passions of our heart today, may endure magnificently tomorrow."

But like so many churches, Broad Street Methodist found itself as a church without a neighborhood or a congregation. The church was being surrounded by businesses instead of the houses of church members. Purchased by the City of Richmond as part of the plans for the new civic

center, the church moved in 1960, built a new church on River Road and became River Road Methodist Church. About half of the members moved, and the rest joined other churches.

The first services were held in December 1962. Today, the church seeks to "Connect with God; Connect with each other; and Connect with the world." It is a worthy successor of the old church on Broad Street that was a sacred space for so many people.

Then, the question surfaced about what to do with the now empty sanctuary. The city planned to tear it down, but there were a lot of protests. Many Richmonders wanted to preserve it. Various people called the church a "beacon light"; artists described it as a "beautiful building that should be preserved." One foreign visitor commented "that Americans go to Europe to see old buildings while they tear down their own old buildings." But the church was doomed; all of the furnishings had been removed, it was filled with trash and rats and was heavily damaged. The church was demolished in 1968 and with it a part of the history of the Methodist Church in Richmond.

Although Broad Street Methodist is gone, I can recall a sign that was displayed in front of the church: "Go to church on Sunday and feel better all week." Not a bad suggestion.

SHOCKOE HILL METHODIST CHURCH

Glory to God, and praise and love
Be ever, ever given,
By saints below and saints above,
The Church in earth and heaven.
—Charles Wesley

L and for another Methodist church was acquired in 1810, not long after the building of Trinity Church. The church was officially to be called the Shockoe Hill Methodist Episcopal Church, but it was generally referred to as the Methodist Meeting House on Shockoe Hill. Located at 410 I Street (now Marshall Street) between Fourth and Fifth Streets, it developed from Trinity Methodist, which had been built in Shockoe Bottom. One of the first services held in the church was a memorial service for those who died in the Richmond Theater fire in 1811. Some historians believe the fire drove people away from frivolity and into the church.

Like many early churches, Shockoe Hill Methodist looked more like a large house or store than a church. The only difference was that it had double-width doors. The auditorium seated about two hundred people and was in a good location surrounded by nice homes. The church was lit by oil lamps. The first minister was the Reverend Thomas Moore. Oddly enough, there was a six-month probation period required of prospective members.

As the church membership grew, the congregation wanted to build a larger church but lacked the funds. When the opportunity to become a

part of the new Centenary Methodist Church was proposed, the members accepted the opportunity.

The church record is as follows: "The trustees of the Methodist Episcopal Church on Shockoe Hill, have for some time entertained the wish to erect a new house of worship, but had had upon all former occasions found themselves unable to do so." When the centenary subscriptions were being made in October 1839, they seized that opportunity as a favorable one to make another effort to obtain their wish. This time they were successful.

With this resolution, the Shockoe Hill Methodist Episcopal Church passed into history. It was sold in 1841, when Centenary Methodist was completed, and torn down in 1913. But you can never tear down the memories and the history of this old church that served the faithful on Shockoe Hill.

Centenary Methodist Church

And am I only born to die?
And must I suddenly comply
With nature's stern decree?
What after death for me remains?
Celestial joys, or hellish pains,
To all eternity?
—Charles Wesley

In 1839, Virginia Methodists raised money for a new church to celebrate the centennial of the Methodist Church and to replace the Shockoe Hill Church. In honor of the centennial, the church was to be called the Centenary Church. One document states, "In Richmond the great bulk of the Centennial Collection was appropriated to the erection of a new house of Worship on Shockoe Hill to be styled 'The Centenary Church.'"

Centenary Methodist Church was constructed in the Toscana style and located at 411 East Grace Street, close to St. Peter Catholic Church and St. Paul's Episcopal Church. The foundation of the church was laid in the summer of 1841, but the construction was slow because many people did not give the money they had promised. Pews were sold to raise the needed additional funds.

The church was dedicated in June 1843 in a "devout spirit and was of an inspiring, though simple, character." The newspaper reported, "Last Sunday, Centenary Methodist Church on Shockoe Hill was dedicated to

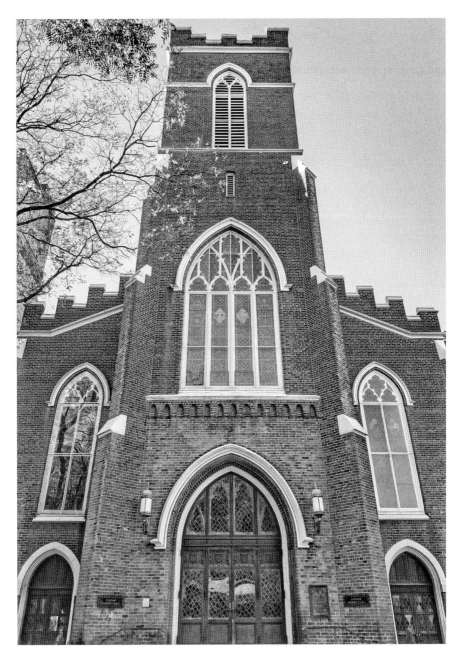

The entrance and bell tower of Centenary Methodist Church was named for the centennial of the Methodist Church, celebrated in 1839.

Religious Worship. This fine building, so imposing in its exterior, and so elegant and commodious in its internal arrangement, will be under the pastorate of the Reverend Dr. Waller." Centenary, as dedicated, did not look like it looks today. The following contemporary description of the church as built is interesting:

> *The church is situated on a very pretty lot in a most agreeable part of Shockoe Hill....The front of the church has a recessed portico graced by two large fluted Doric columns. The outside is plain brick, well-finished, and looks well. The interior of the church is of Grecian Doric order and has a very pleasant and handsome appearance....It has 144 pews and it will hold more people than Trinity Methodist....The walls, columns, pulpit, are white, the pews imitation oak and maple, capped with mahogany and seats with damask cushions....The pulpit is graced by two massive pilasters supporting a finely ornamented frieze which bears this motto, "Thou God Seeth Me." Genesis 16: 13. The aisles and altar are neatly carpeted and the Church is to be warmed...with a stove in the basement.*

At one of the first services, the minister said to the tobacco chewers, "You are frequently the spoilers of fair walls," and he admonished them to use the proper vessels that had been provided, and it was hoped that in no case would people fail to use them. The minister was emphatic, and properly so, for the "habit is a most disgusting one, of which our public halls too strongly portray the evidence."

In 1846, the name of the church was officially changed to Centenary Methodist Episcopal Church, South. In 1861, the Civil War engulfed Richmond, and it was not long before the dead and wounded from battles across Virginia were brought to the city. The Sunday school room at Centenary was turned into an emergency hospital, and the ladies of Centenary established two private hospitals for the care of the sick and wounded soldiers. Although its members cared for those injured in combat, they also lost loved ones in the conflict. Those that returned were frequently wounded, and their presence was a reminder of the "Lost Cause." The superintendent of the Sunday school was killed at the Battle of Malvern Hill, and other men in gray would also pay the ultimate price. One Union general boasted that he had caused so much destruction that a crow could not travel over the land without carrying its own rations. Although their cause was lost, the Confederate soldiers would pray the following prayer:

Thou who are ever nigh,
Guarding with watchful eye,
To Thee aloud we cry,
God save the State!

Following the war, the Centenary Methodist Sunday school sponsored a "Grand Pic-Nic Excursion" on the steamer *John Sylvester* to Norfolk and back. People could visit Portsmouth, Old Point Comfort and other places of interest.

The interior of Centenary was remodeled in 1874, and the congregation met with Broad Street Methodist Church during the renovation. Two years later, the exterior of Centenary was changed when it was remodeled from its plain Doric form to one of Tuscan or Ecclesiastical Gothic. The portico and its columns were replaced by a tower, extending the building at the front and providing space for steps and an enclosed entrance vestibule. Changes were also made to the interior of the church to make it more attractive.

In 1882, twelve chime bells were hung in the church tower. The heaviest bell weighed four thousand pounds and was pulled into place by members of the church who sang "Onward, Christian Soldiers" as they pulled the rope to lift the bell into the spot, where it remains to this day. On April 25, 1882, the *Richmond Times-Dispatch* reported, "On Sunday morning, our people were permitted for the first time in the history of Richmond to listen to the chiming of the church bells as they pealed 'Asleep in Jesus'" from the tower of Centenary Church. A few years later, stained-glass windows were added to the sanctuary. Another change was the replacement of the common cup at communion to individual cups. In the same year, hand-carved pews were installed, and the ladies of the church purchased a marble baptismal font from Tiffany and Sons in New York City.

Over the years, most downtown churches have followed their members to the suburbs. The members of Centenary considered this in 1911 but decided to remain in the city, remembering that the good a church can do is not measured by size alone. In 1911, it was written, "A downtown church, if it is to be kept going, must succeed because its people, wherever they go, will remain true to it." They must be willing to drive to the church from various locations around the city. Other discussions about moving the church have occurred, but Centenary still remains a vital force to serve the city of Richmond, and the people remain true to it. It has been said that Centenary affords a refreshing spiritual oasis in the busy downtown of a bustling city.

A church has to deal with many issues, and some of them seem almost unreal. For example, oil lamps were replaced with gas lamps, but the congregation resisted the use of electric lights since electricity was made on Sunday. Eventually, electric lights were installed. On a more positive note, the Reverend John W. Smith "spoke about the power of God descending on Jesus's disciples as they prayed in an Upper Room." Some Methodists were looking for a name for their devotional book, and they were inspired to call it *The Upper Room* after hearing Smith's sermon.

During World War II, the ladies of Centenary set up a service center in the Sunday school. Many service men and women attended services at Centenary. The U.S. flag was placed in the sanctuary, and the ladies of the church worked with the Red Cross to aid those soldiers who came to Richmond. At the close of the war, Ernest H. Dervishian, a Centenary member, was honored for having won the Medal of Honor, the nation's highest military award.

Over the years, Centenary has had many outstanding preachers, including the Reverend Dr. A. Purnell Bailey. One day, Dr. Bailey overheard a man praying for him. The man was asking that God give Dr. Bailey "the power to preach the Word effectively, especially to young people." Dr. Bailey never forgot hearing the man praying for him, and the ministers at Centenary still seek to preach God's Word.

This church lets people know that it has

Open Hearts
Open Minds
Open Doors

Attending a service at Centenary harkens back to a time when Grace Street was filled with houses and church bells called people to worship God in his Holy Temple.

Centenary proclaims that as one enters the nave of the church today, one is aware of the "cloud of witnesses" of faithful Methodists and of Christians who were baptized, married, ordained and memorialized within the walls of this historic building. Indeed, the walls of Centenary hold time, preserve memories and create a sacred space for all to enter.

Union Station Methodist Church

Glory to God belongs;
Glory to God be given,
Above the noblest songs.
Of all in earth or Heaven!
Him Three in One and One in Three,
Extol of all eternity.
—Charles Wesley

The movement to create a new Methodist church began around 1835. The church developed from a Sunday school and a series of prayer meetings led by two future Methodist ministers: James D. Coulling and Robert Michaels. As the group expanded, they obtained a carriage house and organized Methodism in the sparsely populated area of Union Hill.

Geographically, Union Hill was the area between Mosby, Carrington and North Twenty-Fifth Streets and Jefferson Avenue. For much of its history, Union Hill was separated from Church Hill by a deep ravine. In fact, a mile drive was necessary to go from the future site of Leigh Street Baptist to the new Methodist church even though they were three blocks apart. Today, the area has become a part of Church Hill by filling in the ravines.

Women attending the church were reported to have dressed like Pilgrims, and they sang hymns such as "Oh, for a Heart to Praise My God." On one Sunday, someone visited the church out of curiosity. When the curious visitor went to take communion, his seat was removed. He had no choice but to leave the church after taking communion. The new church was recognized

at a session of the Virginia Annual Conference held at Centenary Church in Richmond in 1843.

Their first church was known as Wesley Chapel and built on a hill called Mount Pisgah, probably on Main Street. The congregation met there only briefly before the hill was removed.

The church continued to grow, and on June 16, 1844, the congregation dedicated a simple frame church on Twenty-Fifth Street between Nelson and Otis Streets known as N and O Streets. The new church was named Asbury Methodist Church in honor of Bishop Asbury, the founder of the Methodist Church in America. The Methodist Church was now growing in Richmond's Union Hill neighborhood.

In 1850, the choir was organized, but some of the Methodists were opposed to it. One person, who opposed the music program, said of church choirs, "terrible nightmares of godless singers cutting up pranks in a corner and squealing out operatic airs, kindling the anger of God and provoking most justly His wrath and indignation against them haunted their steps as they wended their way to the church on that eventful evening." On one best forgotten occasion, the congregation shouted "Amen" when the choir started to sing. Objections were also made about an organ. One member said, "No organ should ever come into the church, and he stoutly declared that if he found one in the church, he would throw it out." Eventually, the church had both a choir and an organ.

Once again, the congregation outgrew the small frame church, and in 1854, the members moved into a new brick church on Twenty-Fourth Street at the corner of Nelson Street. When the congregation moved to the Twenty-Fourth Street location, the name was changed from Asbury to Union Station. Even though "station" means church, they added the word "church" to Union Station. Union was for Union Hill, where the church started. The first service in the new brick Gothic church was held in June 1894.

Now enshrined at Reveille Methodist Church, this bell chimed from Union Station Methodist for many years.

While at this location, Richmond experienced an earthquake, and everyone ran out to their porches. The Methodist minister's loud voice could be heard proclaiming from his porch, "God is our refuge and strength, a very present help in trouble."

It was about this time that the church found an interesting way to raise money. A cedar chest was placed on the altar, and the "people dropped bags and packages into it containing money until the chest was filled to the top. An elderly woman who had very little gave $40.00." This gift reminded some people of the story Jesus told of a poor widow giving two mites. And Jesus said, "Of a truth I say unto you, that this poor widow hath cast in more than all."

The Methodists found an interesting way to stop smoking at church meetings. During these meetings, some of the men smoked cigars, while others thought it was irreverent to smoke during a church meeting. Suddenly, a woman pulled out a cheroot (men did not smoke cigarettes in those days). While the woman puffed away like a steam locomotive going up a steep hill, the men started smelling tobacco smoke. Then the pastor showed up and said, "Brethren, this is the house of God, no smoking in here." The end of smoking in church meetings had occurred.

During the Civil War, hundreds of soldiers were converted to Christianity while attending Union Station. Frequently, they would leave the church and die on some nearby battlefield. Their bodies might well have been returned to this same church for their funerals.

Following the war, the congregation continued to grow, and a new church was necessary. The brick church that had served the congregation for over thirty years was torn down to be replaced on the same site by a new church. However, the destruction of the building did not destroy the many memories associated with the old sanctuary. While the new church was being built, the church constructed a tabernacle on some property that had been lent to them. The building was fifty feet long and fifty feet wide. Over the door was a sign that read "Union Station Tabernacle M.E. Church South."

The cornerstone of the new Union Station Church was laid in 1893, and construction began on the church. Located at Twenty-Fourth and Nelson Streets, it was a brick Gothic church with brownstone and terra-cotta trimming and art glass windows. A major debate occurred when the board of stewards decided to do "away with cuspidors for those saints of the Lord who were devotees of the weed." One devotee asked, "Who can stay in church from 11 to 1 o'clock without taking a chew?" I personally do

not want to think about sitting in church while a saint of the Lord is spitting tobacco during the sermon.

During the great flu epidemic of 1918, the Reverend Fred G. Davis conducted funerals all day and worked at the emergency hospital half the night until he, too, caught the flu. He was truly a man devoted to his calling.

In 1943, during World War II, the church celebrated its one hundredth anniversary. Surely, no one knew that Union Station would cease to exist in less than ten years. During the war years, Claude M. Hesser, the pastor, would say to the congregation: "Lord, we are able, Our spirits are Thine. Remold them, make us, like Thee, divine."

Union Station was building a new church in the West End when a devastating fire at Monument Methodist Church changed their plans. On December 23, 1951, the following advertisement appeared in the *Richmond Times-Dispatch*: "For Sale: Property at the corner of Twenty-Fourth and N Streets, formerly Union Station Methodist Church." No one knew it at the time, but Union Station would soon live under a new name.

Monument Methodist Church

Young men and maidens, raise
Your tuneful voices high;
Old men and children, praise
The Lord of earth and sky;
Him Three in One and One in Three,
Extol of all eternity.
—Charles Wesley

Monument Methodist Church has had an interesting history, with several names and many locations. Following the Civil War, it started out as a small Sunday school in a house on Taylor Street. Because of rapid growth in the 1880s, the congregation moved to a frame building at the corner of Washington and Cary Streets, and it was named Washington Street Methodist Episcopal Church. The church next moved to Lombardy Street between Grove and Hanover Avenues and was named Asbury Methodist Church, and then the name was changed again to Asbury Place Methodist Church.

In 1812, the congregation moved again and held their first service in a new brick building at Park and Allen Avenues. However, the membership wanted a different name to avoid confusion with other churches with similar names, but they could not agree on a new name. Finally, the name "Monument" was agreed upon. The reason for the name was that the church faces Lee's monument on Monument Avenue, and the new church was seen as a monument to Methodism.

The first service was held in what was considered to be one of the best locations for a church in the entire city, and it could seat up to 1,200 people. The church was said to be one of the largest and best appointed in the city. The fact that the church was close to the Lee Monument might have influenced the Reverend Dr. George E. Booker to preach a sermon on "The Life and Character of Lee."

Thanksgiving Day was celebrated in 1950 with four congregations meeting at Monument Church. America was fighting the Korean War, and Richmonders were hoping for a quick end to the conflict. The newspaper headline stated that General Douglas MacArthur was personally leading a major offensive in Korea. With America involved in another war, this sermon topic seemed appropriate: "Thankful for What?" Christians and Jews prayed together for an end of the war and for a bountiful harvest.

A few days later, the church that hosted the Thanksgiving service was destroyed by fire. It was sixteen degrees when a fire broke out at the thirty-eight-year-old church. The fire went to five alarms, and more than 150 firemen, using two-thirds of the firefighting equipment in the city, could not save the building. Less than fifteen minutes after the fire department responded, the church's roof collapsed. Richmond's legendary water tower was called into service, but the fire continued to consume the building. This was the last time the water tower was used to fight a fire in Richmond. It was almost four hours before the fire was brought under control. The next Sunday, the congregation met in Binford Junior High School. The members of the church never had the opportunity to have a final service in their sanctuary. It lived only in their memories.

This loss of the church created the opportunity to merge Monument Church with Union Station Church, which had just started the construction of a new church. It seemed that it would be logical to merge the two churches and create a new Methodist community in the West End of Richmond.

Given these circumstances, the two churches merged to form Reveille Methodist Church. In November 1953, the cornerstone for Reveille Church was put into place, and one of the largest Methodist churches in Richmond was under construction. From the relocation of one church and the ashes of another, a new church was born.

REVEILLE METHODIST CHURCH

Save us from weak resignation,
To the evils we deplore.
Let the gift of thy salvation,
Be our glory ever more.
—Harry Emerson Fosdick

Reveille Methodist was created, and property, called the Reveille Estate, was purchased at 4200 Cary Street. Included in the purchase was Reveille House, which was more than two hundred years old and today is used as office space for the church. While the church was being constructed, the combined congregations of Union Station and Monument met at Thomas Jefferson High School.

Reveille was dedicated in 1954 with a seating capacity of over 1,500. It was furnished in Williamsburg décor and had a Colonial-style elevated pulpit and divided chancel. The exterior was Colonial Revival. Upon walking into the church, your eyes focused on these words behind the altar: "Glory to God in the highest and on earth peace and goodwill toward men." By reading these words, you could not forget that you were in God's house. But God's house was almost destroyed.

In December 1963, a gas explosion wrecked the sanctuary of Reveille. Fortunately, no one was injured from the blast, which seems to have originated in the furnace room. Residents as far as three blocks away felt the blast. The explosion destroyed the furnace room and "shattered the

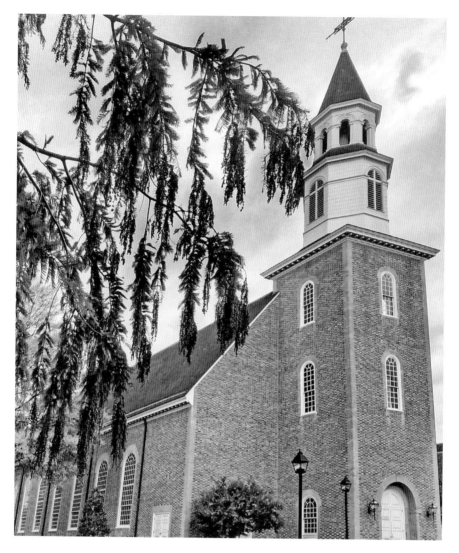

With its Colonial-style décor and brick face, Reveille Methodist Church is reminiscent of Bruton Parish Church in Williamsburg, Virginia.

heating and cooling plant and most of the front of the sanctuary." Also heavily damaged were the pulpit and all of the windows on the north side of the building, as well as the circular stained-glass window above the altar, which was blown several yards from the building.

Although many churches offered to help Reveille, the members elected to meet at Thomas Jefferson High School. The congregation was able to

return to the church in September 1964. People still talk about the fact that if the explosion had occurred when a service was taking place, the loss of life would have been massive. As it was, the church was empty. This could be called a miracle.

Since it opened for worship, "Reveille has been known in Richmond and in the Virginia Conference for its ministries, strong preaching, and stirring music." The congregation has engaged in missions both at home and abroad. It maintains an excellent children's preschool program, from which my daughter, Cara, greatly benefited, as well as programs to meet the spiritual needs of all age groups.

To connect with the past, there is a part of the old Union Station Church at Reveille. The bell from the old church has been preserved and is a reminder of how people were called to worship. No one will ever know how many people responded to the ringing of this bell.

When I walk through the beautiful gardens at Reveille, where my father was a volunteer gardener, I cannot help but recall the words of the hymn "I come to the garden alone, while the dew is still on the roses." But then, I sense that I am not alone, because I can feel that God is there.

African Methodist Episcopal Church

According to the *Times Weekly*, "the African Methodist Episcopal Church is unique in that it is the first major religious denomination in the Western World that had its origin over sociological and theological beliefs and differences." African Americans withdrew from St. George Methodist Church in Philadelphia in 1787 because of unkind treatment, such as being forced to sit in a special section. Those who withdrew from the church rejected the belief that African Americans were second-class citizens, and they opposed slavery and the dehumanization of African Americans. Led by Richard Allen, the group wanted to remain Methodist, so they formed the Bethel African American Methodist Episcopal Church in 1793 and resolved to keep the basic doctrines and forms of government of the Methodist Church. The church adopted as its motto "God Our Father, Christ Our Redeemer, the Holy Spirit Our Comforter, Humankind Our Family." During the Civil War, the Union army allowed AME pastors to go into collapsing southern states to work with former slaves. These ministers used "I Seek My Brethren" as their clarion call. Following the Civil War and the end of slavery, the denomination remained in the South and established more churches.

Third Street Bethel AME Church

Precious Lord, take my hand,
Lead me on, let me stand,
I am tired, I am weak, I am worn.
Thru the storm, thru the night,
Lead me on to the light
Take my hand, precious Lord, lead me home.
—Thomas A. Dorsey

The denomination's presence in Richmond is Third Street Bethel African Methodist Episcopal Church, but the church had its origins at Trinity Methodist Episcopal Church. As slavery became more of a volatile issue, whites and blacks had difficulty worshipping together, and the black members had to sit in the balcony. To address the segregation issue, free blacks organized themselves as a congregation within Trinity Church in 1850. The effect was that the two races met separately in the same church building.

Soon, some of the white members of the congregation arranged for the black members to be given land on Third and Jackson Streets to construct their own church. Named Third Street Church, it still stands on the land that was given to them.

The present church was the work of black artisans; in 1856, a major portion of the church was completed. Although it has been remodeled and enlarged many times, it is best described as a large Victorian Gothic church

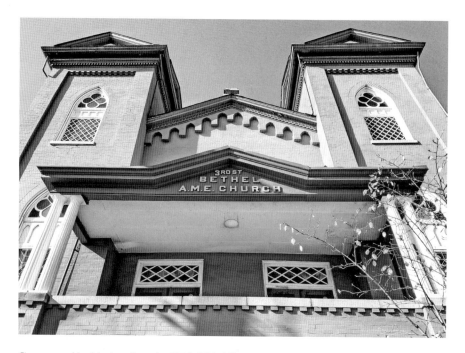

Constructed by black artisans in 1856, Third Street Bethel AME Church has been a force for good in the Richmond community for over 150 years.

with towers on either side of a central gable. The two towers make the church stand out and are quite visible in the community. The architecture of the beautiful building links the past with the present, and its mission reaches far beyond the walls of the building. In compliance with the law, they had a white minister who stayed at the church until 1867, when he was replaced by an African American minister.

In 1867, the Virginia Conference of the African Methodist Episcopal Church was organized in this church. Third Street Church was renamed Third Street Bethel African Methodist Episcopal Church. It was also called the "mother church of the Virginia Annual Conference." As a church, it has been committed to numerous causes, but the most tragic one was the case of the Martinsville Seven.

Seven African American men were sentenced to death in 1951 for the rape of a white woman in Martinsville, Virginia. White men were rarely executed for this crime in Virginia, but this was not the case for African Americans. The seven were arrested, and all but one man were between the ages of twenty and twenty-three. The attorneys tried every

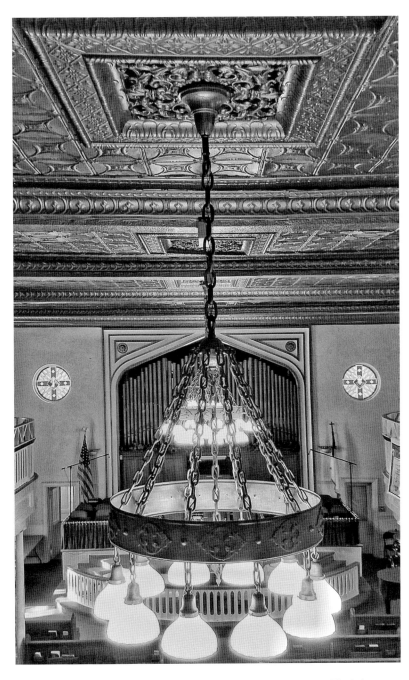

Gracing the sanctuary of the first Richmond black church to attain Virginia Landmark status is a lovely pressed tin ceiling, which replaced the original copper one during an early remodeling.

legal maneuver to save the men, including appeals to the U.S. Supreme Court and a request for Governor John Battle to grant clemency. Nothing worked. They were all sentenced to die in Virginia's electric chair.

When I was in law school, I had the opportunity to sit in the electric chair. It was an emotional experience that I will never forget. Being strapped into this chair of death is still fresh in my mind after all these years. I was also told how painful death by electrocution can be.

The Martinsville Seven died in that same chair. One man said before his death, "I want to meet all of you in heaven." It was the largest execution for a single victim in United States history. There were many protests throughout the nation against this mass execution. The protest in Richmond was led by Third Street Bethel AME Church. Following a memorial service at the church on the day of execution, 218 people walked from the Memorial Meeting—wearing black arm bands—to the Virginia State Capitol, where they placed a wreath and held a prayer vigil. They carried with them a sign that read "Join Us in Prayer for the Martinsville Seven." They did not leave until the last hearse left the state penitentiary in Richmond. Today, rape is no longer a capital crime. And it must be remembered that it took courage to protest an execution when Richmond had rigid segregation laws and African Americans were treated unfairly by the judicial system. This is only one of many community issues on which the church has focused. While some churches remained silent, Third Street Bethel AME spoke out.

The church spoke again in June 2015 when a national tragedy occurred. Nine African Americans were murdered while attending a Bible study at Emanuel AME Church in Charleston, South Carolina. These men and women were martyrs for their faith. Shortly afterward, a group gathered at Third Street Bethel to sing the words to "We Shall Overcome." And the Reverend Reuben J. Boyd Jr., the pastor of the church, said, "Those nine brothers and sisters died by following the greatest commandment of all: 'To love.'"

The peace dove window at Third Street Bethel AME reflects the great commands to "love thy neighbor" and "speak peace."

At the same service, the Reverend Kathryn Lester-Bacon of Second Presbyterian Church offered a prayer for unity. The Reverend Melanie Mullen offered these thoughts, "You've just got to keep coming back and opening the door and shaking the hand, and sitting there at night and praying even where prayers don't seem like enough."

The group that met were from all races and religions, but they were united in their love for those who died while reading their Bibles. The one lesson that was learned was that the church, which has always been a place of peace, can be quickly turned into a place of tragedy, but a tragedy shall be overcome with the help of Almighty God.

Third Street Bethel AME Church has remained a force for good across the years. The vision of the church is as follows: "Our vision is to become the church that reaches beyond its walls with love and service that draws others to Jesus." This church is practicing the Great Commission of Jesus in the greater Richmond area, and we are fortunate that the minister and the members take the time to care about others.

THE JEWISH CONGREGATIONS

I give thanks unto You, O King, Who lives forever. For in mercy You have given
me back my soul. For God's kindness, we give thanks.
—prayer of Jewish children contributed by Melanie Becker

Like most children of my generation, I grew up listening to Bible stories. Every night, my mother read a different one to me. I learned about Adam and Eve, Noah, Moses, Abraham, Cain and Abel and many more. In Sunday school, I memorized the Twenty-Third Psalm, the Ten Commandments and many other passages from the Hebrew Bible.

I did not know that they were Jewish stories; I only knew that they were fascinating, especially Noah and all those animals. Years later, I learned about Judaism and its connection with Christianity and Islam—all people of the Book. And I read these lines in the Torah: The Lord said to Abram, "Go forth from your native land from your father's house go to the land that I will show you."

Through the centuries, the Jews have persevered, in spite of many trials and tribulations, as they traveled to many different lands, crossed the Red Sea and, in many cases, "walked through the Valley of the Shadow of Death" at places called Babylonia, Dachau and Auschwitz.

Eventually, the Jews crossed the Atlantic and settled in America. There were Jews who disappeared with the Lost Colony in North Carolina, as well as those who survived the challenges of starvation and death at Jamestown, Virginia.

IN LOVING MEMORY OF MY DEAR PARENTS
ELLIS AND BARBETTE MITTELDORFER
BY THEIR DAUGHTER

Gracing the temple of the Congregation of Beth Ahabah and signed by Louis Comfort Tiffany, the Mount Sinai window depicts the moment Moses was entrusted with the Ten Commandments.

The first Jew to permanently settle in Richmond was probably Isaiah Isaacs. A silversmith, he was living in Richmond by 1769. Other Jews followed, and they were soon well established in the growing city and accepted by the other Richmonders.

Jews were the owners of the Bird in the Hand, a noted tavern at the foot of Church Hill, as well as other businesses. By 1790, there were twenty-eight Jewish males in Richmond. As more and more Jews came to Richmond, they felt the need to organize a synagogue for worship because the synagogue was the center of Jewish life. They would hold prayer services when they could find a house or shelter like their ancestors did in the wilderness when they were led by Moses. But they needed a permanent sacred space to gather and observe their ancient faith.

CONGREGATION BETH SHALOME

HOUSE OF PEACE

Hear, O Israel! The Lord is our God, The Lord is One!
—Deuteronomy 6:4 (The Jewish Publication Society)

To meet the spiritual needs of the Jewish community, Beth Shalome (The Holy Congregation; House of Peace), an orthodox synagogue, was established. It was the first Jewish congregation in Virginia. Since records have been lost, it is impossible to determine the exact date the synagogue was organized, but it was probably no later than 1789. The congregation affirmed their goals with these words: "We, the subscribers of the Israelite religion in this place, desirous of promoting the divine worship, which, by the blessing of God, has been transmitted by our ancestors, have this day agreed to form ourselves into a society for the better effecting of the said laudable purpose to be known and distinguished in Israel by the name of Beth Shalome."

The congregation followed the Sephardic ritual as opposed to the Ashkenazic ritual. These terms did not refer to reform or orthodox. The differences were related to the pronunciations of Hebrew, prayers and other rituals. Generally, Jews from France, Germany and Eastern Europe followed the Ashkenazic ritual, and Jews from Spain, Portugal, North Africa and the Middle East followed the Sephardic ritual. Richmond synagogues would eventually follow one or the other of these rituals.

In 1790, a number of Jewish congregations sent a letter to President George Washington congratulating him on his "elevation to the chair of the

Federal government." Beth Shalome was one of the congregations that paid homage to the first president.

At first, Congregation Beth Shalome worshipped in a room in a three-story brick building on the west side of Nineteenth Street between Grace and Franklin Streets, which was the home of one of its members. As membership grew, they moved to a new location on the southwest corner of Main and Nineteenth Streets at the rear of what would be the Union Hotel. Unfortunately, the foundation of the synagogue collapsed because proper construction techniques were not used in building the hotel. The synagogue project was abandoned. Eventually, the hotel was torn down by a Jewish company, which some felt was a form of justice. The congregation was without a synagogue for a number of years. During this time, one of the prayers offered by the congregation for the nation was as follows:

> *O God of Hosts, thou has set peace and tranquility in our palaces*
> *And has set the President of the United States as our head…*
> *May God Almighty hearken to our vice and save us.*
> *May we guard and keep the Vice President, Senators, and Representative*
> *of the United States.*
> *May He give good sense and understanding to the officers of the courts.*
> *May He prosper and bless our country,*
> *And deliver us from the hands of outside enemies.*

After worshipping in various houses, the synagogue finally acquired a lot on the east side of Mayo Street just north of Franklin Street. When it was finally built, it was the first synagogue building in Virginia. A reporter wrote of the consecration in 1822 as follows: "Yesterday, the dedication of the new Jewish synagogue took place. The building is new and, though small, is elegantly furnished….The ceremony was witnessed by a large assemblage of Christians."

The synagogue was now a part of the Richmond community. In 1854, Beth Shalome gave sixty dollars to the Jackson Ward Relief Society for the suffering poor. The rabbi of Beth Shalome, Henry S. Jacobs, wrote:

> *Whatever differences of creed may exist between us, I am confident these*
> *noble impulses of humanity, implanted by one common Father, will ever*
> *prevail, as best illustrative of our duties to Him to whom all eyes are*
> *directed, since it has been His all wise ordinance that the poor should never*

cease out of the land coupled with His Divine injunction to open our hand to the needy and the afflicted.

In 1866, the synagogue was remodeled. The newspaper reported on some Jewish customs—which still exist today—when the synagogue was reopened:

The Sephardim, or scrolls upon which are written the Holly Scriptures, were brought in covered with rich silk of crimson and gold, and carried in procession around the synagogue. They were then taken to the enclosed reading stand in the center and an eloquent prayer was read. The lamp in front of the Ark, which is kept burning both night and day throughout the year, was then lit and another prayer was offered. The scrolls were then placed in the Ark.

The Hebrew Cemetery is the site of the only Jewish military burial ground outside of Israel.

Hebrew inscription on a child's tomb at the Hebrew Cemetery on Shockoe Hill.

As was the custom, "The lady members were seated in the gallery, while the gentlemen remained in the lower hall, and during the entire service no heads were uncovered."

For sixty-nine years, the congregation would stay in the building. During the Civil War, the members invested heavily in Confederate bonds, which were not a sound investment. The synagogue also had members who served in the Confederate army, and the congregation went through the pain of Reconstruction.

The congregation remained on Mayo Street until 1891, when the synagogue was sold to the Sir Moses Montefiore Congregation, a newly formed Russian synagogue. Members of Beth Shalome then worshipped at Lee Camp Hall before joining Beth Ahabah. Beth Shalome, the sixth-oldest synagogue in the United States, went out of existence in 1898. It was reported that the members at the last meeting had "silent lips and saddened faces that testified that those present realized that they had witnessed the death of a synagogue as old as these United States." But they were warmly welcomed at Beth Ahabah.

In addition to the synagogue, Beth Shalome had established a cemetery on Franklin Street between Twentieth and Twenty-First Streets in 1791. Although no longer used, it still can be seen on Franklin Street. This cemetery was replaced in 1816 by the Hebrew Cemetery on Shockoe Hill, which is still being used today.

CONGREGATION BETH AHABAH

HOUSE OF LOVE

Oh my friends, heirs to the richest heritage of all ages, firstborn among the spiritual children of God's grace and mercy, do not, like Esau, merely eat and drink and go your way and despise your birthright, but with all your soul and heart and might seek to maintain it, seek to establish it, seek to hand it down to your children.
—*Rabbi Edward Calisch, 1929, Temple Beth Ahabah*

Many German Jews moved to Richmond in the 1830s and 1840s, joined Beth Shalome and were kindly received, but they wanted their own synagogue. In 1839, the Germans established Beth Ahabah, or the "House of Love," to replicate the form of worship that they had experienced in Germany. Unlike Beth Shalome, the new congregation followed the Ashkenazic ritual.

The congregation initially met in a rented house called the Seminarian on Marshall Street between Fifth and Sixth Streets in an upscale residential area. The first rabbi was the Reverend Jacob Gotthold, who led the consecration service for the new synagogue on May 15, 1841.

As the congregation grew, they purchased a site on Eleventh Street between Clay and Marshall Streets and built a new synagogue that was consecrated in 1848. During the Civil War, Rabbi Maximilian Michelbacher requested that General Robert E. Lee grant a furlough from September 2 to 15 to the Jewish soldiers so they could participate in the approaching services at the synagogue. General Lee responded that he could not grant the request

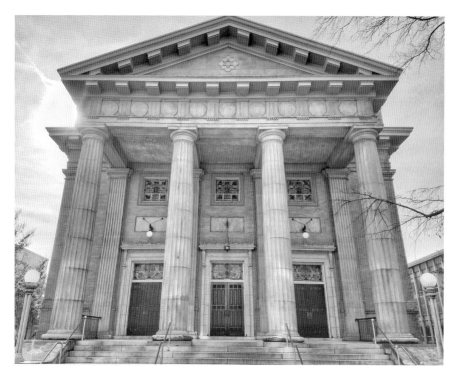

Congregation Beth Ahabah, established in 1789, currently worships in this classical temple dedicated in 1904.

because the "necessities of war admit to no relaxation of the efforts requisite for its success nor can it be known on what day the presence of every man may be required." General Lee concluded by wishing, "That your prayers for the success and welfare of our cause may be answered by the Great Ruler of the universe."

Following the Civil War, a dispute arose over the disposition of seats, and about thirty members left Temple Beth Ahabah to form Congregation Beth Israel. After five years, the members returned to Beth Ahabah.

In 1875, Beth Ahabah joined the Reform Movement of the Union of American Hebrew Congregations. This resulted in family pews where men and women sat together, and women could join the choir. The decision had a profound affect on the future of the synagogue.

Beth Ahabah constructed a new synagogue on the same site in 1880 because the existing synagogue was too small for the growing congregation. During the period that the new synagogue was under construction, the congregation worshipped at Monticello Hall. The new

synagogue was dedicated on Friday evening, September 30, 1880, by Rabbi Abraham Harris.

In 1891, Rabbi Harris closed his sermon with the following poem:

He liveth long who liveth well;
All else is life but flung way.
He liveth longest who can tell
Of true things truly done each day.
Then fill the hours with what will last;
Buy up the moments as they go;
The life above when this is past
Is the ripe fruit of life below.

He then sat down, slumped over his prayer book, fell to the floor and died in the synagogue.

Richmond has had many well-known clergy, including Theodore Adams, Moses Hoge, John Spong, John Jasper and Edward Calisch, who came to Beth Ahabah in 1891. He stayed for fifty years. In his initial comments to the congregation, he said, "I shall endeavor to expound a religion that shall not flinch before the light of science nor cower beneath the flash of research, yet shall be loyal to the core to the grand old mother, Judaism." During his tenure, according to one historian, he preached 10,000 sermons, consisting of more than 36 million words or 5,000 solid hours of talking, or the equivalent of 625 days. Dr. Calisch offered the following thoughts on Mother's Day:

The love of a wife or mother is never sounded by the plummet of reason. There is simply the fathomless depth of pure affection. Be the object of it ever so unworthy in the eyes of the world, ever so powerless to command the respect even of others that affection never flinches or wavers. When the entire world has spurned a man, he will be found in the arms of the woman who loves him.

Beth Ahabah expanded in 1898 when it merged with Beth Shalome. Once again, Beth Ahabah needed a larger synagogue. As the leader of the reform movement in Judaism, the existing synagogue could not accommodate the entire congregation.

The new synagogue was dedicated in 1904 at the corner of Ryland and Franklin Streets. It was described "as the handsomest and most commodious

This lovely window was created for memorializing the Reverend Dr. Abraham Harris, who died among his congregants after finishing his sermon.

synagogue this city has ever had and will compare with any in the South, if not in the entire country. The synagogue is of neoclassical design and, according to some authorities, was patterned after Thomas Jefferson's home, Monticello, and the Rotunda at the University of Virginia." The eternal light burns on the front of the synagogue letting all know that this is the House of God.

During World War II, the synagogue opened its basement as a nonsectarian gathering place for soldiers. There were dances on Saturday nights and informal receptions on Sunday afternoons. The ladies of the synagogue were available to do sewing for the soldiers. Many other synagogues and churches provided the same sort of support, as did the YMCA and the USO.

Following the war, the synagogue continued to grow and serve the community. Beth Ahabah is a good neighbor. When nearby St. James's Episcopal Church was severely damaged in a fire, the synagogue offered its sacred space to the displaced Episcopalians. And in the spirit of love, the church and the synagogue share the same parking lot. (It must take a lot of love to share a parking lot.)

I first visited Beth Ahabah as part of a church youth group, and I was amazed at the beauty of the synagogue. I knew I was in a very sacred place that could trace its origins back to the dawn of history. Even today, when I walk by the synagogue, I cannot help but feel the presence of those generations of Jews who came from Germany and other places to worship their God in this new land in a synagogue that truly is a "House of Love."

43

Congregation Keneseth Israel (Congregation of Israel)

And God saw all that He had made, and found it was very good. And there was evening and there was morning, the sixth day.
—Genesis 1:31 (The Torah)

Whereas the Germans formed Temple Beth Ahabah, the Polish Jewish immigrants established the orthodox synagogue, Keneseth Israel (Congregation of Israel), in 1856. They first met in the Mansion House on Main Street between Fifteenth and Sixteenth Streets. As it proved to be an inconvenient location, the congregation rented and dedicated a house on Main Street between Nineteenth and Twentieth Streets as a place of worship. This building was destroyed by fire in 1869. The newspaper reported that "the roof was almost entirely destroyed and the church furniture much damaged." The loss was reported as three hundred dollars, and there was no insurance. Beth Ahabah invited the congregation to worship with them, but they declined.

Lacking a place to worship, they constructed a synagogue on Mayo Street a short distance from Beth Shalom. In late 1869, the *Richmond Dispatch* described the new synagogue as follows:

The new Synagogue of the Congregation Keneseth Israel, on Mayo Street was, on yesterday afternoon, solemnly set apart for the worship of Almighty God. Although not entirely finished, the building was far enough advanced to seat about three hundred. Besides the members of the

congregation, there were present not a few Gentiles, who manifested much interest in the exercises.

Keneseth Israel returned to Church Hill and, in 1908, dedicated a new synagogue known as the "Nineteenth Street Schul [synagogue or temple]" located on Nineteenth Street between Broad and Grace Streets. For almost a century, Keneseth Israel was the center of worship for Orthodox Jews. In 1952, Keneseth Israel merged with Beth Israel, the successor to Sir Moses Montefiore Synagogue, to form Keneseth Beth Israel. In the future, more mergers would take place. The synagogue is now located on Patterson Avenue.

44

Congregation Beth Israel
(Congregation of the House of Israel)

Assemble and hearken, O sons of Jacob;
Hearken to Israel your father.
—Genesis 49.2 (The Torah)

Most religious people have disagreements. In the case of Beth Ahabah, it concerned the distribution of seats. Because of the disagreement, a number of people withdrew from Beth Ahabah in 1866 and formed a new synagogue. Named Beth Israel, the new congregation rented a house on Seventh Street between Marshall and Clay Streets and prepared it for worship services.

Quickly outgrowing its first location, the synagogue relocated to an unusual place. The congregants moved to Washington Hall, which was located over the fire engine house (some sources state that the location was over the Richmond Water Works) on Broad Street between Ninth and Tenth Streets. This ordinary space was soon transformed into a very sacred place.

The dedication of the synagogue in June 1867 received a great deal of press coverage. The newspaper pointed out that there was a wreath with the words "House of Israel" done in various colors on the wall. And the first words of the Ten Commandments were displayed on a "desk-like structure."

The ceremony began when "A damsel bearing a key mounted the pulpit. She was dressed in white, and her head was encircled with a wreath of roses. She spoke in a very collected and sweet manner" as she delivered the key to the president of the synagogue, who put it in the tabernacle.

After receiving the key, the rabbi read Psalm 24:7–8 in Hebrew: "Raise your head, O ye gates! And be raised high ye everlasting doors, and let the King of Glory enter. Who is the king of Glory? God, strong and powerful, God mighty in battle." The rabbi placed the sacred scrolls in the tabernacle and then spoke to the congregation in German.

After this very impressive dedication, which was attended by many Christians and city officials, the synagogue continued to grow, but a major problem developed. The Richmond City Council ordered the congregation to vacate the building because it was needed for other purposes.

Unable to find a suitable place to meet, the congregation accepted the invitation to rejoin Beth Ahabah. In the words of a resolution drafted by Beth Ahabah, "We tender to the members of the congregation a cordial welcome to our congregation and our Synagogue." With disputes at an end, the two synagogues reunited in 1877.

Sir Moses Montefiore Congregation

And what does the Lord require of you?
To act justly and to love mercy and to walk humbly with thy God.
—Micah 6.8 (The Torah)

If you drive east on Broad Street toward Fulton Hill, you will see Jennie Scher Road. One might wonder why a road is named after this particular woman. It is because her devotion to the Jewish community in Richmond is legendary.

Jennie Scher came to Richmond from Kovno, Lithuania, in 1886. Married to Isaac Scher, a tailor, she devoted her life to philanthropic causes. She served as president of the Hebrew Sick Aid Society, which became the catalyst for the Beth Sholom Home of Virginia, and she led the Ladies Hebrew Aid Society. Jennie Scher is described as "a modest woman who did a lot of good." She believed in practicing acts of loving kindness to all those who needed her help. And she said with humility, "If I do any good, the Good Lord will know it." For her generous heart, Jennie Scher is remembered with a street named in her honor. It leads to a cemetery in downtown Richmond of which she was a founding member, and where she, her husband and most of their children are buried.

Because of Jennie Scher's devotion to the greater Jewish community, she was also active in the Sir Moses Montefiore Synagogue. The Jewish people from Eastern Europe who came to Richmond in the 1880s originally joined Keneseth Beth Israel, but in 1896, they formed the Sir Moses

Montefiore Congregation, an Orthodox synagogue. Moses Montefiore was born in Italy in 1784 and became a financier whose philanthropy was so great he was knighted by Queen Victoria of England. He once said, "The Creator rewards those who keep His commandments." Many places are named in his honor, including a synagogue and a cemetery in Richmond. There are also places named for him in Canada, Ohio, Jerusalem and even North Dakota.

Like the Jewish people who emigrated from Germany, those from Eastern Europe wanted to form a synagogue that followed a tradition with which they were familiar. The Orthodox congregation first met in a building on Main Street between Fifteenth and Seventeenth Streets until 1891. Then they purchased the property formerly used by Beth Shalom on Mayo Street between Marshall and Clay Streets.

An icon of charitable endeavors by the Jewish community, Jennie Scher rests in peace near the street that bears her name. *Becker family collection and Robert Diller.*

In 1905, the congregation acquired the synagogue formerly used by Beth Ahabah on Eleventh Street. It was popularly called the Eleventh Street Shul. In April 1905, there was a ceremony transferring the synagogue from Beth Ahabah to Sir Moses Montefiore, and the new occupants were reminded that the synagogue was the House of God. Julius Straus delivered a stirring address, in which he said, "The members of the congregation by their daily walk, by their worship, by their acts, and by their devotion to the Almighty Father as exemplified by the love to their fellow man, must make their meeting place for worship truly the House of God." Dr. Edward Calisch, the rabbi of Temple Beth Ahabah, summed up the transfer by saying that "Beth Ahabah had left the old home in hands and hearts that would continue that influence for good and for the unity of all of God's Israel." For almost half a century, the Sir Moses Montefiore Congregation remained at the Eleventh Street location.

The congregation next moved in 1950 to the church formerly used by Grace Baptist at Boulevard and Grove Avenues. Sir Moses Montefiore and Etz Chaim, a relatively new synagogue, merged to form Beth Israel. Beth

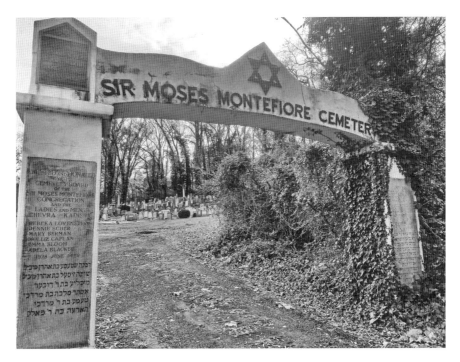

Despite many congregational mergers and name changes, the Sir Moses Montefiore name remains on this venerable cemetery.

Israel and Keneseth Israel merged in 1952 to form Keneseth Beth Israel, which is the Orthodox synagogue in Richmond today.

Richmond has been enhanced by the pillars of Jewish life, and it is a better place to live because of the contributions of the Jewish community.

When I was a college student, a rabbi from Richmond spoke to the student body and said "You cannot break the Ten Commandments, you can only break yourself upon them." I have never forgotten this admonition.

46

PRESBYTERIANS

Thank you for the world so sweet
Thank you for the food we eat
Thank you for the birds that sing
Thank you God, for everything.
Amen
—*evening prayer said by Eileen Foster Beane, Carolyn Whitworth Brittain*

The world changed when Martin Luther led the Protestant Reformation. Following Luther's lead, John Calvin, a Frenchman who lived in Geneva, Switzerland, developed a theological system. The acrostic TULIP summarizes Calvin's emphasis on the absolute sovereignty of God:

Total depravity of mankind
Unconditional election
Limited atonement
Irresistible grace
Perseverance of the saints

John Knox, a Scotsman, studied Calvin's *Institutes of the Christian Religion* and met and talked with theologians. When John Knox returned to Scotland, he instituted religious reform among the Scots that eventually became the Presbyterian Church of Scotland.

One of the original seven meetinghouses built by dissenters to Anglican worship, Providence is the oldest Presbyterian church in continual use in Virginia.

As settlers came to the New World, they brought their religion with them and established the Episcopal Church in Jamestown in 1607, but it would be more than two hundred years before the Presbyterians came to Richmond, Virginia.

Francis Makemie, a Scotch Irish Presbyterian, came to Maryland in 1693 and began to establish Presbyterian congregations. He became the "Father of Presbyterianism in the Colonies." When he established a church at Pocomke and Onancock in Virginia, Presbyterianism had officially arrived in Virginia. He was a man of courage who went to prison for supporting religious liberty for all people, and he won a trial for "Preaching without a license."

Presbyterianism came closer to Richmond due to the work of Samuel Davies. A Presbyterian evangelist, he was ordained in 1747 and came to nearby Hanover County, where he would serve from 1748 to 1759. He was the first non-Anglican licensed to preach in Virginia. Spending most of his life in this state, he traveled between seven churches preaching the gospel. Some of the churches were forty miles from one another. However, the word "church" was not used. They were referred to as "reading houses," which indicated they were used by dissenters from Anglicanism.

One of the churches he served was Polegreen (sometimes spelled Pole Green), which was established in 1747. It is believed that the spiritual "Lord,

An inspired tribute to the Polegreen Church, the structure by Carlton Abbott marks its dimensions and aspects.

I want to be a Christian in my heart" originated at this church. One of Davies's parishioners was Patrick Henry, who admired Davies's ability as an orator and, perhaps, learned from him the skills that enabled him to deliver his famous "Liberty or Death" speech.

Davies is also known for being one of the founders of the Hanover Presbytery in 1755. This was the first presbytery organized in Virginia, and it connected the South with the main body of Presbyterians. In the same year, he preached a sermon in Hanover County that dealt with Virginia and the French and Indian War. A portion of the sermon is as follows:

> *And, O Virginia! O my country! Shall I not lament for you? You are a Valley of Vision favored with the light of revelation from heaven and the gospel of Jesus: you have long been the region of peace and tranquility; the land of ease, plenty, and liberty. But what do I now see? What do I now hear? I see your brazen skies, your parched soil, your withering fields, your dried springs, and your scanty harvests. Methinks, I also hear the sound of the war trumpet and see garments rolled in blood; your frontiers ravaged by*

*revengeful savages; your territories invaded by French betrayal and violence.
Methinks, I see slaughtered families, the hairy scalps clotted with gore—the
horrid acts of Indian and popish torture.*

In poor health, Davies preached a final sermon to the faithful. It was the admonition "Love One Another as Christ Has Loved You!" Although proof does not exist, Davies could have visited and preached in Richmond, which was not far from the Polegreen Church.

In 1779, the Virginia capitol was moved from Williamsburg to Richmond. This move brought a number of lawmakers and other leaders to the new capitol city, but Richmond did not look like a capital city. It had a small population with dirt streets and some unattractive buildings.

One of the men who came to Richmond was John Durbarrow Blair, who was the first Presbyterian minister to live and preach in Richmond. He was extremely popular and known as Parson Blair. In 1785, he became pastor of Polegreen Church. While serving that congregation, he moved to Richmond's Shockoe Hill, where he lived until his death in 1823.

While in Richmond, he continued to preach at Polegreen, but on alternate Sundays, he preached in the Virginia State Capitol. He shared the pulpit with the Episcopal priest John Buchanan. The two ministers became very close friends, and the congregation heard an Episcopal service one Sunday and a Presbyterian service the other Sunday. On the Sundays they were not preaching in the capitol, Parson Blair would preach at Polegreen and John Buchanan would hold services at St. John's or some other nearby parish. The arrangement was so satisfactory that neither clergyman made any effort to organize a church. The capitol pulpit seemed to meet everyone's needs.

The capitol church has been described as having a plain "temporary pulpit in the middle of the hall." In the eastern end sat the choir. Of course, there was no organ. But then a disaster changed the capitol church. Just as a disaster created Monumental Church, it also led to the establishment of a Presbyterian church by ending the worship services in the state capitol.

Tragedy struck in 1811 when the Richmond Theater on Broad Street caught fire, with a great loss of life. The Richmond city government wanted to create a memorial for those who died in the fire. It was decided to build a church on the site of the theater, which resulted in the establishment of Monumental Church as a memorial to those who died in the horrific conflagration. After the Monumental Church was completed, the church was deemed to be Episcopalian, but the Presbyterians continued to meet in the capitol building until they formed a church of their own.

Following the great fire and the establishment of Monumental Church, the Presbyterians began a major effort to establish a church in Richmond. The call went to John Holt Rice of Cub Creek Church to be the minister of what was known as "The Presbyterian Church of Richmond."

The Reverend John Holt Rice preached his first sermon in Richmond in the Masons' Hall at Eighteenth and Franklin Streets on May 14, 1812. It was noted that over five hundred people left the service because they could not find a seat. He commented on the needs of the Richmond Presbyterians as follows: "They are indeed as a sheep without a shepherd, like a vast flock in the wilderness, alarmed and running in every direction, without knowing which way to go." In the years ahead, Presbyterian churches would be organized in Richmond when ministers would seek to show their sheep the "way to go."

FIRST PRESBYTERIAN CHURCH

Lord, I want to be a Christian in my heart, in my heart.
Lord, I want to be a Christian in my heart.
In my heart, in my heart,
Lord, I want to be a Christian in my heart.
—author unknown

The exact location of the first Presbyterian church in Richmond is somewhat of a mystery. The generally accepted location was on Main Street between Twenty-Seventh and Twenty-Eighth Streets at the foot of Libby Hill. However, there is some evidence that the first church might have been near Rocketts Landing. Regardless of the location, the church building did not meet the needs of the congregation.

In 1815, construction began on a new church on the south side of Grace Street between Seventeenth and Eighteenth Streets. The newspaper commented that "the pews will be taken up (fully rented) and there will, very probably, be a call for more than the house can contain." While the church was being built, the congregation worshipped at Mason's Hall.

Because of the design of the steeple, which seemed to have spirals below the cross, it became known as the Pineapple Church. In the South, the pineapple is a symbol of hospitality. In addition to being called the Pineapple Church, in 1816, the church was given the name First Presbyterian Church, instead of the Presbyterian Church in the City of Richmond.

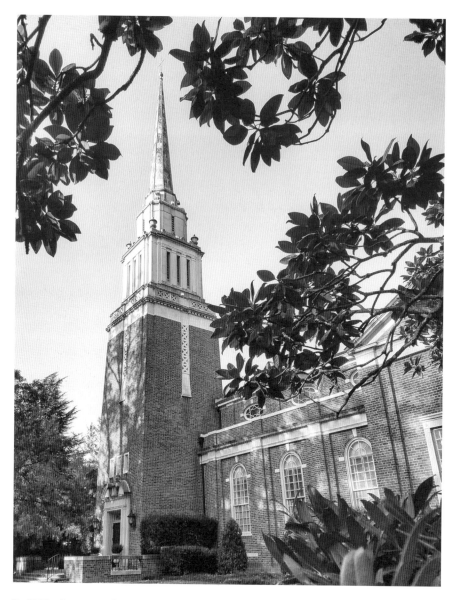

In 2012, after years of service, growth and change, First Presbyterian Church celebrated two hundred years of ministry in Richmond.

By 1829, the Presbyterians had once again outgrown their church. The congregation bought property on the north side of Franklin Street between Thirteenth and Fourteenth Streets. For the third time in seventeen years, the church would move. The new church was described "as having an

imposing front, a commodious audience chamber, and wide galleries. It was well lighted, well ventilated, with no interceding pillars to obstruct the sight, and arches to distract the sound. It was a noble edifice, easy to the speaker, pleasant to the hearer, and in all respect, comfortable to the large congregation who for many years crowded its walls." But the church would move again in 1851 to a more prominent location.

The new location of First Presbyterian was at Capitol and Tenth Streets facing the Virginia State Capitol. Its location put it in the center of Virginia's government. The church was described as of Byzantine style, presenting a front of fifty-four feet on Capitol Street overlooking the capitol grounds. The interior was divided into "nave and aisles by the octagonal iron shafts that bore the galleries." The new church was dedicated on October 16, 1853.

Prior to the Civil War, the minister, the Reverend William Plummer, criticized those who kept posing the slavery question:

> *Thus, our church would be rent asunder and Southern and Northern Presbyterians and Congregationalists could no longer meet, even in a Social way, and hail each other as brethren....Thus, the strong bonds of religious friendships will be broken. Then nothing is left to be done to finish the work, except to arouse and inflame the infidelity and animalism of North and South against each other, give the tocsin of disunion a blast, and rend the star-spangled banner in twain, and soon the hostel forces will be absent from each other, and the Potomac will be dyed with blood.*

These were like unto the words of an Old Testament prophet. But more than the Potomac would turn red; Richmond would become a city of hospitals and cemeteries, and the farms around the city would become battlefields drenched with the blood of young men from both the Union and Confederate armies.

At the end of the 1880s, the City of Richmond needed the land on which First Presbyterian was located to build a city hall. The City of Richmond traded the Capitol and Tenth Streets location for property at the corner of Grace and Madison Streets. The move was without expense to the congregation, as the City of Richmond agreed to move and reconstruct the church at the new location at no cost to First Presbyterian.

The new church was dedicated in 1885, and it remained the home of First Presbyterian until a move was initiated to purchase a lot at Locke Lane and Cary Streets on December 18, 1939. The new church on Cary Street was built in phases. It was to be of "Colonial Georgian architecture, consisting

of red brick and white wood trim, the auditorium being surmounted by a graceful Sir Christopher Wren spire." During the years of World War II, this prayer was prayed at First Presbyterian for those in service:

O God bless our soldiers wherever they are on land or sea or in the high heavens. Give them courage to meet their perils, fortitude to endure their hardships and an abiding faith in Thee to sustain them in their hours of trial.

We commit to Thy loving care our sick and wounded. O Thou Great Physician, heal them of their diseases and ease the pain of their sufferings that they may soon be restored to health and service once more.

Bless our men who are prisoners of war and give them patience in tribulation. May their hearts be cheered by the hope of eventual freedom and restoration to their countrymen.

If it be in accordance with Thy holy will, bring peace to this war-torn world that all the nations of the earth may know and realize that the Lord God Omnipotent reigneth above them all. Amen.

Several people, including the pastor, agreed to pray this prayer every night until the war ended. When it ended, work was begun on a new sanctuary. The congregation first worshipped in the new sanctuary on Cary Street on September 17, 1950. Since that date, the church has added many programs, and the sanctuary has been refurbished.

In 2012, First Presbyterian celebrated its 200th anniversary. The Reverend Dr. Brian Blount, president of Union Presbyterian Seminary in Richmond, offered these thoughts at the celebration:

A church can get tired of handling fire for 200 years. And yet, doing just that is your accomplishment. The call now is to find new ways to set your journey face and get on the path that leads into the next 200 years of supporting theological education, of revitalizing churches, of building community where there is anger and mistrust, of bringing good news to the poor, of proclaiming release to the captives and recovery of sight to the blind, and helping the oppressed go free.

After more than two hundred years, the mission of First Presbyterian has been "to inspire faith in Jesus Christ, nurture disciples of Jesus Christ, and to serve the world God loves to the glory of God."

From First Presbyterian, other Presbyterian churches would develop, including Second Presbyterian.

SECOND PRESBYTERIAN CHURCH

And we know that all things work together for good to them that love God, to them
who are the called according to his purpose.
—Romans 8:28 (KJV)

Unlike First Presbyterian, Second Presbyterian has always been at the same location on Fifth Street between Main and Franklin. One Sunday in June 1842, the minister at First Presbyterian said in the course of his sermon that "the time was at hand when it would be desirable to send out a colony," adding that "perhaps one reason the church had not been more blessed was because it had made no attempt at enlargement by the erection of a second church." The congregation liked the suggestion and started to act on the proposal that created Second Presbyterian Church. The colony needed a minister and a place to meet.

The minister was found at Hampden-Sydney College. He was a tall, slender student named Moses Drury Hoge. It was not long before Hoge visited Richmond and became the assistant to the minister of First Presbyterian.

In February 1844, a lecture room was completed on Fifth Street between Main and Franklin Streets. The new congregation met there. Hoge preached using the text "For he loveth our nation and he hath built us a synagogue." The building was dedicated to the worship of Almighty God.

On January 29, 1845, an invitation was extended to all members of the First Presbyterian Church who wished to join the Second Presbyterian Church to apply for a letter of dismissal. Almost one hundred letters were

submitted. Following the submission of the letters, Second Presbyterian was authorized by East Hanover Presbytery on February 4, 1845; on February 15, 1845, Second Presbyterian was organized as a separate congregation, and Moses Hoge was selected as the first minister. He was ordained and installed as minister on February 27, 1845, in a ceremony that took place in the lecture room. He would serve the church until his death in 1899, and Second Presbyterian was frequently referred to in the press as Dr. Hoge's Church.

The next step was to construct a church building. It was proposed and accepted that the new church be of Gothic architecture, because Reverend Hoge said that he was "tired of Grecian temples with spires on them." Pursuant to this goal, a building committee was appointed, and to raise money, the following advertisement appeared in the *Richmond Enquirer*:

> *The Ladies of Reverend Hoge's Church will open a fair on Thursday at twelve o' clock in Mr. Bosher's new building, on Main Street. A great variety of fancy and useful articles will be offered for sale. The proceeds will be devoted to the erection of a more commodious House of Worship for Second Presbyterian Church.*

Minard Lafever, one of America's most distinguished architects, was selected to design the church. He had already designed more than forty churches in the United States and Canada.

The new church was soon under construction and was completed in May 1848. Two things stood out about the church: the Gothic architecture and the gas lights. Reverend Hoge commented that within a year he expected Second Presbyterian to be the leading Presbyterian ministry in the city. It was amazing that a new congregation could build a church in such a short time. Unfortunately, there was not enough money to place a bell in the bell tower. This was finally done in 1995.

On May 11, 1848, the *Richmond Enquirer* wrote about the church's dedication as follows: "An immense crowd filled this new and beautiful Gothic structure at the dedication on Sunday afternoon. The church was occupied by ladies who wore gay dresses and were waving fans (the weather was oppressive) remind[ing] us of a splendid collection of bright-winged butterflies." The text for the dedication sermon was from the Deuteronomy 32, "For their rock is now as our Rock, even our enemies themselves being judges." The press stated, "In the meantime, we congratulate Mr. Hoge and our whole city over the erection of so ornamental a temple of religion.

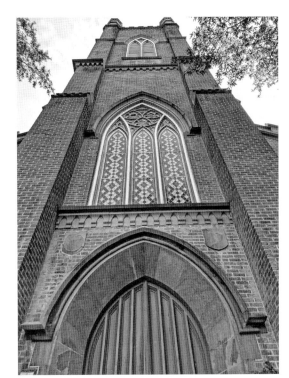

Right: A steadfast presence in downtown Richmond, Second Presbyterian Church continues its worship, work, ministry and mission at its original 1844 location.

Below: Overlooking the city of Richmond, the burial site of the Reverend Moses Hoge stands in a place of honor adjacent to Presidents Monroe and Tyler at Hollywood Cemetery.

Considering the style of architecture, which is entirely novel here, the cost of the building is reasonable enough. The church is beautifully lit up with gas (another novelty here). The effect was very fine. The magnificent center window presented a gorgeous appearance on the exterior."

The church made a significant statement on the Richmond skyline. Upon seeing Second Presbyterian, a critic called St. Paul's steeple "the Devil's toothpick."

Since Presbyterians emphasize preaching, the most important feature is the pulpit, which is the focus of the sanctuary. In 1873, north and south transepts were added, which altered the building's original appearance but accommodated the growing congregation.

But a church is more than a building—a church is people. Second Presbyterian was blessed by being led for over fifty years by an outstanding clergyman, Moses Hoge. He was one of the best-known ministers in Richmond, if not the entire state. Dr. Hoge's ministry was marked by the Civil War. He was well known in Confederate camps and supplied Bibles to the Confederate soldiers. On a trip to England, he met Queen Victoria, to whom he preached. Refusing a special gift from the queen, he asked for some ivy, which still grows around the church.

One of the best-known events that happened during the Civil War occurred when the Confederate general Thomas J. "Stonewall" Jackson came to worship at Second Presbyterian. Sunday, July 13, 1862, was a lovely summer day in Richmond, Virginia, the bustling capital of the new Confederate nation. Part of this optimism was based on the successes of the two Confederate generals—Robert E. Lee and Stonewall Jackson—who were meeting with Virginia governor John Letcher early on this Sunday morning. Following the meeting with the governor, they rode to the White House of the Confederacy to meet with President Jefferson Davis. The purpose of the conference was to plan for Jackson's future engagements with the enemy.

When the conference with the president ended, General Jackson mounted his horse and headed west from the White House toward Richmond's Second Presbyterian Church on Fifth Street. It is not known which route Jackson took to the church, but it is likely that he tied his horse to a tree at Main and Fifth Streets. Leaving an orderly to watch the horses, he walked to the nearby church, accompanied by several staff officers. Arriving late and while the congregation was singing a hymn, he probably slipped into a side door and was seated in a side pew near the back of the church along with his staff officers, including Dr. Hunter Holmes McGuire, Lieutenant

Alexander S. "Sandy" Pendleton, Captain Henry Kyd Douglas and Captain Hugh A. White of the Stonewall Brigade. Since he arrived late and was dressed in the plainest of uniforms, most members of the congregation did not recognize the presence of the famous general and devout Presbyterian. Conducting the service was the Reverend Dr. Moses Hoge, who was one of the best preachers in Virginia. However, Jackson, although deeply religious, apparently went to sleep during the service and slept through the greater part of it. Maybe the exhausted general only appeared to be sleeping. Perhaps he was pondering his favorite Bible verse, Romans 8:28: "And we know that all things work together for good to them that love God, to them who are called according to his purpose." Or maybe he was recalling the days long past when he would sing "Amazing Grace" in the Sunday school he had conducted in Lexington, Virginia, for the children of slaves. Or maybe he just slept. Dr. Hunter McGuire, who was the staff surgeon in Jackson's command, commented that "a person who could go to sleep under Dr. Hoge's preaching can go to sleep anywhere on the face of the earth."

When the service ended, members of the congregation suddenly became aware of the famous visitor in their midst. Some members climbed over the pews to get near him. Other members filled the side aisle in order to see the general who had earned the name "Stonewall" at the Battle of First Manassas and who had confounded the Union army in the Shenandoah Valley.

Soon the general and his staff were forced into the back corner of the church, trapped. The church members had done what the Union army could not do: they had cornered "Stonewall" Jackson. One observer commented that "the general seemed uneasy, he really appeared confused." When Jackson and his aides finally got outside the church, "a lady, evidently an old friend, came up, seized the general by the arm, and hurried him down the street." According to some accounts, General Jackson left the church and went to a nearby house to "call on a mother who had lost a son." Such a visit would have been in keeping with General Jackson's concern for the men under his command. If he made the visit, it was very brief. Within fifteen minutes, he had rejoined his waiting staff and returned to his army, which he called the "Army of the Living God."

General Thomas Jonathan Jackson would never again attend services at Second Presbyterian Church. Within a year of his attendance, the mighty Stonewall was dead, in spite of the best efforts of Dr. Hunter Holmes McGuire, who had attended the service with him. As he met the God he served, he was heard to say, "Let us cross over the river and rest under the

shade of the trees." For Thomas Jackson, the cruel war was over. Of the staff officers who had attended church with him, only Dr. McGuire and Henry Kyd Douglas survived the war. Dr. McGuire became Richmond's most well-known physician, and Douglas became a successful attorney in Hagerstown, Maryland. Captain White, who had planned to study for the ministry, died at the battle of Second Manassas while leading his men. The Southern Cross on the Confederate flag he was carrying fell across his lifeless body. His last words to his men were, "Come on, come on!" Alexander "Sandy" Pendleton of Jackson's staff accompanied the general's body to Lexington for burial. Returning to Confederate service, Pendleton was killed at Fisher's Hill. His final words were "It is God's will; I am satisfied."

Today, a small plaque marks one of the pews where General Jackson and his staff sat to worship in Second Presbyterian Church. Given by the United Daughters of the Confederacy, it is inscribed: "General Thomas J. (Stonewall) Jackson, C.S.A."

If you look carefully, it is still possible to imagine a group of Confederate officers quietly entering through the side door of the building and being seated near the back of the church in a side pew. With a little imagination, you can almost see the ghost of a general in a tattered gray uniform bowing his head in prayer in the dimly lit sanctuary.

When Richmond was burned at the end of the war, some damage was done to Second Presbyterian, but unlike United Presbyterian Church, it survived. Across the years, the church has had a series of excellent ministers who cared for the children of God. Dr. Frederick H. Olert was the minister of Second Presbyterian during the integration crisis of the 1950s. As president of the Richmond Minster's Association, he was involved in the adoption of a statement condemning Virginia's efforts to retain segregated schools. The statement stated in part: "The Governor and the General Assembly coerced their own solution without due consideration of either moral or religious teaching." This statement was adopted in January 1957, and it was condemned by the Richmond papers. In early May, at the end of one service, Dr. Olert announced his resignation from Second Presbyterian to the shock of the congregation. His only comment was "I believe in basic civil and religious freedom." Most people felt it was the anger generated by the Minister's Association in support of integration that caused him to resign.

Second Presbyterian Church, unlike many other churches, did not move west. It is still located where Dr. Hoge had it built, and it still serves the downtown Richmond community, as well as those who drive from the suburbs to worship in a church filled with memories. If members of

In Memory of
Martha C Hawes

The chapel at Second Presbyterian is graced by an exquisite window of Dorcas, known for good works and love for the poor. It is one of only two Dorcas windows ever created by the Tiffany Studios.

the congregation look to the right of the pulpit, they are able to see the memorial to Dr. Hoge, which shows his face and suggests that he is still looking over the congregation.

The Reverend Dr. Alexander W. Evans, the twelfth and current pastor, offered these thoughts about Second Presbyterian:

The sacred and historic sanctuary at Second Presbyterian never fails to remind me of the many people across the ages who have come into that space to sing and pray, to hear God's Word, to receive the sacraments, and to recommit their lives to serving God. The great beauty and the tradition of the sanctuary continues to generate faith and connect people with God's Spirit for faithful worship and work in the world. Whether entering or departing, we know we belong to God; we strive to serve God with our lives.

Second Presbyterian Church seeks to follow this guidance: "We are called to be a witness to and for the world of the new reality that God has made available to all people in Jesus Christ. We seek to know Christ and to make Christ known in downtown Richmond and throughout the world."

THIRD PRESBYTERIAN CHURCH (BETHEL CHURCH)

Shall we gather at the river,
Where bright angel feet have trod,
With its crystal tide forever
Flowing by the throne of God?
—Robert Lowry

Jesus spent a lot of time beside the River Jordan. He associated with men who understood fishing, storms and life on the water. Jesus would have understood why a Scotsman named George Hutchison, a member of First Presbyterian Church, visited the Richmond waterfront at Rocketts Landing beneath Chimborazo Park. Like a missionary, he began visiting this rough part of Richmond and decided to start a mission for the sailors and dock workers even though they were frequently referred to as the dregs of society. Hutchison began to go from ship to ship on Sunday mornings distributing religious tracts and talking to the sailors. This act of visiting the sailors eventually led to the establishment of Third Presbyterian Church.

The exact date of the church's organization has been lost to history, but records dated April 16, 1835, indicate that sixteen people met in the home of William Rowlett for a religious meeting. Although the church was eventually named Third Presbyterian, it was initially called "Bethel" by its members, as "Bethel" is a Hebrew word for a place of worship on either sea or land.

Soon the congregation moved their place of worship to a tobacco factory until a small chapel could be built on Elm Street at the mouth of Gillis Creek

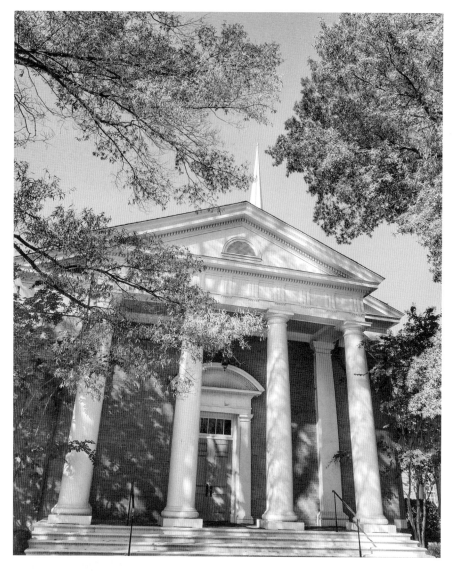

Begun as an outreach to sailors and dock workers, the mission of Third Church has now brought it to Forest Avenue in Henrico County.

near Williamsburg Road. When they moved, they ceased using the name Bethel Church and became Third Presbyterian. The church was dedicated on December 3, 1835, and the Reverend Alexander Mebane was the first pastor. To announce the time of the service, the pastor hung a bell out of the rear window.

When the chapel was no longer in an ideal location, the congregation moved west. Responding to the needs of the people, a new brick church was dedicated on the corner of Twenty-Fifth and Broad Streets in 1850. The church building was described as a plain, simple, brick structure. When the Civil War broke out, the minister left the church and went north. As the war continued and the fighting got closer to Richmond, prayer meetings were held three nights a week at the church. The invitation was that all people with an "interest in praying for our country are cordially invited." There were many people who attended these meetings as the war got ever closer to Richmond and defeat was inevitable.

The Reverend W. E. Hill, the pastor of the church, preached a sermon on May 6, 1870, on John 13:17: "What I do thou knowest not now, but thou shalt know hereafter." He spoke "of the consolation to be derived from believing

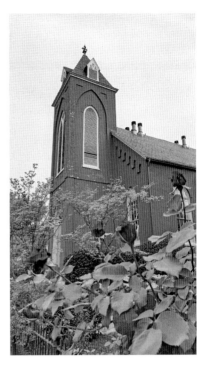

The collapse of the Church Hill Tunnel led to the relocation of Third Presbyterian and the construction of a new building at Thirty-Sixth and Broad Streets.

that this Savior, who, on earth, washed his disciples' feet and sacrificed His life for sinners, being exalted to the right hand of God, was now ruling over all things in the same spirit of love which characterized His actions on earth, and that we can safely trust ourselves fully in his hands."

In 1873, the Chesapeake and Ohio Railroad was completing a tunnel under Church Hill. A portion of the tunnel ran very close to the church. Unfortunately, a large section of the tunnel caved in, taking a large section of Broad Street with it. Although the church was not damaged, its foundation seemed sufficiently unstable and warranted abandonment. The congregation feared that the church would be swallowed up by additional cave-ins.

Historic St. John's Church, which was across the street from Third Presbyterian, invited the congregation to worship in their church. The congregants worshipped there while a temporary wooden building called the "Tabernacle" was constructed near the damaged church.

Using funds from a damage settlement from the Chesapeake and Ohio Railroad and parts of the old church, the congregation built a large but simple Gothic church on the southwest corner of Twenty-Sixth and Broad Streets. It seated about four hundred people.

The *Daily Dispatch* reported that the main audience room of the new building was opened for religious service for the first time on December 17, 1876. As a fundraiser, a lecture on "The Choice of a Husband" was presented. Proceeds from the lecture were to be used to help pay for the church. It was said that the lecture was "a rare treat by all who have heard it, and all who wish to spend a pleasant hour." After eighty years, the congregation, facing declining attendances, voted to follow the people and move to Henrico County in 1956. The church they left behind is now known as the Belfry Condominiums.

While the new church was being built, the congregation worshipped in the Tuckahoe Elementary School. In 1958, Third Presbyterian Church was dedicated with special services and programs. The cost of the new church at the time was $300,000. The Reverend W. Arnold Pate said of the new church, "We hope to serve a cross section of the community today—a renewed mission of bringing the Word of God to all who seek it."

Today, the church known as Third Church has left the Presbyterian Church in the USA. Third Church is committed to the doctrines of the Reformed Christian faith as taught in the Holy Scriptures and expressed in the historic confessions of faith. It offers many programs for all people and is an active force in the community and beyond. Third Church has come a long way from the days when sermons were preached along the James River waterfront.

50

THE CHURCH OF THE COVENANT
(FOURTH PRESBYTERIAN CHURCH)

What a Friend we have in Jesus,
All our sins and griefs to bear!
What a privilege to carry
Everything to God in prayer!
Oh what peace we often forfeit,
Oh what needless pain we bear,
All because we do not carry
Everything to God in prayer!
—Joseph W. Scriven

The Church of the Covenant began as a Sunday school under the leadership of the Reverend Dr. Moses Hoge of Second Presbyterian. Meeting in an old house at 600 East Marshall Street, it was called Fourth Presbyterian Church and was described by Dr. Hoge as "Bleak House." Because of its success, a granite chapel was constructed in 1891 on Harrison Street. In 1907, the congregation occupied a new church, which was located at Harrison Street and Park Avenue across from the Howitzer's Monument. The name of the church was changed from Fourth Presbyterian to the Church of the Covenant. "The church was described as 'French semi-Gothic' and was finished throughout in white and oak with a dark oak ceiling. It was brilliantly lighted by brackets of electric bulbs around the sides." The new church was considered one of the most impressive ecclesiastical edifices in Richmond. But there was a problem.

Once again the church had to deal with the movement of the population to the West End. To meet this need, the East Hanover Presbytery met in 1914 and authorized the merger of the Church of the Covenant and Grace Street Presbyterian.

The two congregations met together for the first time on Easter 1915. The first service of the two congregations was led by the Reverend Dr. J. Calvin Stewart at the Church of the Covenant, and he "reminded the congregation that he was their servant and would always be willing to serve them." He also pointed out the "excellent cooperation between the two congregations and that everyone should be willing to help each other." The minister urged the congregation to "give their steadfast and undivided support to the work of the new church that was to be called Grace Covenant Presbyterian Church." He also commended the congregation on how the merger was accomplished with love and peace.

At the time of the service both churches had been sold, so the congregation worshipped at the Covenant Church for several years. When the new owners took possession of the church, the congregation met at Binford Junior High School, pending the completion of the new sanctuary on Monument Avenue.

GRACE STREET PRESBYTERIAN CHURCH (UNION PRESBYTERIAN CHURCH)

Make a joyful noise unto the Lord, all ye lands
Serve the Lord with gladness: come before his presence with singing
—Psalm 100:1–2 (KJV)

Shockoe Hill Presbyterian Church was established when the Episcopalians left the state capitol—where they had shared services with the Presbyterians—to establish the new Monumental Church. The Presbyterians continued to meet in the state capitol until 1821, when they built a church at Eighth and Franklin Streets. The church was a beautiful building with a tall steeple, a bell and iron rails. In 1838, the Church on Shockoe Hill merged with the Fourth Presbyterian Church, which was formed from disgruntled members of First Presbyterian Church. With the merger, the church was renamed the United Presbyterian Church.

During the Civil War, the congregation donated the church bell to the Confederacy along with the pew cushions to be used in hospitals. But then the war hit home. On April 3, 1865, near the end of the Civil War, Richmond was set ablaze by the Confederate government. In the terrible conflagration, floating cinders landed on the church, and within an hour, the church and the adjoining lecture rooms were consumed. Nothing was saved but the Bible and the books taken from the pulpit. The minister, the Reverend Dr. Read, was in Cartersville, Virginia, on the day of the fire. He walked home along the James River to Richmond, and upon arrival, he saw that both the church and his house had been destroyed. The congregation was invited to meet

with Second Presbyterian Church while plans were being made to rebuild United Presbyterian Church. Obviously, the combination of a destroyed city and a burned church was a devastating blow to Richmonders.

A lot of money was needed to rebuild the church, so the following appeared in the *Richmond Whig* on September 29, 1865: "We would again invite the special attention of our readers to the Card [request for money] issued by the Trustees of the United Presbyterian Church. Among all the widespread ruins, there are none which present a more sad spectacle than those of the church on the corner of Franklin and Eighth Streets." While a new church was being built at Grace and Fourth Streets, the name of the church was changed to Grace Street Presbyterian Church, since "United" no longer had any meaning.

In May 1872, the congregation moved to the new building. The Reverend Dr. Charles H. Read preached on the Gospel of St. Luke. The newspaper announced it was a beautiful sermon. The press continued, "In one of the pews sat four old ladies...all of them being over four score years of age, the youngest one being eighty-three years old. Their presence was beautifully and feelingly alluded to by the gifted pastor."

But as time passed, the congregation wanted to move west to be closer to their members. In 1912, they sold their church but continued to worship there. When the congregation had the chance to repurchase the church, they declined. The congregation was more interested in a merger with another church.

Grace Covenant Presbyterian Church

And, I behold. I establish my covenant with you.
—*Genesis 9:9 (KJV)*

A new church was built in 1923 on Monument Avenue, and it was called Grace Covenant Presbyterian Church in order to join the names of the two churches that had merged. The design was in the Tudor style with a hammer beam roof, high ceilings, large windows and linen-fold paneling. The sanctuary represented a Tudor Great Hall. The *Richmond Times-Dispatch* reported as follows: "The aisle windows are designed after the manner of the glass in the Cathedral of St. Serge, Angers, France. It is automatically heated and ventilated, has soundless floor, and conveniences for the deaf. The new church could seat 1000 people and had one of the finest organs in the south." At the time of its dedication, it had the largest membership of any Presbyterian church in Virginia.

At the dedication, over 1,100 people attended the service, with several hundred being turned away for lack of space. The men who worked to build the church were invited guests.

In 1926, the Girl Scouts held a Peace Service in the church. Christians and Jews joined together for the service, and the choir of Westhampton College provided the music. The newspaper reported that "each person participating in the service entered the church with a lighted candle, as they entered the church the lights of the church were extinguished."

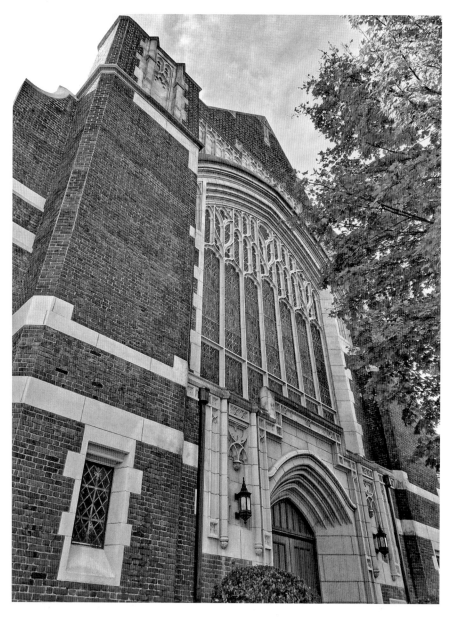

Through these doors of Grace Covenant Presbyterian Church passed the U.S. Supreme Court in tribute to its fallen member, Justice Lewis F. Powell Jr., in 1998.

Left: A highly decorated World War II intelligence officer, Powell was one of the few Allied Forces officers entrusted with how to use military secrets gleaned from Enigma, an encrypted German communication device.

Below: The Tiffany chandeliers in the sanctuary of Grace Covenant Presbyterian Church, brought from Grace Street Presbyterian Church, reflect the storied history of the congregation.

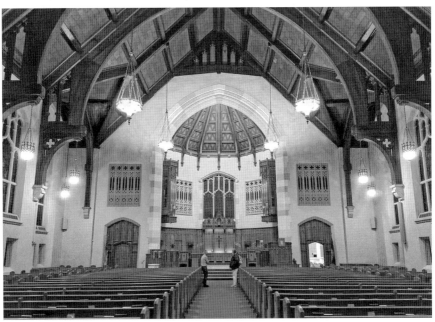

Grace Presbyterian's bell had been used in Grays' Armory to strike the time of day for many years. When the old armory was being demolished in 1933, the bell was sold to Grace Covenant for one dollar. The bell is now on display at the church as a reminder of its rich history.

In 1998, one of the church's most distinguished members passed away. Supreme Court Justice Lewis F. Powell Jr. was a longtime member of the church, and at his funeral, the entire U.S. Supreme Court was in attendance. Chief Justice William Rehnquist offered the following: "Other widely known and distinguished lawyers have been appointed to the Court in the past. But many of them did not thrive under this regime. Lewis Powell did. He combined a fair-minded willingness to see both sides of a question with an impressive ability to persuade others to his view. As a result, he was an extraordinarily influential member of the Court." A concluding remark was offered: "How fortunate we are to have known this remarkable man, how fortunate we are to have been loved by him, we shall never forget him. God bless him."

Grace Covenant has a rich heritage that can be felt if one sits in the sanctuary and reflects on the great cloud of witnesses that have gone before, as well as those who call Grace Covenant their church home. And the church continues to move forward. It offers many programs for both its members and the Greater Richmond community. The church is committed to "Awakening a love for Christ in the heart of Richmond." Its mission statement is as follows: "To train grateful disciples of Christ, by doing justice, loving mercy, and walking humbly with our God."

GERMAN PROTESTANT CHURCHES

The sounds of the hammer with which Martin Luther nailed the Ninety-Five Theses on the Castle Church door in Wittenburg, Germany, in 1517 echoed across all of Christendom, and the Protestant Reformation was born. Many Germans became Lutherans, and when they came to the New World, they brought their religious beliefs with them.

Germans were some of the earliest settlers at Jamestown. And when Richmond, Virginia, was founded by William Byrd, he sought to encourage Germans to come to "settle my land." However, it had been said that "No German who wishes to attain longevity should settle south of the left bank of the Potomac [River]." Fortunately, many Germans disregarded this advice

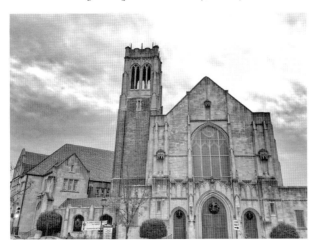

St. John's United Church of Christ was originally established by the German population of Richmond as a place to worship in their native language.

and came to Richmond. This was especially true following the failure of the Revolution of 1848 in Germany.

By the 1850s, Richmond's white population was about 25 percent German, and many of them lived in the northwestern section of Richmond in an area called Navy Hill. Some Richmonders did not like the Germans, so to avoid being stereotyped, some Germans began to deny their nationality.

The Germans might deny their ancestry, but they did not deny their religious beliefs. As more and more Protestant Germans came to Richmond, they joined any number of churches. But these existing churches did not meet their needs. The primary concern of the Germans was that the services were in English, and they wanted a service in their native language. Two churches were established to meet the needs of Protestant Germans prior to the Civil War: St. John's and Bethlehem Lutheran.

St. John's United Church of Christ (St. John's Evangelical Lutheran Church)

Oh, Jesus, Thou hast promised to all who follow Thee
That where Thou art in glory there shall Thy servant be;
And Jesus, I have promised to serve Thee to the end;
Oh give me grace to follow, my Master and my Friend.
—John E. Bode

Now I lay me down to sleep
I pray the Lord my soul to keep
When in the morning light I wake
Help me the path of love to take.
—Joan Newell, as rewritten by her father, the Reverend Dr. Arthur W. Newell

St. John's, the first church established by the Germans, began in a room where a group of Germans gathered to sing hymns and pray. Surely people who heard the hymns in German as they walked down the street must have wondered what was taking place. There was no minister to conduct a service. The Germans seemed unable to establish a church.

Finally, a meeting was held on May 8, 1841, for the purpose of organizing a church to serve the German people of Richmond. They selected the name "St. John's German Evangelical Lutheran Church of Richmond, Virginia." However, it was not a traditional Lutheran congregation. The first service was held on October 8, 1843, at a house at 412–14 East Marshal Street. Since this was a congregation with no affiliation, it was

difficult to secure a preacher. Finally, a Mr. Strater, trained in the Evangelical Church of Germany, became the first minister. After a year, he left and was replaced by the Reverend John C. Hoyer. He brought a new spirit to the congregation, and they soon were planning to build a church.

The congregation secured a lot on North Fifth and Jackson Streets, and a church building was constructed. The first service was held on Christmas Day 1847, but a problem soon developed. In 1852, a group of Germans left the church in protest against the liberal views of the congregation. They established a new German congregation to be called Bethlehem Lutheran. It was reported that the "walkout at St. John's was tumultuous and for many years the

Several windows from the original sanctuary were installed in the current building to provide continuity.

two congregations were hostile to each other." I do not know if any of my relatives walked out, but I do know I have relations in both churches.

After thirty years of operating as an independent congregation, the congregation at St. John's realized that they needed to unite with a denomination in order to secure a minister. They joined the Evangelical Synod of North America in 1874, and the Reverend Edward Huber became the pastor.

A lot was purchased in 1879 at the corner of Eighth and Marshall Streets for a new church. On October 8, 1881, the new sanctuary was dedicated. It was described as "an imposing structure with its spire pointing men's souls upward." Not only was it considered to be a beautiful church, but it was also strategically located in the middle of the German community. In 1886, the Reverend Dr. Paul Menzel became pastor.

Toward the end of the nineteenth century, St. John's faced a major problem: the use of the German language in services. The younger members preferred English, and the older members wanted the more familiar language of their Fatherland. Over time, the church transitioned to English, but it was a slow and somewhat painful process. Eventually, evening services were

The Gothic lines of the sanctuary have been softened by the use of color and light.

conducted in English and the morning services in German. Even today, the Scripture is sometimes read in German on Christmas Eve as a reminder of the church's German heritage.

The Reverend Oscar Guthe became pastor in 1907 and was always known as Pastor Guthe. Under his leadership, it was decided to build a new church building. The people had moved away from the existing church, and a move farther west was in order. In May 1913, a lot was purchased at the corner of Franklin and Lombardy Streets that was part of the old Richmond College Campus. The house of the president of the college was still there, and the minister lived in it.

Following the purchase of the lot, World War I broke out, and everything German was suspicious. To avoid this, the German language was no longer used. But these were difficult times for churches with German congregations.

Finally, the first unit of the new church to be built was the parish house, which served as a Sunday school and a temporary sanctuary. On December 11, 1926, the cornerstone was laid for the church, and it was dedicated on February 19, 1928.

The church was in Tudor Gothic style, which combined the awe-inspiring features of Gothic with a lightness and radiance that comes from added color and the modification of the harsher Gothic lines. The windows from the old sanctuary were installed in the new one to create a connection of the old with the new. Because of the design of the ceiling, the congregation had the feeling that they were worshipping in a forest like the early Christians.

A horse played a role in church lore. As JEB Stuart's monument was right outside of the church, Joan, a young girl, thought that Stuart's horse might charge down the church aisle. It never happened! At one time, the church had a bell, but because it was located across the street from a hospital, it was removed and sent to a mission in Honduras.

With the retirement of Pastor Guthe, the Reverend Arthur W. Newell became the minister, and he led the congregation for almost thirty years. In 1943, the congregation adopted a revised constitution that officially included the change of the name of the church to "St. John's Evangelical and Reformed Church."

I have fond memories of Dr. Newell. One youth Sunday, the choir director told me I could not sing in the choir because I could not carry a tune. Immediately, Dr. Newell told me that I would read the Scripture. It was Matthew 22:15–40. Perhaps this was the start of my career as a professor. For some reason, I have never been asked to be in a church choir. My brother, Bob, was taking up the offering as a teenager when a "Saint of the Lord" handed him a twenty-dollar bill and asked for three five-dollar bills in change. Bob gave her the change, which is an example of the money changer not being chased out of the temple. Later, Bob became a United Church of Christ minister

Joan recalls the stained-glass window of Christ knocking at the door. Since Stuart Circle Hospital was across the street, patients in ambulances could find hope by seeing the window showing Jesus standing at the door to help; they only had to open the door for him.

In 1962, the church's name was changed to St. John's United Church of Christ to recognize the merger of the Evangelical and Reform denomination with the Congregational Christians to form the United Church of Christ. Dr. Newell was very much involved with this merger and wrote part of the Statement of Faith for the new denomination.

Dr. Newell was also a leader in the ecumenical Thanksgiving service, which brought Christians and Jews together in a service of thanksgiving. I recall one of these services in a synagogue when the lady behind me wondered aloud why the prayer book was in Chinese. I could not bring myself to tell her it was Hebrew. Dr. Newell left St. John's in 1964 to serve a church in Indiana. It is a testimony to his ministry that Temple Beth Ahabah gave him a farewell reception. He was followed by the Reverend Richard A. Cheek, who served faithfully for a number of years, as did the ministers who followed him.

Like many downtown churches, St. John's has gone through many transitions. Its membership is drawn from throughout the city, but it still clings to its motto: "In essentials unity, in non-essentials liberty, in all things charity." And it reminds all people that "God is still speaking."

BETHLEHEM LUTHERAN CHURCH

Therefore we conclude that a man is justified by faith
without the deeds of the law.
—Romans 3: 28 (KJV)

Lord God, heavenly Father, bless us and these your gifts which we received from
your bountiful goodness through Jesus Christ our Lord.
—A prayer of Martin Luther's said by my grandfather, Martin Feitig

Those who left St. John's because of its liberal views formed a new Lutheran congregation. At the request of the church, the Virginia Synod sent the Reverend William Schmogrow to Richmond to organize it.

On October 3, 1852, the newly established church held its first service in a rented hall at 412 East Marshall Street. The church was named Bethlehem after the name of the city in which Jesus was born. Also, the name might have been selected because it was the name of the church in Germany led by Johannes Gossner, the founding pastor's spiritual mentor. Richmond now had two German Protestant churches that remained somewhat hostile toward each other.

Soon the Bethlehem congregation purchased land on Sixth Street near Clay Street in the Richmond German community. The congregation built a small building on the rear of the lot with the expectation that a church would eventually be built in front of it. The new building was dedicated on June 4, 1854. Shortly after moving into the new church, the founding pastor resigned.

With the departure of their pastor, the opportunity was provided for Bethlehem Lutheran to leave the Virginia Synod and affiliate with the more conservative Synod of Missouri, Ohio, and Other States. The reasons given for the new affiliation was that the church was having difficulty in finding a German-speaking pastor and because the thirty-nine communicants agreed with the purity and soundness of the doctrines held by the Missouri Synod, which is the most conservative of the Lutheran bodies. The first minister assigned to Bethlehem by the synod was Pastor Carl Gross. Pastor Gross and Bethlehem Lutheran Church were part of Richmond's "Little Germany," which had its own stores, newspaper and beer (Ein Prosit!).

When the War Between the States engulfed America, many Germans served in the various guard units defending Richmond. At Bethlehem Lutheran, this was easy to see, as men and women sat on opposite sides of the church, and the side for the men was sometimes virtually empty. By the time the war ended, the membership was reduced from about forty members to about twenty voting members. And the pastor's only suit was a Confederate uniform dyed black.

The death of the Confederate nation left Richmond and the South in a desperate financial condition. In *Der Lutheraner* dated December 2, 1867, there was a plea signed by the new pastor, Louis Lochner, and my great-great-grandfather Conrad Feitig requesting funds to build a new church for Bethlehem Lutheran.

Pastor Gross, who had recently left Bethlehem for another church, assured the northern churches that not a single member of the congregation had seen active militia service. This is highly questionable. Perhaps he forgot that my great-great-grandfather served in the Second Virginia State Reserves. The church did not like to ask for help from other churches, but its impoverished condition left no viable alternative.

Recovering from the war, the congregation decided to build a church in front of the small building that had served them during the war years. The cornerstone was laid on April 13, 1868, with Pastor Lochner conducting the service. Prior to the church's dedication, the Richmond newspaper commented that the new church was "one of the finest examples of church architecture" in the city. The building was described as Byzantine in style with a one-hundred-foot steeple crowned with a cross.

Over the doorway of the church was the German inscription "Behlehems-Kirche." On August 23, 1866, the church was dedicated. The pastor preached in German on a text from Luke 19, which includes the verse that

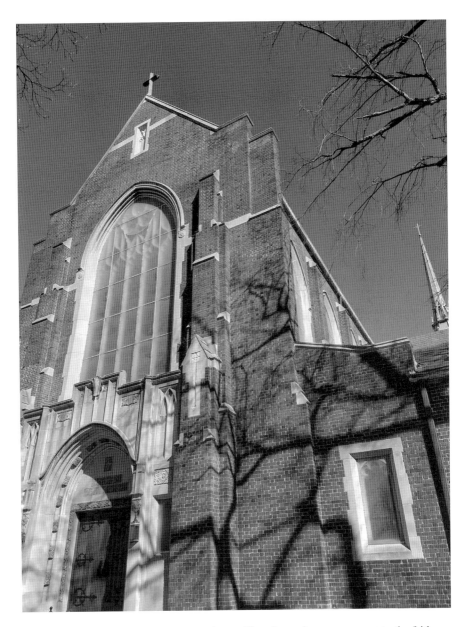

Rising over Grace Street, Bethlehem Lutheran Church stands as a testament to the faith and perseverance of its German congregants.

"the son of man is come to seek and to save that which was lost." An evening service was held in English on the same day.

In 1903, the Reverend Frederick H. Meuschke was installed as the church's pastor. The pastor had to face a major crisis when Europe began to move toward war. Many of the church members had close ties to Germany and were soon faced with the possibility of fighting their Fatherland.

When World War I erupted in Europe, Pastor Meuschke of Bethlehem Lutheran criticized the unilateral neutrality of President Woodrow Wilson, while Pastor Oscar Guthe of St. John's predicted a speedy German victory. But they were wrong. Not only was their adoptive land beginning to prepare to fight the Fatherland, but also their fellow citizens turned against their German neighbors. The *Richmond Times-Dispatch* suggested that the German American press had come close to committing treason. Indeed, one of my relatives was arrested for walking around a factory in which he worked, praising Kaiser Wilhelm of Germany. He was eventually acquitted. As America entered the war, German-language church services were abandoned, sauerkraut became liberty cabbage, hamburger became Salisbury steak, German measles became Liberty measles and the Germans in Richmond went "over there" to fight against their Fatherland. During the war year 1918, the church celebrated its fiftieth anniversary. It was reported that goldenrod was brought in by automobiles to decorate the church. For years, horses had brought worshippers to the church; now the horses were being replaced by automobiles.

The celebration gave way to a crisis when the Great Influenza Epidemic of 1918 struck Richmond. To stop the spread of the flu, Bethlehem Lutheran, as well as many other churches, did not hold services on Sundays, October 6 and October 13. With the defeat of Germany later in the year, the wartime prejudice slowly abated, and Richmond's German community tried to forget what was referred to as the "painful years."

By 1924, the Bethlehem Lutheran congregation had outgrown their church on Sixth Street. On December 14, 1924, Reverend O.A. Sauer, the new pastor, preached the final sermon in the old sanctuary based on the text "Stand fast, and hold the tradition which ye have been taught."

Just as the congregation had first built a small building before building a church on Sixth Street, the church members again built a parish house for worship at Ryland and Grace Streets. After worshipping in the parish house for a number of years, the congregation dedicated a new church building on Sunday, May 4, 1931. Over seven hundred members and visitors attended the morning service in which the pastor preached the

dedicatory sermon on the text "Blessed are they that hear the word of God and keep it." The new church had fewer and fewer services in the German language. And by 1941, they were largely discontinued.

Bethlehem Lutheran was holding its usual Sunday morning services on December 7, 1941, while the world was changing forever. The Japanese had attacked Pearl Harbor. Although the congregation did not know it at the time, a chaplain on board the USS *New Orleans* yelled, "Praise the Lord and Pass the Ammunition." World War II did not bring about a repeat of the anti-German feeling that had occurred in Richmond during the last world war. Indeed, the only notable episode was a whispering campaign against Nolde Brothers' Bakery and other bakeries with German names. It was alleged that Nazis were poisoning their bread. The bakeries took out newspaper ads to refute the fallacious accusation. Eventually, the war ended, and the days of peace returned for Richmond and the members of Bethlehem Lutheran Church.

In 1957, Pastor Saurer died after serving Bethlehem Lutheran for over thirty-six years. Although his death removed him from the pulpit, he is still remembered for teaching generations of young people that they "should never go any place where they would not want to be found dead." He is also remembered by a man named Fred who was caught running through the chancel following a confirmation class. Following a lecture from Reverend Sauer, he never ran through the church again, even though he might miss the streetcar that would take him home to Highland Park.

Today, Bethlehem Lutheran stands like a European cathedral overshadowing the nearby residences, with its steeple holding a cross over the city. Pastors and people have changed, but the inscription on the pulpit, "Blessed are they that hear the word of God and keep it," remains as true today as when the church was first dedicated. And perhaps, if one sits in a pew with closed eyes, one can imagine a pastor in a Confederate uniform dyed black praying, "Vater unser im Himmel." And if the person listens carefully, the congregation can be heard singing "Ein' feste Bur ist unser Gott," or as one sings today, "A Mighty Fortress is our God."

Amen.

BIBLIOGRAPHY

Books

Abernathy, Jack. *Living Monument: The Story of Grace Covenant Presbyterian Church.* Richmond, VA: Grace Covenant Presbyterian Church, 1989.

A Century with Christ: A Story of the Christian Church in Richmond. N.p.: Editorial Committee of the Disciples Centennial General Committee, 1932.

A History of Congregation "Beth Ahaba" Richmond, Virginia. Richmond, VA: Issac Thalhimer, 1926.

Bagby, Bathurst Brown. *Recollections.* West Point, VA: Tidewater Review, 1950.

Bailey, James Henry. *History of St. Peter Church.* Richmond, VA: Lewis Printing Company, 1959.

Barklely, J.M. *Francis Makemie of Ramelton.* Belfast: Presbyterian Historical Society of Ireland, 1981.

Beacon on a Hill: Pine Street Baptist Church. Richmond, VA: Williams Printing Company, 1955.

Berman, Myron. *Richmond Jewry.* Charlottesville: University Press of Virginia, 1979.

Blanton, Wyndham B. *The Making of a Downtown Church.* Richmond, VA: John Knox Press, 1945.

Brydon, George MacLaren. *Religious Life of Virginia in the Seventeenth Century.* Williamsburg: Virginia 350th Anniversary Celebration Corporation, 1957.

Calisch, Edward Nathan. *Three Score and Twenty.* Richmond, VA: n.p., 1945.

Cheek, Richard A. *Through One and One Quarter Centuries of St. John's United Church of Christ.* Richmond, VA: Dietz Press, 1962.

Christian, W. Asbury. *Richmond: Her Past and Present.* Richmond: Virginia State Library, 1912.

Clemmitt, Thomas Jr. *Old Sycamore Church and Some Other Things.* N.p: Press of Fleet-McGinley, 1932.

Crumley, Marguerite, and John G. Zehmer. *Church Hill.* Little Compton, RI: Fort Church Publishers, 1991.

Dabney, Virginius. *Richmond, The Story of a City.* Charlottesville: University of Virginia Press, 1990.

Ellyson, Belle Gayle. *The History of Second Baptist Church, Richmond, Virginia 1820–1970.* Richmond, VA: Whittet and Shepperson, 1970.

Ezekiel, Herert Tobias, and Gaston Lichtenstein. *The History of the Jews of Richmond from 1769 to 1917.* Memphis, TN: n.p., 2012.

First Baptist Church Richmond 1780–1955. Richmond, VA: Whittet and Shepperson, 1955.

Fisher, George D. *History and Reminiscences of the Monumental Church.* Richmond, VA: Whittet and Shepperson, 1880.

Fogarty, SJ, Gerald P. *Commonwealth Catholicism.* Notre Dame, IN: University of Notre Dame Press, 2001.

Gaines, William H. Jr. *A History of Grace and Holy Trinity Episcopal Church, 1858–1987.* Richmond, VA: Grace and Holy Trinity Episcopal Church, 1981.

Greenberg, Marilyn. *Through the Years: A Study of the Richmond Jewish Community.* Richmond, VA: n.p., 1955.

Griggs, Walter S., Jr. *Hidden History of Richmond.* Charleston, SC: The History Press, 2012.

Hatcher, William E. *John Jasper: The Unmatched Negro Philosopher and Preacher.* New York: F.H. Revell, 1908.

Horn, James. *A Land as God Made It.* New York: Basic Books, 2005.

James, William Carey. *Leigh Street Baptist Church, 1854–1954.* Richmond, VA: Whittet and Shepperson, 1954.

Marshall, Catherine. *The Prayers of Peter Marshall.* New York: McGraw-Hill, 1954.

Mead, Frank S. *Handbook of Denominations in the United States.* Nashville, TN: Arlington Press, 1990.

Moore, J. Staunton. *The Annals and History of Henrico Parish.* Baltimore, MD: Genealogical Publishing, 1979.

Mordecai, Samuel. *Richmond in By-gone Days.* Richmond, VA: Dietz Press, 1946.

Newell, Arthur W. *Whispers in the Silence* N.p.: n.p., N.d.

Remke, Ignatius. *Historical Sketch of St. Mary's Church, Richmond, Virginia*. Richmond, VA: n.p., 1938.

Richardson, Selden. *Built by Blacks*. Charleston, SC: The History Press, 2007.

Richmond: City of Churches. Richmond, VA: Southern Bank and Trust Company, 1957.

Sadler, R. Jackson. *Footprints of the Saints*. Richmond, VA: First Presbyterian Church, 2013.

Scott, Mary Wingfield. *Old Richmond Neighborhoods*. Richmond, VA: n.p., 1975.

Sweet, William Warren. *Virginia Methodism*. Richmond, VA: Whittet and Shepperson, 1955.

Taliaferro, Grace E. *A Story of St. John's Church*. Richmond, VA: Trevett, Christian and Company, 1968.

Urofsky, Melvin. *Commonwealth and Community: The Jewish Experience in Virginia*. Richmond: Virginia Historical Society and the Jewish Community Federation of Richmond, 1997.

Webster, Richmond. *A History of the Presbyterian Church in America*. Philadelphia: Joseph M. Wilson, 1857.

Weddell, Elizabeth W. *St. Paul's Church, Richmond, Virginia*. Richmond, VA: William Byrd Press, 1931.

Weeks, Nan F. *Grace Baptist Church, 1833–1958*. Richmond, VA: Garrett and Massie Inc., 1958.

Weisiger, Minor T., Donald R. Traser and E. Randolph Tirce. *Not Hearers Only: A History of St. James's Episcopal Church*. Richmond, VA: St. James's Episcopal Church, 1986.

White, Blanche Sydnor. *First Baptist Church 1780–1955*. Richmond, VA: Whittet and Shepperson, 1955.

Wiltshire, Mrs. J.L. *A Century of Service: The History of Union Station Methodist Church, 1843–1943*. Richmond, VA: Whittet and Shepperson, 1943.

Newspapers

Daily Dispatch (Richmond, VA). March 29, 1866; May 19, 1866; April 8, 1869; May 6, 1873; December 27, 1876; December 28, 1876; August 2, 1896; November 1, 1898.

Enquirer (Richmond, VA). July 10, 1812; December 7, 1822; April 3, 1938; March 20, 1866.

Planet (Richmond, VA). May 4, 1901.

Richmond (VA) Dispatch. June 7, 1891; June 15, 1901.

Richmond (VA) Examiner. February 1, 1866.

Richmond (VA) Times-Dispatch. December 19, 1876; March 15, 1903; March 16, 1903; March 17, 1903, March 18, 1903; April 16, 1903; July 4, 1903; July 25, 1903; March 15, 1904; December 9, 1904; April 13, 1905; April 25, 1905; June 17, 1905 ; April 13, 1905; July 9, 1905; October 16, 1906; March 4, 1907; March 30, 1907; April 7, 1907; March 28, 1908; September 3, 1908; March 18, 1910; March 17, 1910; May 20, 1910; September 19, 1911; September 21, 1911; October 27, 1911; October 30, 1911; November 24, 1911; May 2, 1912; May 8, 1912; May 26, 1912; June 17, 1912; July 17, 1912; September 28, 1912; October 25, 1913; March 18, 1914; December 9, 1914; January 10, 1915; January 15, 1915; March 28, 1915; March 29, 1915; April 5, 1915; December 15, 1918; September 13, 1920; December 4, 1921; January 20, 1923; November 10, 1923; December 8, 1923; December 9, 1923; December 10, 1923; May 31, 1924; June 3, 1924; March 15, 1925; October 13, 1925; July 24, 1926; December 31, 1926; March 17, 1931; September 5, 1931; November 13, 1931; February 27, 1932; March 17, 1932; September 10, 1932; September 30, 1932; November 6, 1933; June 11, 1933; April 7, 1935; February 13, 1936; February 16; 1936; May 3, 1936; September 10, 1938; December 31, 1939; April 1, 1940; November 2, 1940; November 21, 1943; February 17, 1945; February 20, 1945; September 24, 1945; January 27, 1946; October 1, 1946; May 22, 1947; January 11, 1949; April 22, 1949; March 17, 1950; April 23, 1950; May 7, 1950; June 6, 1950; November 27, 1950; February 5, 1951; July 10, 1951; February 13, 1952; March 29, 1953; November 18, 1953; September 26, 1954; October 31, 1954; May 22, 1955; June 26, 1955; December 28, 1955; September 18, 1955; January 15, 1956; February 28, 1957; April 29, 1957; May 1, 1957; May 13, 1957; May 24, 1957; November 1, 1958; November 11, 1958; November 15, 1953; September 18, 1955; February 5, 1951; February 8, 1951; December 21, 1952; December 18, 1957; January 29, 1961; July 25, 1961; July 26, 1961; December 23, 1961; June 18, 1963; December 21, 1963; March 21, 1964; May 3, 1964; September 12, 1964; February 8, 1965; February 28, 1966; April 30 1966; June 16, 1966; December 16, 1966; August 2, 1968; October 9, 1968; July 12, 1969; January 1, 1974; March 8, 1975; March 13, 1976; June 5, 1978; October 18, 1981; October 3, 1983; December 11, 1983; October 3, 1983.

Richmond (VA) Whig. June 23, 1835; October 23, 1835; July 9, 1841; October 15, 1841; May 12, 1843; November 14, 1845; November 18, 1857; August 21, 1863; August 31, 1863; September 29, 1865; May 17, 1867; June 4, 1867; June 22, 1869; March 1, 1972.

Times (Richmond, VA). September 9, 1901.

About the Author

D r. Walter S. Griggs Jr. is a professor emeritus at Virginia Commonwealth University in Richmond, Virginia, where he taught law for forty-five years. He has also taught history courses in the Honors College and courses in religion. He holds a master's degree from the University of Richmond, a juris doctorate from the University of Richmond School of Law and a doctorate from the College of William and Mary in Virginia. Griggs has written the following books published by The History Press: *The Collapse of Richmond's Church Hill Tunnel*; *The Hidden History of Richmond*; *World War II Richmond, Virginia*; and *Historic Disasters of Richmond*. He has also written books on the Civil War, fire departments and moose. He was awarded the Jefferson Davis Medal for his Civil War books and articles. Griggs is married to the former Frances Pitchford, who is fortunately a retired English teacher and librarian. She edits and proofs his work. He is also fortunate to have a daughter, Cara, who is a reference archivist for the Library of Virginia. Walter Griggs and his family live in Richmond, Virginia.

About the Photographer

Robert Diller is an award-winning nature photographer. He holds a bachelor of science degree in biology from George Mason University and did graduate work in molecular biology and biochemistry at Pennsylvania State University. Robert Diller had been a guest travel writer, photographer for the Virginia State Park Systems and a travel blogger for Virginia Through Our Eyes. He is an avid hiker and proponent for Virginia Outdoors conservation and public access. He has also worked in the retail book industry. Robert Diller and his husband, Kevin Divins, are residents of Richmond, Virginia. They are participants in many civic activities in the community and in their church.

Visit us at
www.historypress.net
..
This title is also available as an e-book